LOCOMOTIVE PORTRAITS

LOCOMOTIVE PORTRAITS

JONATHAN CLAY

PEN & SWORD
TRANSPORT

First published in Great Britain in 2015 by
Pen & Sword Transport
An imprint of Pen & Sword Books Ltd
47 Church Street
Barnsley
South Yorkshire
S70 2AS

All royalties from this book will be donated to the Railway Children
charity (reg. no. 1058991) www.railwaychildren.org.uk

ISBN 9781783463886

Typeset by Pen & Sword Books Ltd
Printed and bound in China by Imago Publishing Limited

Pen & Sword Books Ltd incorporates the imprints of Pen & Sword
Archaeology, Atlas, Aviation, Battleground, Discovery, Family History,
History, Maritime, Military, Naval, Politics, Railways, Select, Social
History, Transport, True Crime, and Claymore Press, Frontline Books,
Leo Cooper, Praetorian Press, Remember When, Seaforth Publishing
and Wharncliffe.

For a complete list of Pen and Sword titles please contact
Pen and Sword Books Limited
47 Church Street, Barnsley, South Yorkshire, S70 2AS, England
E-mail: enquiries@pen-and-sword.co.uk
Website: www.pen-and-sword.co.uk

Contents

Foreword

It gives me great pleasure to commend Jonathan Clay's first book to you. We met a few years ago, when he and Barbara were first selling prints of his paintings and I was covering events at narrow gauge railways for my magazine column. With the passage of time we became friends and I watched as he developed in artistic stature, becoming one of the 'go to' artists for special event or commemorative paintings. I am pleased to have three Clay originals on my walls. With talent and personality, Jonathan has developed his own instantly recognisable style to carve out a niche for himself both in the field of railway art and in heritage railways. Enjoy his paintings.

Peter Johnson
Railway photographer and author

Autobiography and the story behind Locomotive Portraits

Although in my sixties, I've been a professional transport artist for only sixteen years. About five years into my new career we were spending a few days at Donaghadee in Northern Ireland, as the guests of the Belfast and County Down Miniature Railway. Whilst there we managed to include a bit of a tourist trail, which included the wonderful Ulster Folk & Transport Museum at Cultra, Dunluce Castle, and the Giant's Causeway. It was early in the year, and the newly built narrow gauge railway at the latter location had yet to open for the season. However, I knew that there were locomotives to be seen, so, braving the wind and the rain, I put my nose around the door of what appeared to be the workshop. I became aware of the smell of machine oil and the sight of two diminutive steam locomotives, from behind one of which appeared a figure in a boiler suit. I apologised for entering unannounced, to which the gentleman replied that it was 'no problem'. At this point I introduced myself and, without hesitation, he said, 'I've heard of you! You're a railway artist, aren't you?' When you set out to do something, particularly if it involves a career change later in life, you do not know whether it's going to work. So to be recognised by someone I didn't know, in a place I'd never been before, was something of a confidence booster. It was at this point that I began to think I'd 'arrived'.

I am a product of the post-war baby boom. My parents married in 1939, but I guess events got in the way of starting a family. Dad was called up in 1940, joined the army and ended up in the Normandy landings in 1944. It was still a time of austerity and rationing when I made my entry into the world in 1950 at Queen's Park Hospital in Blackburn. Apparently I gave Mum something of a hard time in the process, which is probably more significant than I realise. My younger brother Christopher happened along a couple of years later.

My father, Edward Geoffrey Clay, came from a 'respectable' middle-class Leeds family. Art must have been in the family for some time, since Albert, his father, and Gilbert, the elder of his two brothers, were both very accomplished watercolour artists. Uncle Gil's beautiful picture of the interior of Lichfield Cathedral currently hangs in our apartment. Dad went to Leeds College of Art in the 1930s and subsequently became an art teacher at St Peter's School in Blackburn. He was also one of the founding members of Blackburn Artists' Society, and his name can be seen on a roll of honour in Blackburn Museum, which also has one of his paintings. Dad was a talented and resourceful man and, as well as being an artist, could turn his hand to most practical things, from woodworking to rewiring the house; from metalwork to model making. He was a dab hand at

motor mechanics, even building a complete new chassis for the family's Wolseley 14 when the old one gave up the ghost. In the 1960s we spent many happy hours together rebuilding and modifying cars and motorbikes. The garage was full of tools, including a metal turning lathe, in addition to hundreds of things that he had accumulated and which would one day 'come in useful'. He made several beautiful models of racing yachts, which we would sail on the boating lake in Fleetwood. In fact it is only in the last four years or so that we had to part company with the last of his yachts – fully six feet long! He was the perfect role model for an inquisitive youngster, and I honed my rudimentary skills with the obligatory Meccano and Bayko building sets, as well as helping tinker with the family cars. This had an unusual spin-off, since after he died I was occasionally called upon by his friends to sort out their cars, as he always had. In the family, I'm still called upon to do odd jobs whenever I visit any of my offspring. I think they either store them up until we visit, or invent them to make me feel useful.

Dad also built a series of model railways. The first was a small, inverted figure-of-eight, on which we could run two trains. In the 1950s you were either Hornby Dublo, Tri-Ang or Trix. We were of the Tri-Ang persuasion (possibly because they were the cheapest) and we spent hours just watching these trains go round and round. Dad also started an end-to-end layout in the garage, but that was never very successful, until after we moved house, when it was incorporated into a huge layout.

Although he wasn't a 'trainspotter' as such, Dad knew a lot about railways and could, for example, tell the difference between an A3 and a V2, or a Black Five from a Jubilee, from a good distance, and he did nothing to dissuade me from taking up a railway-based hobby. These were the days when trainspotting was considered to be a worthwhile (and almost compulsory) hobby for a boy, and, even though people tend to look down on it today, it certainly gave me a good grounding in things like numeracy and travel organisation, and a pretty good knowledge of British geography. I was also encouraged by several friends to take up that other spotting hobby – buses – and still take a passing interest today.

Mum was of that generation of stay-at-home mothers, and was the kind of quiet, methodical type who ran the house without making a fuss about it. She had worked in a secretarial capacity in the Civil Service during the war, but gave it up when peace broke out. Until her eyes started to fail her in the early 1980s, she always used shorthand for things like shopping lists. I still have her handwritten recipe books and often try to replicate some of her cooking; my youngest daughter prides herself in being able to 'cook like Grandma'. Mum's books even contain recipes for patent medicines, though I've never been tempted to try them out. She was a bit of a railway-cum-motoring widow, although more often than not she would accompany us on our explorations and had a reasonable knowledge of railways, at least of the Welsh narrow gauge variety. More importantly, she had an encyclopaedic knowledge of the locations of the public conveniences along any route we might be likely to take. Even though she's been gone since 1986, it's still a bit of a family

joke. Mum also avoided upset wherever possible, and if anything nasty came on the television it was hastily switched off with the comment, 'We don't need to know about that!'

We often get our memories from photographs, but my first conscious railway memory is of the Ravenglass and Eskdale Railway, in what is now Cumbria. We were on a family holiday at Seascale (in the days before it achieved notoriety as Sellafield). Dad was very good at making sure our photo albums were captioned and dated, so I know it was around my second birthday when a very young Jonathan, looking very apprehensive, was photographed sitting in the driver's seat of River Irt. I have since visited the R&ER several times, although the loco looks a bit different these days. My other recollection from that time is of a really bad dream in which railway tank wagons kept exploding! I steered well clear of them for many years after that, and it was a long time before I was persuaded to have any on our model railway.

Family holidays elsewhere often had a railway interest, whether it was at Hest Bank on the West Coast main line, where I saw both pioneer LMS diesels 10000 and 10001, and their Southern equivalents, double-heading the Royal Scot, as well as Duchesses, and many other LMS locomotive types, or in North Wales, where my love affair with the narrow gauge really began. Sadly, I have mislaid another photograph, taken on the beach at Barmouth: while all the other youngsters are happily building sandcastles, catching crabs, or chucking stones in the sea, there I am, gazing inland at a passing Manor loco on the Cambrian Coast Express. It wasn't always trains, though; I recall one holiday in Scotland where we went to see the battleship Vanguard being broken up.

My paternal grandmother lived in Leeds, and here I was introduced not only to the splendid trams but also to the products of the LNER, by visiting the stations in Leeds. One of Dad's old college pals, Harry Dickinson, lived at Cookridge, and on a visit we would traipse over the fields to the railway line, where we would watch A3s, V2s and the like steam past. I'm still in contact with James (the son of the family), though my recollections are that he was more interested in butterflies than trains. (He has since spent his entire working life as a taxidermist!) In 1957 Grandma came to live with us, and the trips to Leeds ceased, although we have been back several times since, as Leeds is coincidentally also the birthplace of my wife, Barbara.

Mum's parents lived in Fenay Bridge, near Huddersfield, although her father died when I was small. There was a railway line at the end of the garden, and we would often see and hear WD 2-8-0s passing by with goods trains. I have a vague memory of discovering some narrow gauge tracks in the woods near there, but I can't for the life of me discover what they were from. My granny, Amina, was a lovely lady who always went out of her way to spoil us boys. She later moved into a block of high-rise flats in the centre of Huddersfield, from where we would look down on the trolleybuses far below. Nearby there was also a street tramway, which was used by the local gasworks to move supplies about, and which was home to a tiny saddle-tank locomotive.

My parents bought a very large house in West Park Road in Blackburn, specifically so Grandma could have her own space when she moved in with us. Unfortunately the house was dilapidated, with water running down the walls and non-functioning electrics. However, it did have a huge garage and back garden, and was only a stone's throw from Corporation Park. Dad had a lot of friends who were 'handy' in one way or another, and he and his pals spent a great deal of time renovating the house before we could move in. I lived there for sixteen happy years until my marriage. My brother Chris and I were allocated the largest attic as our railway room, and Dad built a magnificent model railway, some 20ft by 14ft, which gave us countless hours of pleasure. Those were the days when new locomotives and rolling stock arrived only at Christmas and birthdays. We didn't care that British prototypes ran alongside those from across the Atlantic; there was only a limited selection of stock available anyway, unlike today. What we couldn't buy we made for ourselves, which I'm sure added to the enjoyment. My prized possessions were a couple of very well-thumbed Gamages catalogues. Ah, the joys of Bilteezi and Superquick!

Our favourite spotting place became Brock, on the West Coast main line. There was a parking place by the side of the line, close to a church and near a bridge over the line, and we would spend many happy hours ticking off locomotive numbers in our Ian Allan ABCs. On one visit my brother and I discovered a rather salacious magazine under the hedge, which was quickly confiscated! We also spent time at Preston station, though that was usually in connection with the collection or delivery of visitors. The parking place, the church and the West Coast main line are still there, although rather overshadowed by the M6.

I tried to combine my trainspotting jaunts with my other hobby – bus-spotting. With my good school friend Stuart Ferguson, I went all over the place. We were only eleven or twelve at the time; these days, kids would not be allowed to travel about as we did. We were adventurous enough to venture outside Lancashire, and to other places where we happened to have friends or family. Stuart's dad travelled about on business, so we would occasionally go with him. We would also go to the North East, where Uncle Gilbert lived, and to Maidstone in Kent, where Dad's younger brother Bernard lived. He and my cousins were somewhat more cultured than us, since they all played a variety of musical instruments. I can just about pick out a tune on the piano and guitar, but my cousin Michael ended up in the Welsh National Opera Orchestra. On my visits to Kent I was less than enthralled with the electric trains thereabouts, but there was always the compensation of Maidstone & District and East Kent buses! And of course it was here that I was introduced to the Romney, Hythe and Dymchurch Railway.

Two or three weeks of our summer holidays were usually spent in North Wales, where I was introduced to the Ffestiniog, the Talyllyn and the Fairbourne railways by the time I was eight, and we continued to make regular pilgrimages right up until my teenage years. We always stayed in a big house called 'Erw Fair' ('fair acre' in English) in the centre of Beddgelert, and I became

very familiar with what remained of the Welsh Highland Railway. The trackbed was our playground and our footpath, and I once cycled along it to Porthmadog, though with several detours where bridges were missing or unsafe. One year we arrived in Beddgelert to find that the emergent railway society (which became the 1964 Co.) had left track and other equipment on the site of Beddgelert station. More fun was had trying to push slate wagons around. Little did we think, in those far-off days, that the Welsh Highland would become a fully functioning railway once again, and we certainly would never have imagined Garratts in the Aberglaslyn Pass.

After an interlude at about the age of twelve or thirteen, when I had a brief flirtation with the then-popular hobby of slot racing (Scalextric ruled the roost even then), one of the last of my spotting adventures took me to Crewe station with a crowd of other pupils from my grammar school. I tried to combine watching Duchesses at the station with seeing Trent and PMT buses in the town. It was 1963 or 1964, and everything on the railway seemed run down, even with the proximity of Crewe Works, where you could at least see some decently presented locos in the past. Occasionally we would see freshly overhauled locomotives on test, but I'm not sure we saw any on that visit.

This was also a time of rising hormones, and my interest in transport began to wane, apart from on a personal level, for I had discovered the joys of motorcycling. I also began to compete with my contemporaries in that time-honoured pursuit of chasing girls, and started to enjoy other 'grown-up' pursuits, including pop music and beer. It came as a bit of a jolt when, one day in 1968, Dad looked up from his newspaper (the *Yorkshire Post*, even though we lived in Lancashire!) and announced that the last steam train in Britain was coming through our town the following day. I was mortified. Fortunately, I had left school and was waiting to start my first job, so the following day, we all (including my girlfriend and my mother) trooped off to stand on the embankment at Whitebirk Power Station to watch the train pass. While we waited, a very grimy 8F pulled a freight train in the opposite direction, so I guess we saw the next-to-last train as well. The passenger train duly arrived, hauled by the Britannia Pacific Oliver Cromwell, and at its passing an era ended. The modern railway held little interest for me. Thank God for railway preservation societies, I say (although my wife and three girls might not accord with that, as they have been dragged unceremoniously around various railways for years).

I'm often asked when my interest in art began. I had been pretty good at drawing from an early age, and won several prizes at primary school for my paintings. I owned a series of little books (which I still have) about how to draw such things as trains, cats and cars. It must have been Dad's influence rubbing off, though I don't remember him giving me any formal lessons. I suspect I may have learnt the basics, like perspective, from him.

As youngsters, Chris and I were supplied with a number of periodicals, initially comics such as the Lion and Eagle, where there were some fascinating cutaway drawings by artists such as

L. Ashwell Wood and Geoffrey Wheeler, and front page illustrations, usually racing cars, by Michael Turner, who is still around today. We also took the Model Railway News, and a feature of this in the late 1950s and 1960s was that the cover illustrations tended to be paintings. I was particularly impressed by those of George Heiron, which were extremely realistic. I kept the covers long after the magazines had disappeared, and still have some. Sadly, although he was one of my influences, I never met him, and he died a few years ago. Fortunately, I do have a very good autobiography of his, which contains many of his paintings. Tri-Ang model railway catalogues introduced me to the work of Terence Cuneo, and Dad used to delight in pointing out that 'You can't see where the boiler ends and the sky begins.' If you look at Cuneo's pictures, you'll see what he meant.

The first time I indulged consciously in anything arty myself was after I had finished my A Levels, which weren't very successful, largely because I hated school. But with time on my hands, as we were required to stay on school premises until the end of term, I gravitated to the school's art department, which was run by a lovely chap called Jack Marchant. He was remarkable in that he had only one lung, the other having been removed after being ill-treated in a Japanese POW camp during the Second World War. Rather annoyingly, some of the more Neanderthal students thought this was highly amusing, and I took great exception to their attitude, which didn't make me terribly popular. With Jack's encouragement I began to paint not trains, but my other love, racing cars. I got a great deal of enjoyment out of this,

though Dad was quick to point out that this would never be a good way to earn a living. I must admit that those first pictures weren't particularly good, and none survives, but I wasn't put off and continued to draw and paint whenever I could, sometimes even at work, if I was particularly bored. By the early 1970s the advent of a family meant that a conventional means of earning a living was paramount, which led me to a succession of mediocre jobs. Sadly, I was never very ambitious in that respect.

We did start to move in artistic circles, though, and became friendly with the owners of a local pub. The Seed family ran the Clog and Billycock, and I became friendly with the eldest daughter, Adrienne. She was, and still is, a very fine painter of fantasy scenes, and eventually we resolved to hold a joint exhibition. It was called 'Steam Dreams', and apparently, Adrienne still has one of the posters. It was held under the auspices of the Mid-Pennine Arts Association in the mid-1970s and was relatively successful. Some paintings were sold, though not enough to warrant a career change. I also submitted various pictures to other local art or craft events, and in 1979 held a one-man exhibition of my motor racing paintings at Donington Park Racing Museum.

My father died in 1980, and I suffered a period of personal upheaval. I had not really succeeded in my education, and felt I had let him down, so I took three years out to study for a degree in history and politics, graduating with honours in 1984. Barbara completed her degree at the same time, but whilst she went on to great things work-wise, I resumed my habit of taking dead-end jobs. As it

turned out, this was probably a good thing, because had I been adventurous or academic I might not be doing what I do now.

By the late 1990s. I had begun to tire of my working life, not least because I detested the man who was my boss at the time: he was a real bully. Also by this time, our three girls had left home and begun their own families, and Barbara was tiring of her pressurised job in Social Services. And so it was that on New Year's Eve 1998 we sat down with a comforting draught or two, full bellies, and a flip chart (yes, really!). The brainstorming session that followed showed that, whilst I undoubtably had artistic talent, it had never been used, so I should really try and find a way of harnessing it. I began to make contacts with friends and relations in various places, one of the first of which was at the Ffestiniog Railway. I managed to obtain a space for a stall at its steam gala in May 1999, at which I received several other invitations to exhibit my wares, and things developed from there. And yes, Barbara really is to blame. 2014 marked my fifteenth such visit to the FR.

This was where the concept of producing a series of locomotive portraits began – but only by accident. In order to prepare for my first event, and so that I would have enough work to show, I decided to paint seven or eight originals of narrow-gauge locomotives, but leave the background plain. The idea was that I would add the backgrounds later, when I had more time. More fool me! I sold most of those originals, and people started to ask me to paint other locos for them, in the same style. By then we had attended only about half-a-dozen events. Initially we were very brave and camped, using a

very swish and commodious Khyam tent. I remember being woken up at some ungodly hour by the side of the Bala Lake Railway, by both the extreme cold and some idiot blowing a locomotive whistle. We also visited Launceston, amongst other lines, and also did the first couple of model railway exhibitions, at places like Leigh and Preston.

Within a couple of years we were away at exhibitions of one sort or another for thirty-two weekends a year, at which point we tired of the camping life and bought a motorhome. This provided an ideal base for our activities, as well as accommodation, and lasted until February 2005, when it disappeared from outside our house, never to be seen again. Strangely, we had discussed the possibility of selling it, as neither of us was getting any younger, and the thief made the decision for us. Since then it has been cheap hotels, B&Bs and friends who have accommodated us. We began to follow similar patterns each year, and started going to some major shows, such as the Warley Club exhibition at the NEC, and Model Rail Scotland and, whilst we don't travel so far afield these days, there are some events we can't do without, such as the Welshpool and Llanfair Railway Gala in early September. One of the nicest aspects of this job is the number of good friends we have made. Railway enthusiasts are some of the friendliest, most genuine and selfless people you could wish to meet, and honest, too: in fifteen years I have only had two bad debts.

My work has given me access to all sorts of railway-related locations, and I have visited many fine railways, large and small, both in the UK and on mainland

Europe. It has been a privilege to have been allowed to fire or drive a wide selection of locomotives. I can't say I'm superbly qualified, but I know how to make them go, and more importantly, how to make them stop!

I realised early on that it might be useful to have the blessing of my peers, and so I approached the Guild of Railway Artists. My first contact was with that fine gentleman and supreme artist Barry Freeman. He was quick to point out that membership of the guild was not a passport to fame and fortune, but it hasn't done him any harm! Initially I became an associate member, having completed an evaluation process in Warwick, conducted by members of the Guild Council. I have subsequently had work accepted for GRA exhibitions and my pictures are featured in two of the guild's books, the latest of which was Emotions of Railway Art, published in 2011. Having gone through another assessment a few years ago, I am now a full member of the guild (and also of the Guild of Motoring Artists).

I currently attend between twelve and fifteen shows a year, most of which I do on my own. Barbara has served her time admirably and, although she sometimes accompanies me, she also likes to follow her own interests. Although I appreciate the value of meeting and talking to people as the best form of marketing, most of my work comes through commissions. I have tried formal advertising in the past, but it doesn't work. Without being immodest, my best advert is me! When I sell a picture from my exhibition stand, it leaves a gap, and if I go somewhere new, which requires something appropriate that I haven't already done, then I fill the gap with the new painting. Although my series represents a cross-section of the UK's railway locomotives, there is still plenty of scope to add more.

I have illustrated several books, including three children's books by Christopher Awdry. One was on behalf of the Corris Railway, and the other two, based on North Wales quarry lines, were published by Chris himself. I have since provided pictures for other authors, most notably Peter Johnson, John Milner and Gordon Rushton, as well as a number of magazine covers for the Narrow Gauge Railway Society. I have had the good fortune to be awarded several prestigious commissions. In 2012 I produced a picture, on behalf of Heritage Painting Limited, for the occasion of the Great Gathering of A4 locomotives at the National Railway Museum in York, at which, on the first day, my picture was ceremoniously unveiled by locomotive owner John Cameron. An interesting aside to this commission was that I was required to produce a painting along the lines of one by Terence Cuneo's, called 'Giants Refreshed'. Because of this, I felt it prudent to contact Cuneo's daughter Carole, who holds all his copyrights. We did vaguely know each other, and she was happy for me to do this because she knew my style was sufficiently different to his. Fortunately I had email correspondence to back up our exchange, since I also included a mouse in the picture at the behest of the owner (in this case being chased by his cat!). I was subsequently asked by a Dutch customer to include a mouse in a painting which I shall be producing for him. In this case it will be 'a little mouse with clogs on'. My work has been featured in several railway

magazines over the years, and in 2013 I was asked to write six articles and provide six new pictures for one of the UK's leading bus magazines.

In 2013 I was asked to provide the official picture for the new P2 locomotive project, by the group which has successfully built and which operates the locomotive Tornado. I was mighty relieved when it was revealed, in October 2013, that it was to be named Prince of Wales (the Queen had to be approached for permission to use this name) because, like the others involved with the project, I had been sworn to secrecy, and there was a great deal of speculation in the railway press about what the name was going to be. It's not easy keeping secrets like this, particularly when people think you know!

By the end of 2014 I had produced over a thousand pictures, the overwhelming majority of which involve railways. Those who know only my single locomotive portraits are often surprised to discover that I've also painted non-railway scenes (though some had trains in them!), racing cars, buses, trolleybuses, trams, aircraft, ships and animals. I also have an ongoing project, begun at the request of my wife, Barbara, to paint portraits of each of our grandchildren. To date I have completed six, and am waiting for the youngest to develop a bit before I attempt him. And who's to say my daughters will not add more potential models to our family?

The series of locomotive portraits from which the paintings presented in this volume are taken, now totals over 800 subjects. Will I live long enough to complete a thousand? Watch this space!

How to paint a locomotive portrait

I'm often asked how I produce my paintings and, since it is not rocket science, and, more importantly, not copyright, here we go.

The vast majority of my portraits originate from commissions from individuals or organisations. The first approach from a customer might be by email, phone, letter, or in person at an event. I love this, because I never know what I will be asked to do, and I am often surprised by the variety of things which interest people. I then need to find an image of the subject, and can often find one within my extensive reference library or photographic collection; alternatively a customer might provide photographs (crucial in the case of home-built locos). The advent of pocket-sized, digital cameras and mobile phones has proved to be a boon. If all else fails, there is always that marvellous resource provided by 'Mr Google'.

Once the subject has been determined and images sourced, the size of picture, its orientation and the medium it is to be painted in (all of which go to determine the price) and a timescale must be agreed. Most customers leave it to me to choose how the subject is presented. The most common deadline given is: 'whenever', although a picture is sometimes needed in a hurry. For example, one gentleman approached me at the NEC in November 2013 and asked if he could have the painting by Christmas. This wasn't a problem because, even though the loco itself — No. 5053 Earl Cairns — no longer exists, it was a Great Western Castle class, of which there are plenty of images available. I based the picture on a photograph of a sister locomotive, which I had taken at Tyseley.

My locomotive portraits are all created with gouache (poster paint), which can be worked even if it has dried. This is particularly useful at exhibitions, when I often break off to talk to people. Although I am quite happy to work with a variety of media, such as pencils, crayons and oil paints, I can't get along with acrylics. They cannot be worked once they have dried (and, being water based, they dry pretty quickly). Some artists use them successfully, but to me it's like painting with emulsion.

Here is the sequence of steps I use to create a locomotive portrait, using *Earl Cairns* as an example.

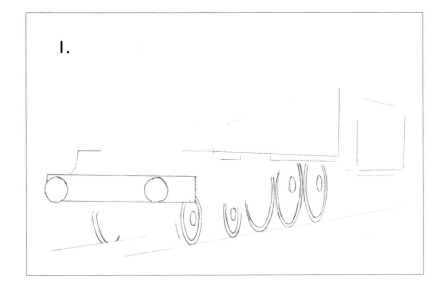

1.

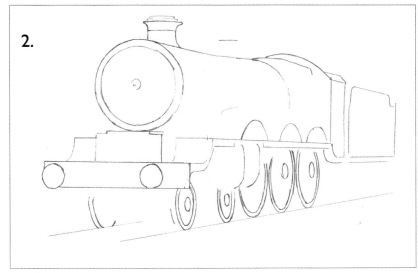

2.

Image 1: Once the orientation of the subject is decided, I start with a few straight lines. This depends on the original image size and the finished size of the painting. In the case of *Earl Cairns* I began with the side footplate, the front buffer beam, the cab rear and the tender. I then added the basic outline of the wheels. People usually say that these are the most difficult part to do, but I always repeat what I was told: everything has perspective, even circles. If you try to imagine the wheels as being square, and then see that square in perspective, all you have to do is join up the mid points of the square with arcs to create an ellipse. However, this is not true ellipse, as any engineer will tell you, and anyone who uses one of those stencils we used to have at school will be disappointed.

Image 2: Next comes the smokebox. This is also in perspective, but usually at ninety degrees to the other lines. Things like the chimney and other boiler fittings are also added at this point. This helps to get the perspective of the boiler (mind you, taper boilers are difficult to get right, since they tend to contradict the perspective). Then it's just a matter of adding all the other details in proportion to what I've already done. There are usually plenty of reference points to use for this.

Image 3: After having added as much detail as I need, I arrive at the finished drawing and painting can begin. I seem to add more detail than is strictly necessary. I think it's just a habit picked up from painting at exhibitions. You'd be surprised how many people will ask: 'Did you draw it out as well?' That which is left off can be added with a paintbrush later.

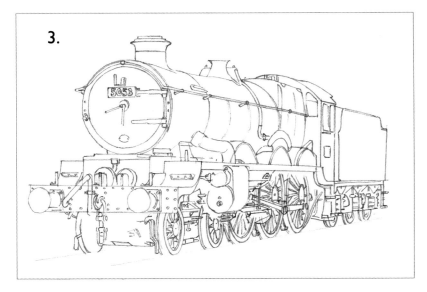

3.

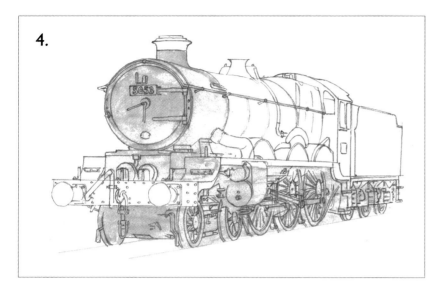

Image 4: Here I have added a couple of quick washes, one very light green and one grey, to 'prime' the paper. Some artists will soak the whole sheet and stretch it onto a board but, since there is no background, there is really no need.

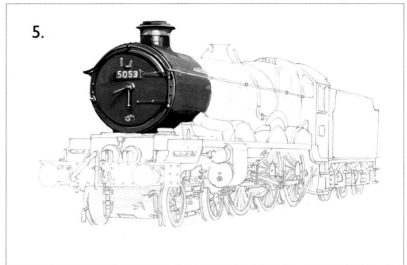

Image 5: When adding the paint, I usually start with something recognisable, particularly if I am painting while at an exhibition. In this case, it is the smokebox and chimney, which people regard as the 'face' of a locomotive. Again there is no hard and fast rule about whether to start at the top or the bottom, although I find if I paint the running gear first it will smudge if any stray water gets near it. On the other hand, the pencil outline can also get a bit messy when you rest your hand on it. The image shows the front of the smokebox finished.

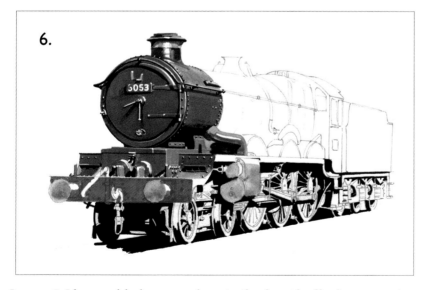

Image 6: I have added some colour to the front buffer beam, and the shading to the running gear.

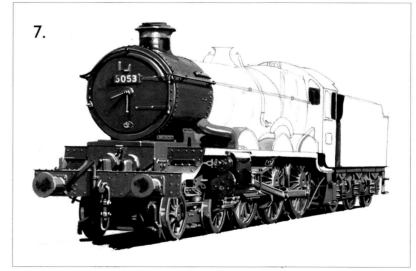

Image 7: The front end and the wheels and chassis of both loco and tender are finished. At this stage it is important to show where the light is coming from, and where to apply any highlights to the wheels and motion.

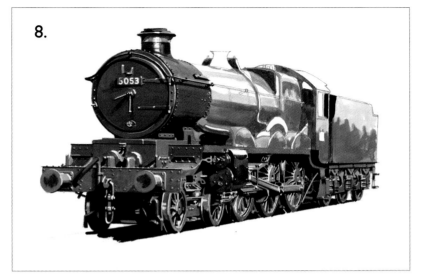

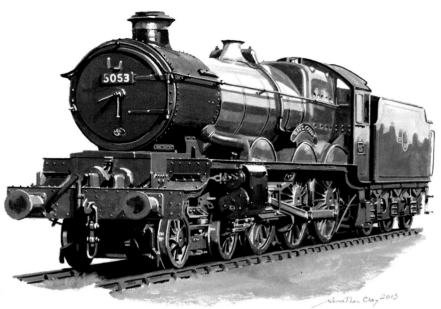

Image 8: I have added a couple of quick shades for the body colour, remembering that the top of a curved surface often reflects the colour of whatever is above it – in this case, the sky. If you ever studied O Level physics (and that dates me!) you will remember that light is made up of the colours of the spectrum, and each colour has a different wavelength. This means that some colours will reflect others, and green is a good example here. A red object placed next to it will still appear red. However some colours absorb others; for example, a blue object reflected in a red engine will just be another shade of red. At this stage a picture can start to look a bit of a mess. It is surprising, though, how quickly it comes together again as you add detail.

Image 9: Finally, I may have to blend in some of the harsher demarcations, but that is the beauty of working with a water-soluble paint like gouache: the ability to go back and work with them even after they have dried. Last of all, I add small details such as lining, crests, nameplates and numbers, and the picture is finished.

For anyone who is tempted to 'have a go', there are several easy ways to get the basic outline. It is the initial drawing that tends to put people off, but you can simply trace it, or project a picture onto a piece of paper, perhaps with a digital projector. I have even seen people use bleached-out photographs as a basis. Lest you think this is 'cheating', a friend of my father, a very accomplished artist, made a point of projecting colour slides onto paper fixed to a wall, and he produced some stunningly detailed townscapes. Another method, one which I have used for larger watercolours or oil paintings, is to draw a grid of squares onto a photograph of the subject, and then copy each square of the grid, but on a larger scale, onto the canvas. Whatever your chosen method, I recommend that you start with something simple, such as a diesel or a small tank engine. You can always choose more complicated subjects later.

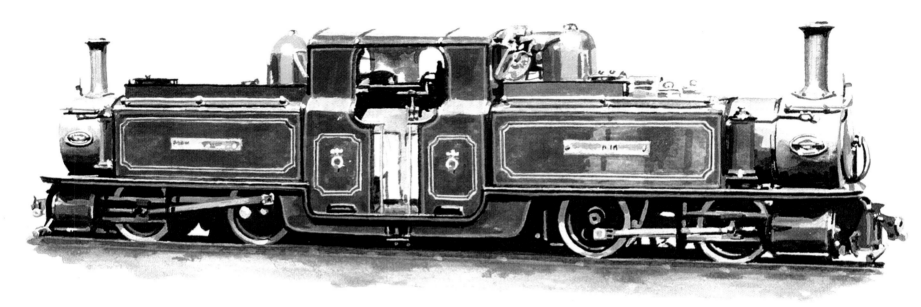

Ffestiniog Railway Double-Fairlie Locomotive *Merddin Emrys*

Merddin Emrys was the first locomotive portrait I painted, in 1999. Due to an oversight I sold (or misplaced) my original, master copy, and the scan of it was of no use for prints; so, for a few years, this loco didn't figure in my catalogue. Fortunately, I was commissioned to paint it again in 2002 and this is the result. Each picture shows a different side of the loco, the other side having pale blue lubricators on the driving bogies. If you spot a painting showing these lubricators, that is the rarer version.

When I visited the FR in 1958 *Merddin Emrys* was languishing in Boston Lodge works, having lain unused since before the Second World War. Happily, it was restored in 1961 and has gone through several incarnations since, including a period in the 1970s when it was fitted with hideous, D-shaped smoke-boxes. It was restored to its former glory in the late 1980s and has run in this form ever since.

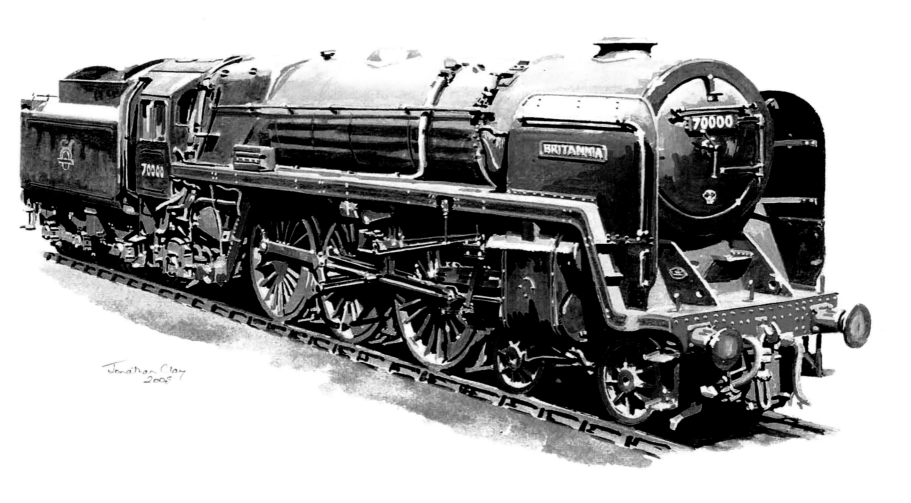

British Railways Standard Class 7 Pacific No. 70000 *Britannia*

Every loco has its devotees, and I've always had a soft spot for the BR Standard designs of the 1950s. After the Second World War the railways, their motive power and their rolling stock were in a pretty poor state, and so the Standards were designed, incorporating the best locomotive thinking from the previous Big Four companies. Since I'm neither an engineer nor a railwayman, I will leave it to others to debate the success or otherwise of these designs. To me they look just right (except maybe for the Class 3 2-6-0).

I remember the excitement when, at Christmas 1960, Santa Claus brought the brand new Tri-Ang model of *Britannia* to our house, though it has long since gone the way of all things. Happily, the real thing is still with us, and along with sister (brother?) loco *Oliver Cromwell* continues to perform well on the main line hauling enthusiasts' specials.

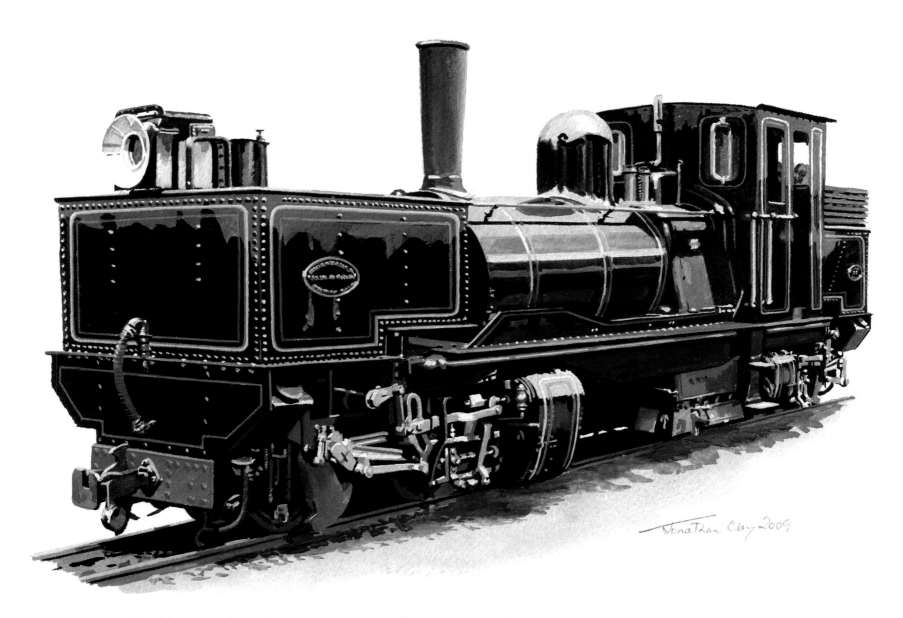

Ex-Tasmanian Government Railways (Dundas Tramway) Beyer-Garratt K1

The first Beyer-Garratt locomotive was brought back from Tasmania and kept at Beyer-Peacock's works in Manchester until purchased by the Ffestiniog Railway in the early 1960s. However, it proved too big for use there and was placed on static display at Porthmadog. It led a nomadic existence for a couple of decades before being cosmetically restored and displayed at the National Railway Museum. In the 1990s a decision was made to restore it to working order; this was completed in 2004, and it entered service on the Welsh Highland Railway the following year. This is my third picture of the loco and I've since painted it again as a Christmas card design for the WHR. It depicts the loco as it is in 2014.

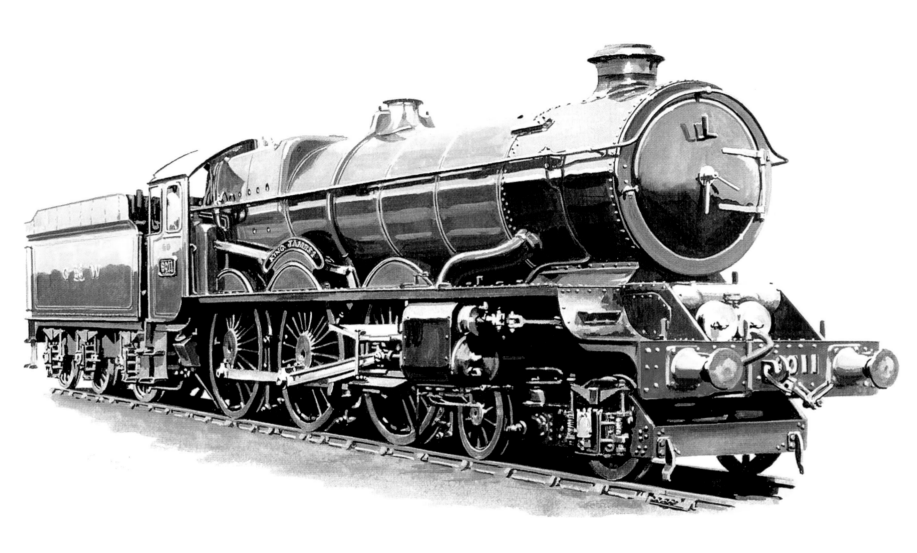

Great Western Railway King Class 4-6-0 No. 6011 *King James 1*

The grandest GWR locos we saw as children were the Manor class, which pulled the Cambrian Coast Express through North Wales. The rest were more humble types, such as prairie and pannier tanks. My first Ian Allan ABC was for the Western Region, wherein I learned that the flagships of that fleet were the Kings, which hauled the most important express trains from Paddington. I remember comparing the power outputs of various express locomotives, and couldn't understand why a loco which wasn't a pacific appeared to be the most powerful of the lot. Although I was a confirmed trainspotter in those days, my first sighting of a King was at Tyseley in 1989, on the occasion of No. 6024's first public appearance after overhaul.

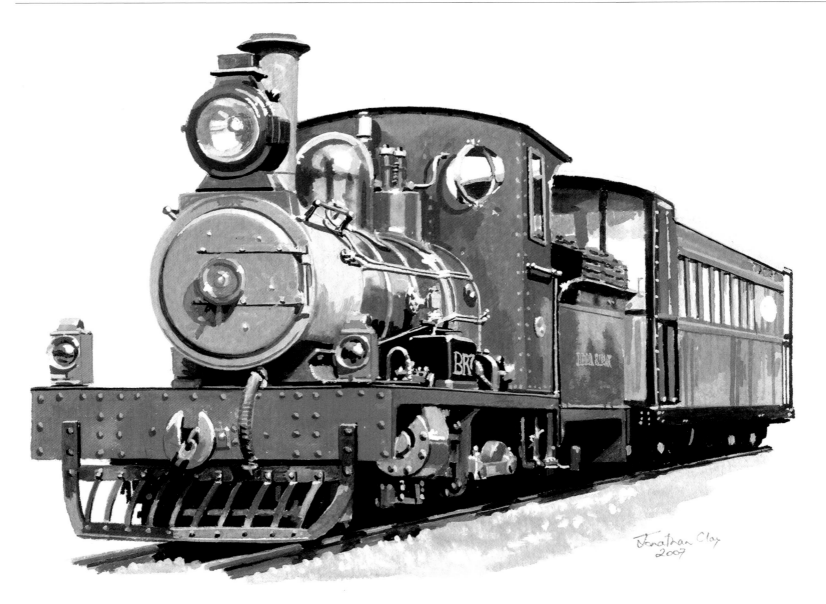

Sandstone Heritage Railway Ex-Beira Railway Lawley 4-4-0 No. 7

In the 1970s I was given a copy of the 7 1/4" Gauge Society magazine, containing photos of two delightful little 4-4-0s, described as 'Lawleys'. Much later I read about them again in Antony Baxter's 1998 booklet The Two Foot Gauge Enigma, about the Beira Railway in Mozambique. The Beira had over forty of these Brush/Falcon locomotives, and many found work elsewhere in Africa after the Beira was re-gauged. Several became South African Railways Class NG6, and a number survive today, including No. 7.

The Sandstone Heritage Railway in South Africa was set up by Wilfred Mole in the late 1990s and has become one of the greatest 2ft gauge railways in the world. It has two Lawleys and I was commissioned to paint both. Two more Lawleys are in a private collection in Britain, unrestored and kept out of public view.

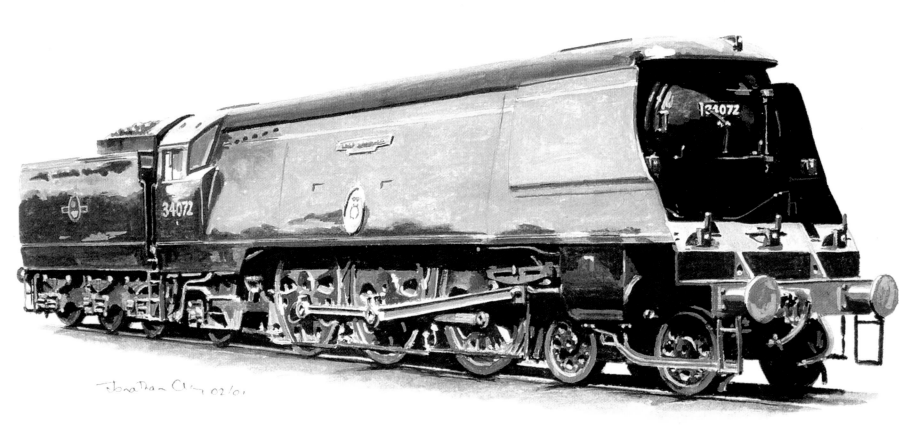

Ex-Southern Railway Bulleid Battle of Britain Class 4-6-2 No. 34072 *257 Squadron*

Rail enthusiasts still debate the merits of Oliver Bulleid's designs, but he was a forward-thinking chap who produced some very unusual designs, such as the Q1 freight locos and the ill-fated Leader. The Merchant Navy and his slightly smaller West Country and Battle of Britain locomotives were built with chain-driven valve gear, but the majority were rebuilt with conventional valve gear in the 1950s. The streamlining, as depicted above, led to their being nicknamed 'Spam Cans'.

Back in the 1990s I enjoyed a cab ride on *257 Squadron* on the East Lancashire Railway. A friend had arranged a special train for his stag night; 34072 was the engine used and, on the way back from Rawtenstall, I was invited onto the footplate – best suit and all. It was a surreal experience, riding tender-first along the ELR in the pitch black of night.

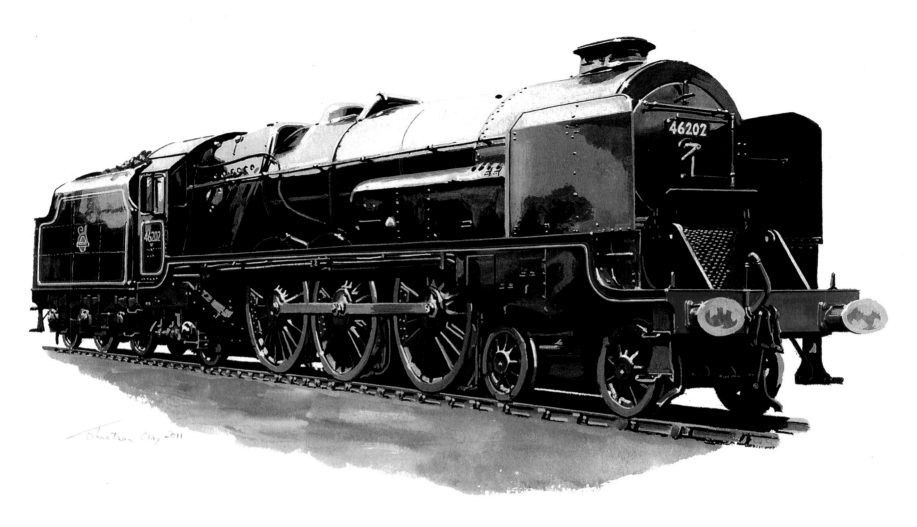

Ex-LMSR Steam Turbine Turbomotive Locomotive No. 46202

Like Bulleid on the Southern, Sir William Stanier liked to experiment, and he explored other ways of powering a loco by steam. This resulted in the Turbomotive. Instead of having conventional cylinders, it was provided with steam turbines where the cylinders would have been (one for forwards motion and a smaller one for reverse). The loco was basically a Princess Royal Pacific, but it was driven by gearing from the turbines, and although it spent long periods out of use for repairs, it was surprisingly long-lived.

In BR days it was rebuilt as a conventional locomotive, with four cylinders, to become a sort of Princess/Duchess cross, carrying the same number and the name *Princess Anne*. Sadly, it lasted only a matter of weeks in this form, as it was written off in the horrific Harrow train crash in 1952. It was nominally replaced by the newly-built *Duke of Gloucester* a couple of years later.

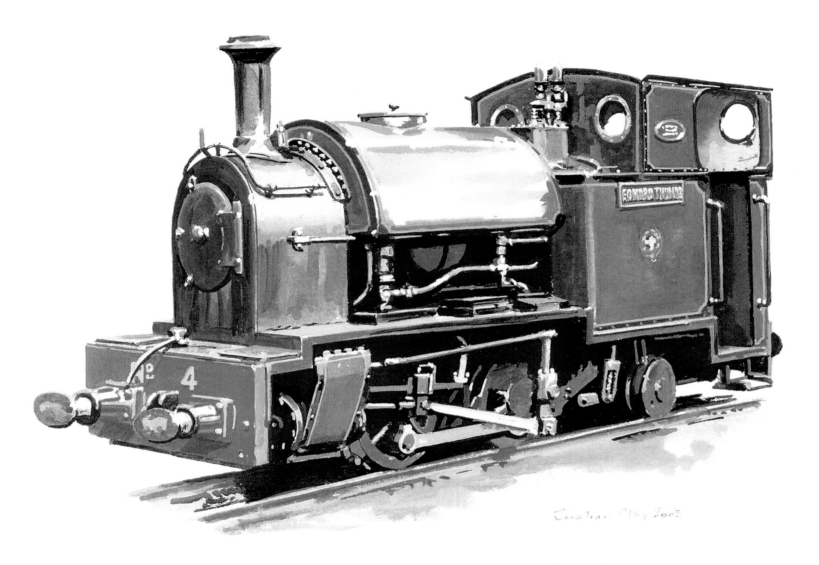

Talyllyn Railway Kerr, Stuart 0-4-2ST No. 4 *Edward Thomas*

The Talyllyn was the first preserved railway in the UK. When a group of like-minded individuals, led by Tom Rolt, set out to rescue the moribund railway in 1951, they cannot have imagined the movement it would spawn. My first visit was in 1958, when the newly restored No. 1 *Tallylyn* had just entered service. But it was *Edward Thomas* that pulled our train, and it was notable for having a tall, thin, oblong chimney – a Giesel ejector. Yes, even the TR was experimenting for efficiency. The loco was built by Kerr, Stuart & Co. for the Corris Railway, as its No. 4. and was purchased for the TR when the Corris closed. It has been immortalised in the Reverend W. Awdry's books as *Peter Sam*, and has even carried that name and red livery on occasion. Happily, it now looks like it does in the painting, complete with a conventional chimney.

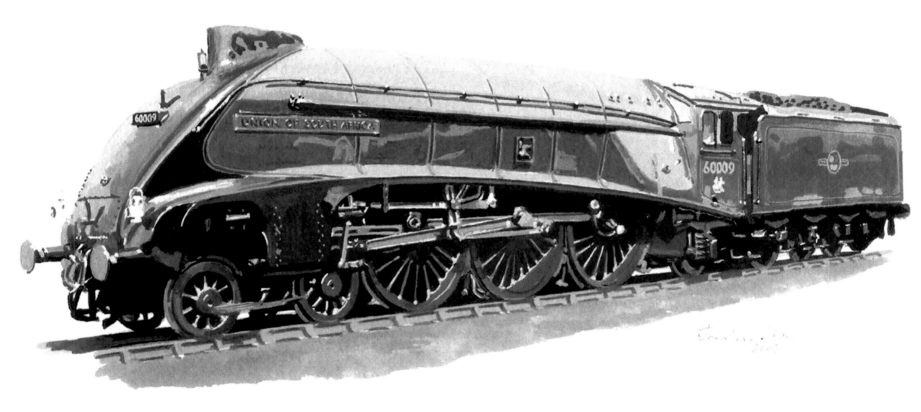

Ex-LNER Class A4 4-6-2 No. 60009 *Union of South Africa*

2013 was a big year for the A4s. Two exiles were brought back across the Atlantic for refurbishment, and the opportunity to see all six surviving locos together in one place was a chance in a lifetime. When they were designed, under the auspices of Sir Nigel Gresley, there was intense competition between the LMSR and LNER for the prestigious passenger traffic between London and Scotland, and both companies designed streamlined locos in the search for ever-higher speeds. The fact that the Germans were doing something similar in the 1930s spurred on our engineers even more. It is well known, of course, that in 1938 one of the class, *Mallard*, became the fastest steam locomotive in the world, although there have been anecdotal claims recently of even higher speeds. I was privileged to be commissioned to produce a painting for the Great Gathering at the NRM in 2013, which was unveiled by John Cameron, a thoroughly decent chap and the owner of *Union of South Africa*. I have painted three of the surviving A4s and hope to complete the set.

Sutton Miniature Railway 4-4-2 Locomotive No. 2 *Sutton Flyer*

Railway locomotives come in all shapes and sizes, and I've been interested in miniature railways for a long time. In the 1950s many seaside towns had lines of 15" gauge or less (I have vague memories of one running round the top of the Great Orme in Llandudno). *Sutton Flyer*, built in 1950, is one which I thought I would never see, because when the 15" gauge Sutton Miniature Railway closed in the early 1960s, all its equipment was put into store in a factory in Oldbury, and very few people were permitted to view it. It remained there – locomotives, rolling stock, track and buildings – for forty years, until purchased by the Cleethorpes Coast Light Railway. The collection has become the focal point of the Miniature Railway Museum in Cleethorpes, whilst the locomotives were restored to steam and occasionally work trains. I have had the privilege of driving this little loco on two occasions, both times in the company of John Tidmarsh, one of the original drivers at Sutton Coldfield.

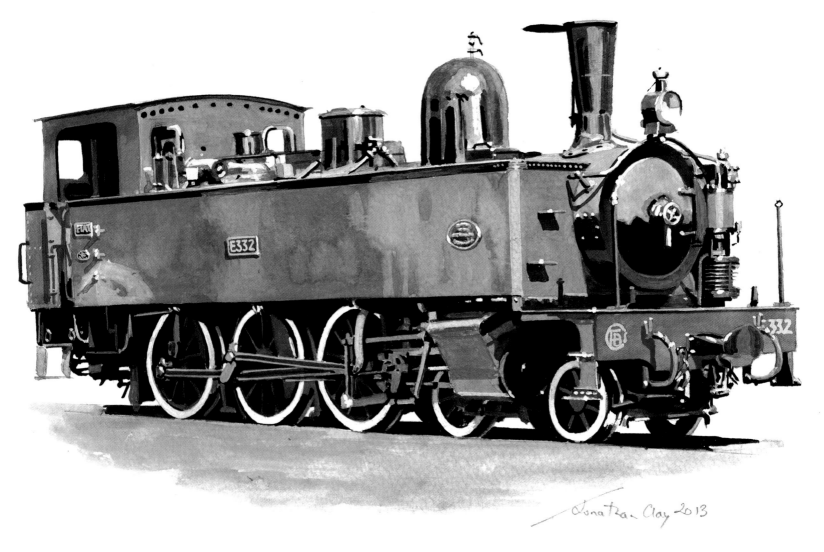

CF Baie de Somme Fives-Lille 4-6-0T No. E332

The CFBS is a survivor of a large network of rural, metre gauge railways in Northern France, and is well known for its occasional Fêtes de Vapeur. I was asked to design an advertising poster for its 2013 event, and to take my display stand to the event. I painted seven portraits of CFBS locomotives (of which this is one) and all were sold on the first day. The Fête de Vapeur was an excellent example of how to hold a railway gala, since it featured all sorts of other attractions. Part of the line, between Noyelles and St. Valéry, is dual gauge (standard and metre) and the most unusual visitor was an old Paris Métro Sprague multiple unit, powered by a generator in the luggage compartment. Imagine someone trying to do that in the UK with a 4-CIG unit, in the face of the health and safety police! The Spragues ran turn-and-turn-about with the metre gauge trains and a standard gauge train, top-and–tailed by steam locos from Belgium and the Kent and East Sussex Railway.

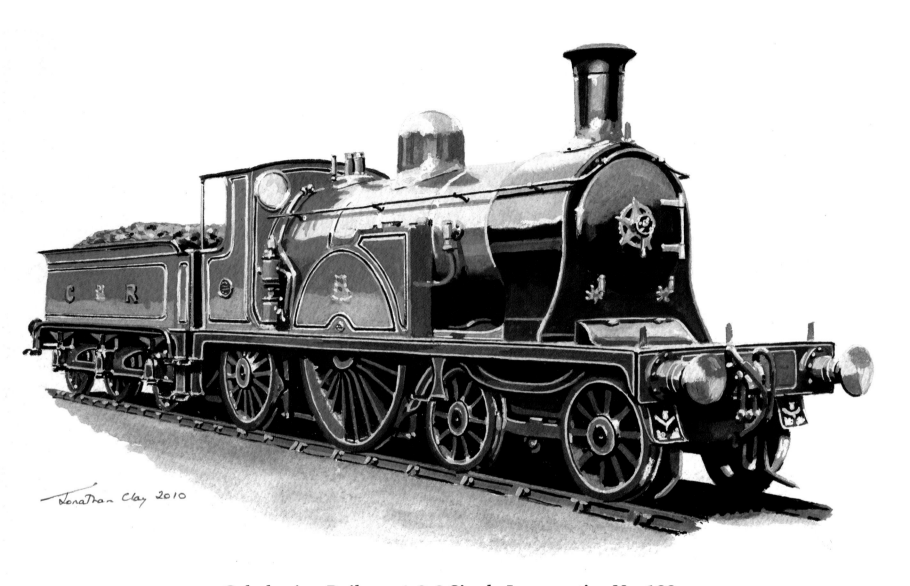

Caledonian Railway 4-2-2 Single Locomotive No. 123

In my view the railways of Britain produced some of the most elegant locomotive designs in the world. This is particularly true of the pre-grouping companies before 1923. They often adopted elaborate and attractive liveries, none more so than the Caledonian Railway in Scotland. It had a fine fleet of powder-blue locos, from humble goods engines to expresses like the Cardean class. No. 123, however, was a one-off, built as an exhibition loco by Neilson & Co. in 1886, and later taken over by the CR. It lasted long enough to be absorbed by the LMS and was used to haul an inspection coach. Preserved in 1935, it was restored to steam by BR in the 1950s and used for enthusiasts' specials. It is currently in the new Riverside Museum in Glasgow, along with several other Scottish locomotives. It was also produced as an OO gauge model by Tri-Ang in the 1960s, and is still available from Hornby today.

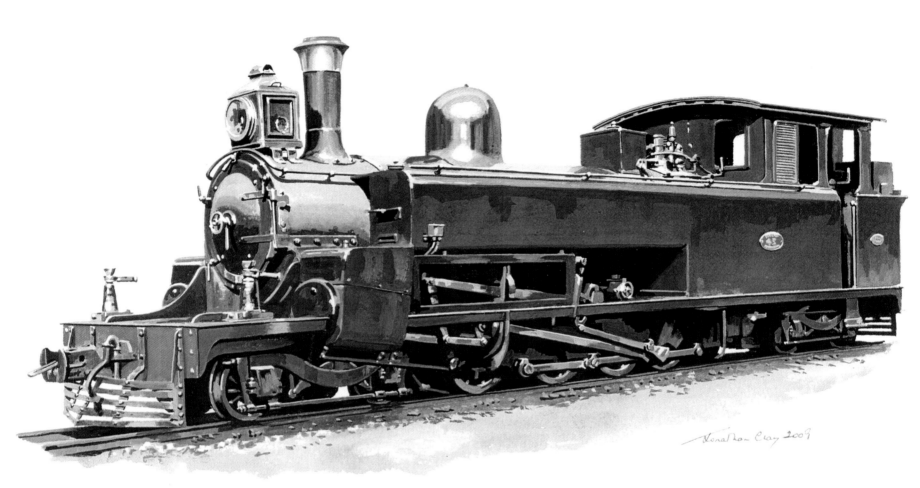

Cyprus Government Railway Kitson 4-8-4T No. 43

When we visited Cyprus in the late 1980s, I was unaware that the island ever had a railway, and yet there was once some seventy-six miles of 2ft 6in gauge track, worked by twelve steam locomotives of various types. They ranged from the diminutive, Hunslet-built No.1, which still survives on a plinth at Famagusta, to four of these large 4-8-4 tanks, which are very similar to twelve built for the Barsi Light Railway in India. They also had some delightful 4-4-0s, which were not unlike the Lawleys in South Africa.

Sadly, Cyprus railways closed in 1951 and little physical evidence remains. There has been an attempt to set up a museum at Evrychou, in the north of the island, where there are also several derelict industrial diesel locomotives, survivors from various mining companies.

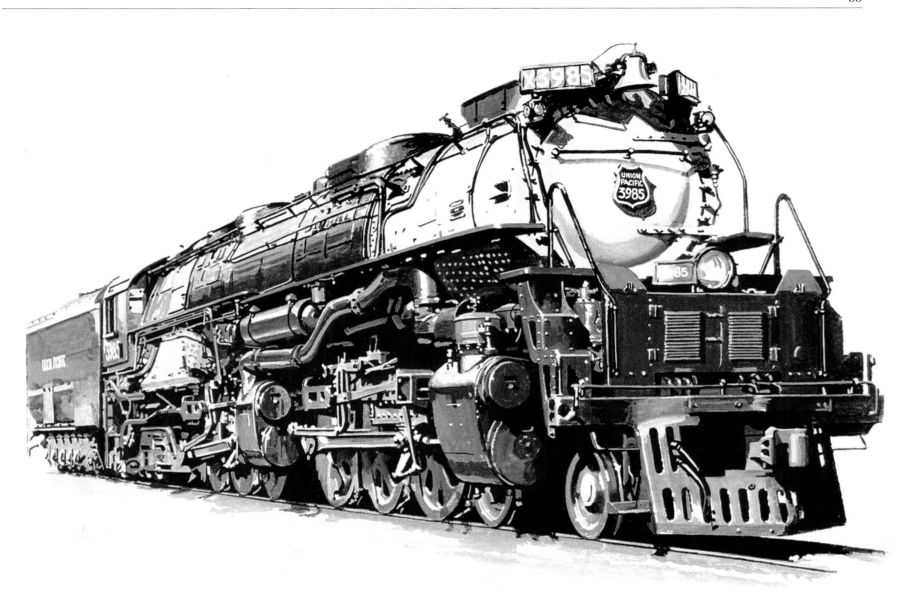

Union Pacific Railroad Challenger *Mallet* 4-6-6-4 No. 3985

My dad was an art teacher and well-known artist in Lancashire. Although primarily a landscape painter, he did paint one or two locos. A *Duchess* painting of his appeared on a auction website a year or two ago, and at one time we owned his painting of *Evening Star*. However, the one I really liked belonged to my brother; it was a picture of a great big American locomotive, all cowcatcher, lights and bells!

The Challenger is currently the world's largest working steam locomotive, and is used for railfan specials in the United States. I say 'currently' because the Union Pacific Railroad has re-purchased one of the even larger, Big Boy locos, with the intention of returning it to steam. This restoration is well under way.

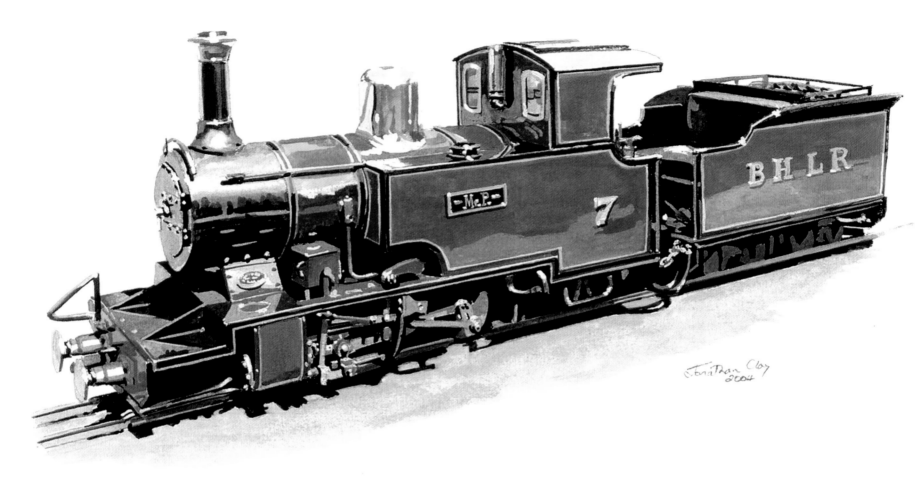

Beer Heights Light Railway Locomotive *Mr. P*

Several years ago we visited the Beer Heights Light Railway in Devon, for the AGM of the 7$^{1}/_{4}$" Gauge Society. This is a most wonderful railway, situated in the grounds of the Peco factory at Beer. Although primarily a tourist and pleasure line, it consists of a very elaborate track plan, including a single-track tunnel, which dictates the routes the trains take. Because it is used intensively in the summer season, the locomotives and rolling stock have to be strong and sturdy. There are currently eight steam locos on the railway, made by various builders.; it even owns a single Fairlie, called *Claudine*. *Mr. P* – named after Michael Pritchard of Peco Ltd – is just one example of the locos built for the line; it was produced in the workshops at Beer in 1997.

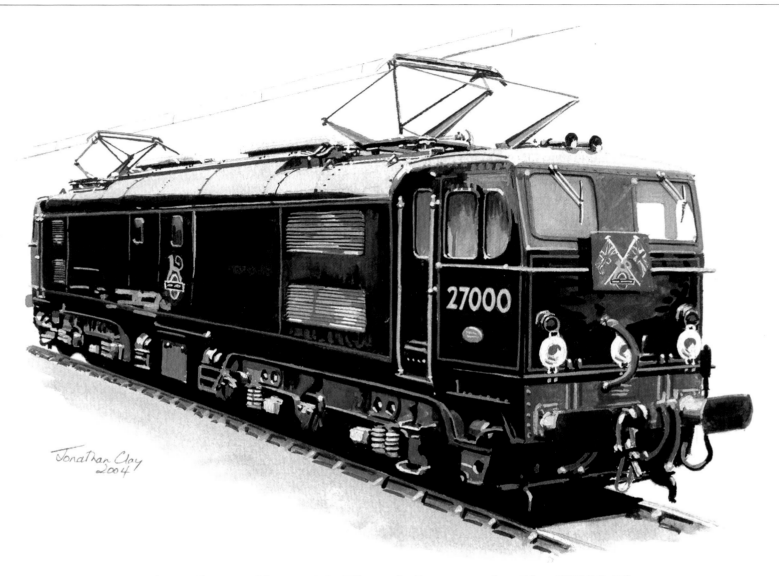

British Railways Class EM2 Electric Locomotive No. 27000 *Electra*

One of the more unusual locations we visited as juvenile trainspotters in the early 1960s was Woodhead Tunnel, on the electrified line between Manchester and Sheffield. The viewing area and car park were just above the western mouth of the tunnel, and from there you could watch the trains (although it was quite some way from the tracks). The majority of the locos on the line were the smaller, Bo-Bo EM1 class, used mainly for freight traffic, but there were also seven Co-Cos built for passenger trains, of which *Electra* was one. After they were withdrawn in 1971 they were all sold to the Nederlandse Spoorwegen (the Dutch railways) where they continued to be used successfully until quite recently. (One never ran in the Netherlands; it was used purely as a source of parts.) Three survive: one in the Netherlands and two (including *Electra*) in the UK. The Tri-Ang model of *Electra* was another of my prized possessions in the 1960s, but is, sadly, long vanished.

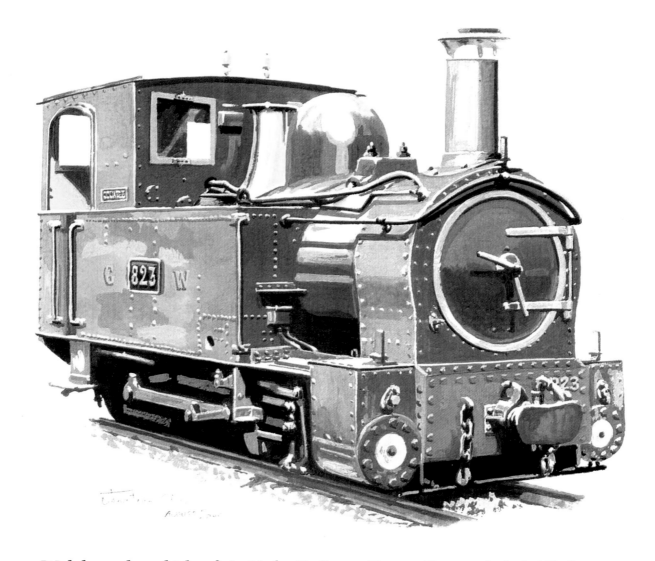

Welshpool and Llanfair Light Railway Beyer-Peacock 0-6-0T *Countess* (GWR No. 823)

The Welshpool and Llanfair Light Railway in Mid Wales is one of my favourite lines. For the whole of its existence, whether independent or as part of the Cambrian, the Great Western or British Railways, it relied solely on two locomotives for its motive power: *Countess* and *The Earl*. Happily, both survived in storage at Oswestry Works. The line was reopened by enthusiasts in 1962 with a variety of rolling stock, as the original passenger carriages had long since been scrapped, and these two locomotives have been joined by a variety of others from around the world. Replicas of the three original carriages have also been built (by the Ffestiniog Railway) in recent years. We have set up my stand at the WLLR galas every September for fifteen years, and consider ourselves fortunate to have made some lovely friends there.

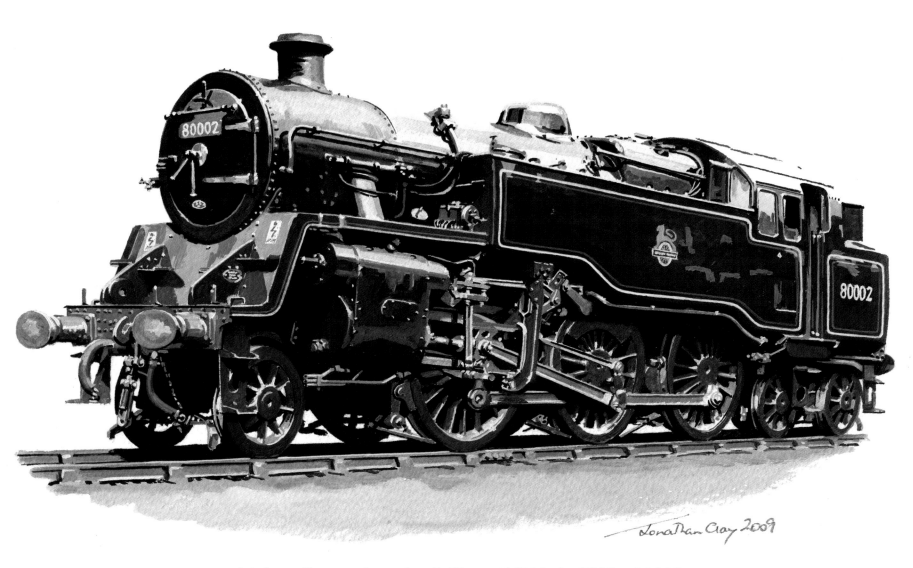

British Railways Standard Class 4MT 2-6-4T No. 80002

When asked which is my most popular locomotive subject, I always answer without hesitation, 'the BR Standard Class 4 tank'; the prototype Deltic comes a close second. I must have sold more of my first picture of a Standard (No. 80136) than all others put together. No. 80002 is the third Standard I've painted (the second being 80072, from Llangollen, notable for its GWR lamp brackets). 80002 has had several periods of operation at the Keighley and Worth Valley Railway. At the time of painting, it sported a traditional 'Scottish' feature – a blue front numberplate – and I was asked to leave this in, even though it has since acquired a more traditional black one. This was also a very familiar prototype for model railway fans in the 1950s and 60s, as it was another loco modelled by Hornby Dublo. There are no less than ten of this type in preservation.

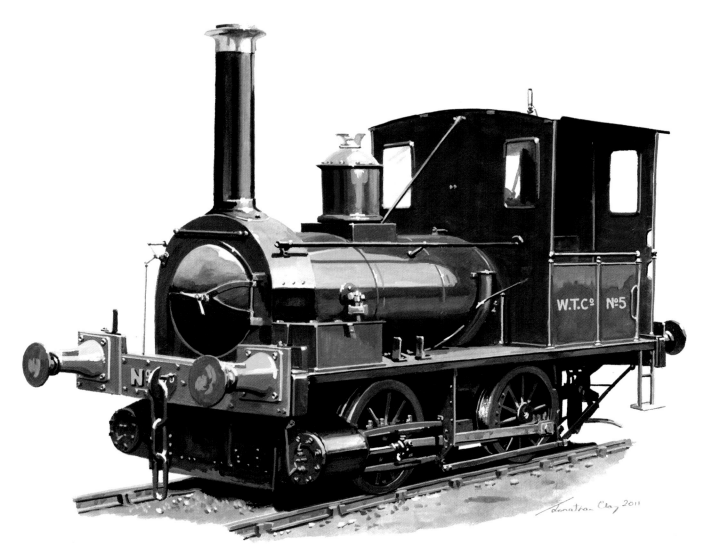

Wantage Tramway George England 0-4-0WT No. 5 (*Jane/Shannon*)

The Wantage Tramway ran for two-and-a-half miles from Wantage in Berkshire to the GWR station at Wantage Road. It remained independent throughout its life, from its opening in 1875 (as a horse tramway) to its closure in 1946. It managed to acquire an eclectic stud of locomotives, including steam trams and conventional – if small – industrial locos. No. 5, originally known as *Shannon*, was built in 1857 for the Sandy and Potton Railway by George England and Co., and was sold shortly afterwards to the London and North Western Railway. Subsequently it found its way to Wantage, where it spent the rest of its working life, and where it was known as *Jane*, though it doesn't seem to have ever carried nameplates. When the tramway closed Jane was bought by the GWR and placed at Wantage Road station. After the closure of the latter, it found its way to the Great Western Society at Didcot, where it was restored to steam. However, it was found to have problems with its firebox and remains a static exhibit.

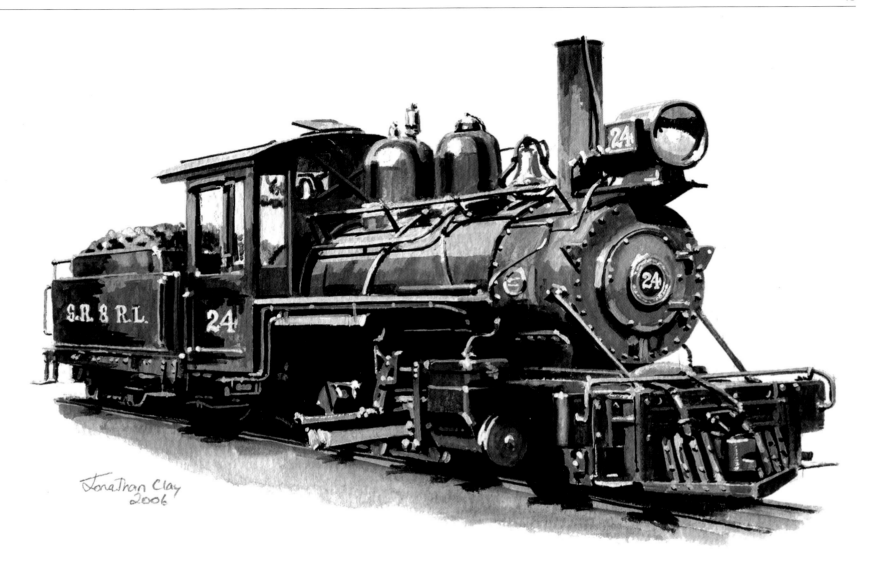

Sandy River and Rangeley Lakes Railroad 2-6-2 No. 24

Most narrow-gauge lines in the USA were built to the more popular 3ft gauge. However, the state of Maine had several 2ft gauge lines, the largest of which was the Sandy River and Rangeley Lakes Railroad, which arose out of the consolidation of several other lines – the Franklin and Megantic, the Kingfield and Dead River, the Phillips and Rangeley, and two other, smaller railroads. The locomotives of the SRRL were of several types, ranging from small Forney tanks to a series of 2-6-2 tender locos, culminating in No. 24, which I have painted twice.

This loco has been replicated a number of times, in both model and miniature forms. The best known is one of 15in gauge, built by the Fairbourne Railway and subsequently much altered. It now resides at the Cleethorpes Light Railway in Lincolnshire, and I have painted no less than three different pictures of it. The Brecon Mountain Railway in South Wales has plans to build a replica of sister locomotive No. 23.

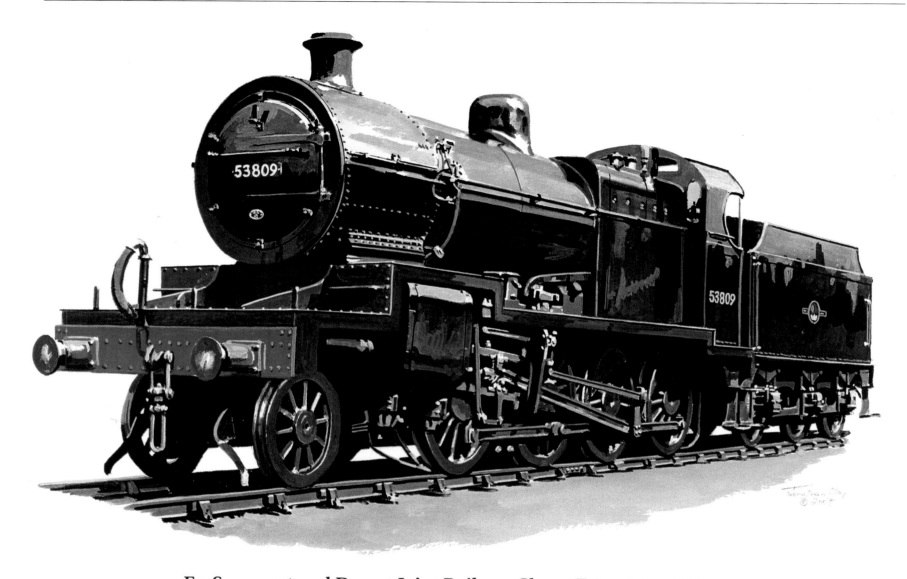

Ex-Somerset and Dorset Joint Railway Class 7F 2-8-0 No. 53809

Of all the former railways of the UK, the SDJR seems to attract the most nostalgia. Jointly owned by the Midland Railway and the London and South Western Railway, it fell to the Midland to provide the motive power. Most of the designs used were the same as those elsewhere on the Midland, and came within its 'small engine' category. However, the demands of the traffic on the S&D demanded something bigger, and the 7Fs were the result.

Thanks to the miracle that was Barry scrapyard, two of the class have survived. No. 88, now on the West Somerset Railway and 53809, which has spent periods running on the main line. This picture was originally painted as No. 88 in SDJR blue livery, but I later overpainted it black as number 53809. Amusingly, the two paintings were featured in one of the leading UK railway magazines, as an illustration that Photoshop techniques are nothing new: we artists have been altering our pictures for donkey's years!

Listowel & Ballybunion Railway Hunslet 0-3-0 Locomotive No. 2

You can't get a much narrower gauge than a monorail! I often marvel at the sheer inventiveness of the human spirit. Nowhere is this more prevalent than in the history of railways. The L&B opened in 1888 and used the Lartique Monorail system. A similar line was later built at Panissières in France, using similar locomotives (though without tenders), but was never opened to the public. There were lines, particularly in the USA, where the trains ran on two rails – one on the ground and one overhead!

The Listowel and Ballybunion in Eire was relatively successful, considering the impossibility of either level crossings or points (every change of direction required a turntable). The original locomotive had twin vertical boilers, but the Hunslet Engine Co. was prevailed upon to build three of these locos. A diesel-powered replica was built by Alan Keef Ltd. in 2002 and runs on a short reconstruction of the railway at Listowel.

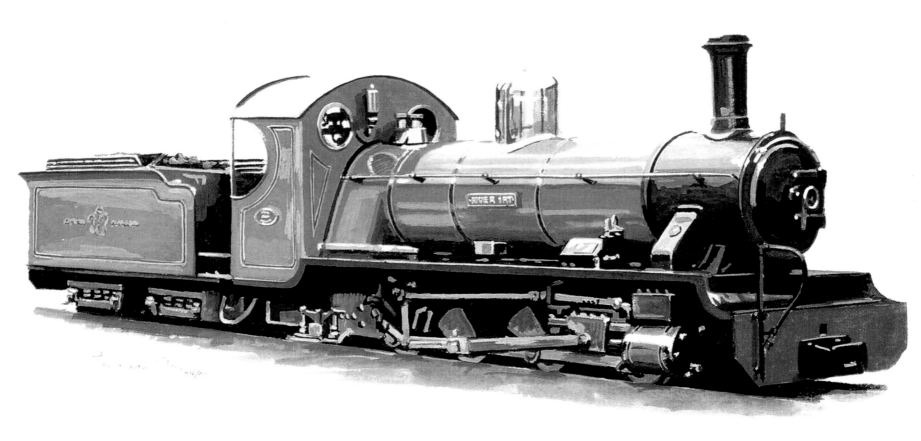

Ravenglass and Eskdale Railway 0-8-2 *River Irt*

My Facebook page has a title photograph showing me, looking very young (and very apprehensive), sitting in the cab of this locomotive. At the age of about two I was taken on holiday to Seascale, Cumberland, and introduced to the 15in gauge Ravenglass and Eskdale Railway. In those days it had only two steam locos and one diesel tractor, although these have been added to over the years. Most visitors probably don't realise the significance of this little loco, but it is one of the pioneers of the 'minimum' gauge, having been built by Sir Arthur Heywood, no less. When the derelict R&ER was revived after the First World War by W.J. Bassett-Lowke, several of Heywood's Duffield Bank Railway locos were used, including an 0-8-0 tank locomotive called *Muriel*. After the original boiler wore out it was rebuilt as a miniature locomotive and renamed *River Irt*. In the 1980s it was rebuilt again, with a narrow-gauge outline; the chassis, however, is still pure Heywood.

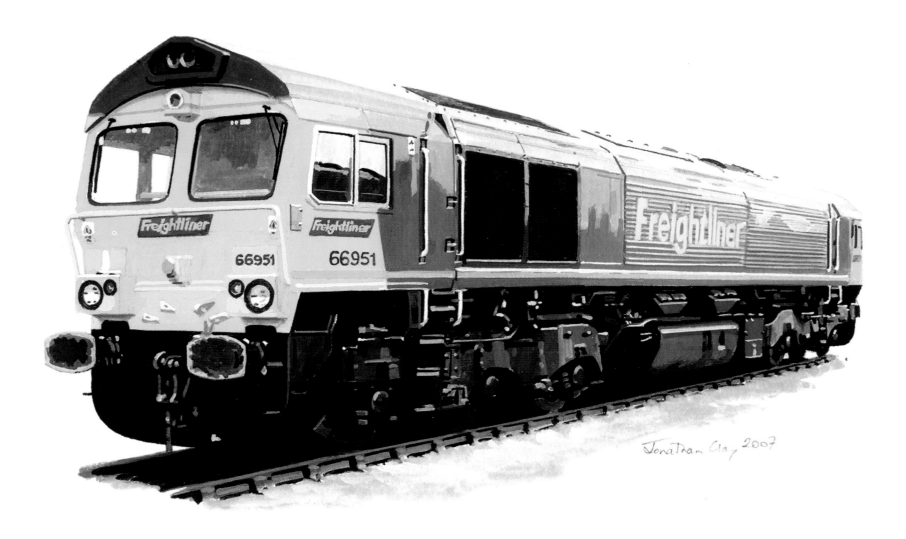

Freightliner GMD Class 66 Diesel Locomotive No. 66951

Few people get sentimental about modern traction, but it does have its devotees. I must confess that, as a child, I was just as interested in the new as in the old. I have a photograph of myself in school uniform, standing proudly alongside a brand new English Electric Type 4 diesel (Class 40 to those who don't know). I lost interest in the modern railway in the 1970s and 1980s, but was aware that powerful freight locomotives were being imported from the United States. On holiday in Somerset in the mid-1980s, I was standing on the side of a cricket pitch when a new Class 59 passed by with a stone train. I was impressed how quietly it gave an impression of great power.

The Class 66 story is now well known as a successful one, there being several hundred in the UK and on mainland Europe. This one was chosen because it was the first Freightliner 66, and is a nicely colourful example of the type.

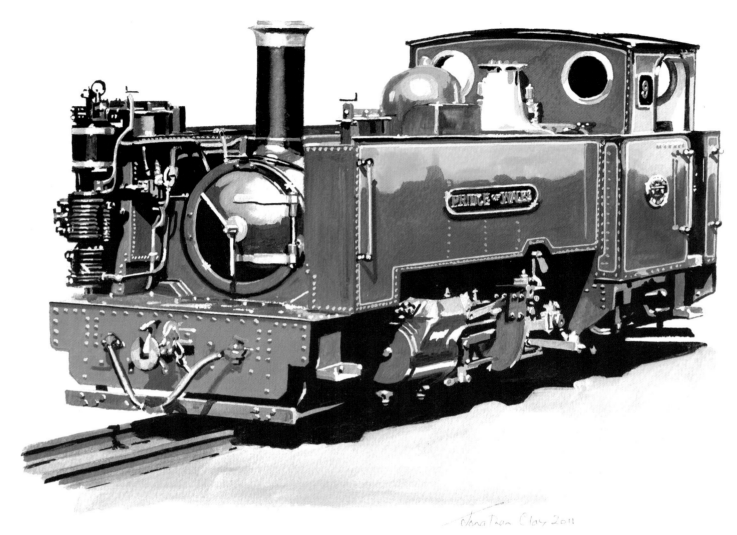

Vale of Rheidol 2-6-2T Locomotive No. 9 *Prince of Wales*

The Vale of Rheidol tends to be a bit neglected amongst preserved railways, since it has never gone out of its way to cater for enthusiasts. However, it has an interesting history and possesses three of the finest narrow gauge locomotives to be found anywhere. It is also notable as the final bastion of steam run by British Railways and the only steam locos painted BR blue.

 The Vale of Rheidol Railway was bought from BR by private individuals in 1989 and has since benefitted from a range of improvements, particularly in the 2000s, when the line came under ownership of the Phyllis Rampton Trust. The locos have had continual improvements, without detracting from their historical value, and No. 9 was for many years painted in a red livery, as above. However, it has recently been repainted an authentic Cambrian Railways 'invisible' green colour. The railway has recently completed a very impressive new workshop, and is currently planning a museum at Aberystwyth.

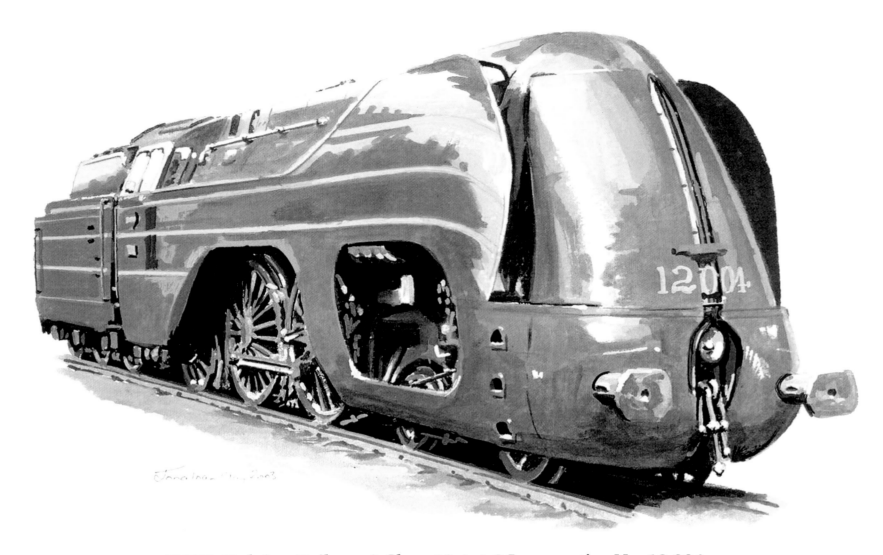

SNCB (Belgian Railways) Class 12 4-4-2 Locomotive No. 12.004

About twelve years ago we were invited to a railway gala at Maldegem, Belgium, and I produced several paintings of Belgian locos for the event, Fortunately I sold most of the originals, and the event spurred me to delve further into the history of the SNCB and its forebears. To get an overview of Belgian steam, there is no better book than Jean-Luc Vanderhaegen's *Un Siècle de Vapeur* (or *Een Eeuw Stoom*, to give its Flemish title) which was published in 2001.

These iconic, streamlined locos are often featured in literature about Belgian steam. They were a class of six, built by John Cockerill in 1938–9 and were used on fast, light trains from Brussels to Ostend, often travelling at well over 90mph. No. 12.004 was retained by SNCB after the end of steam, and is now a static museum piece, though in 1985 it was restored to working order to celebrate the 150th anniversary of Belgian railways.

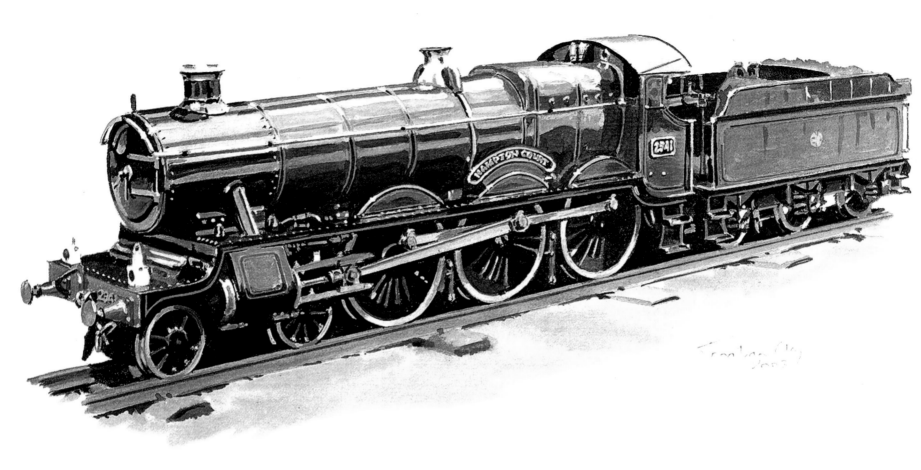

Stapleford Miniature Railway Saint Class 4-6-0 No. 2941 *Hampton Court*

By now you will probably have guessed that I like miniature railways. The line at Stapleford Park, near Melton Mowbray in Leicestershire, is one of the finest 10 $^1/_4$" gauge railways in the country. It was built by Lord Gretton in 1958 but, after his death in 1982, it was mothballed. A band of supporters arose, who wanted to see the railway run again, and, with the help and approval of Lady Gretton, it has been restored to its former glory – with a number of improvements – and is open to the public on two weekends a year.

 Amongst the fine stud of locomotives is *Hampton Court*. Built by Ernest W. Twining in 1939, it spent a considerable time at Hastings Miniature Railway before moving to Stapleford, which is also home to two American-style New York Central locos and two other steam locomotives.

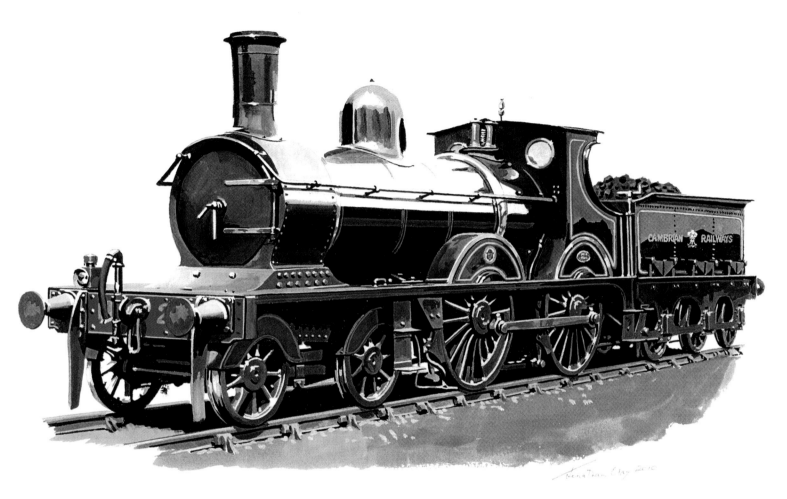

Cambrian Railway Sharp, Stewart 4-4-0 No. 21

Although when I was young we spent many holidays on the Cambrian Coast, I was unaware of the Cambrian Railway, and by the time we visited Barmouth it had become part of BR's Western Region. I was happy to sit and watch the trains pass by whilst all around made busy with their buckets and spades. There was little left of the rolling stock of the Cambrian, and there wasn't much literature available, the history of the line having been published way back in 1923. (This has been remedied with the recent publication of Peter Johnson's *The Cambrian Railway: A New History*.) Consequently, I came to this commission a bit cold. I subsequently discovered that Sharp, Stewart had built a number of 4-4-0 locomotives for the Cambrian, and that this type was known as a 'Small Sharpie'. I delivered the painting to Towyn on the Talyllyn Railway, which of course is right next to the Cambrian main line.

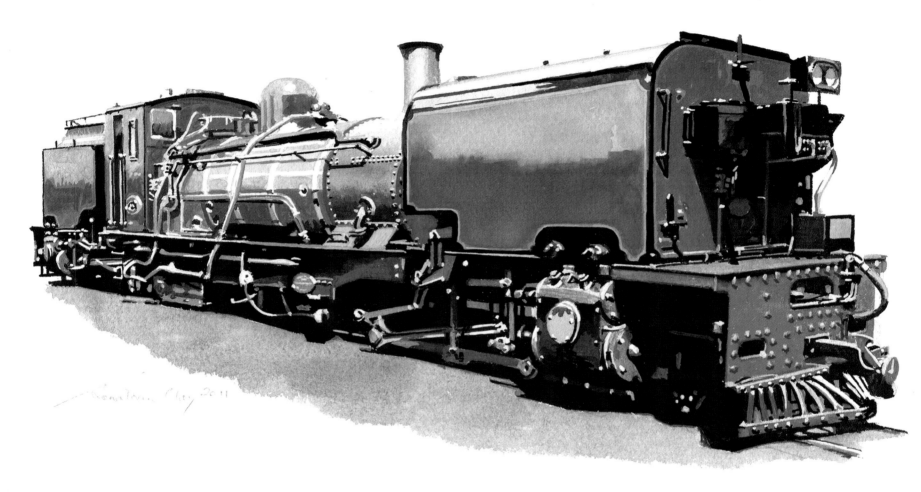

Welsh Highland Railway NG/G16 Garratt Locomotive No. 143

When we were young, the derelict Welsh Highland Railway was a playground for my brother and me. From the early 1960s our family would decamp each summer to Beddgelert and spend hours exploring, walking and cycling along the disused trackbed, never dreaming that it would one day be revived. During our 1964 visit we discovered track and rolling stock on the site of Beddgelert station. However, nothing much came of this attempt to reopen the line and it fell to the Ffestiniog Railway to take the bull by the horns, and the railway reopened in stages from 1997.

We can now ride between Porthmadog and Caernarfon in trains pulled by these magnificent machines. There are three currently in use: Nos. 87, 138 and 143, with possibly two more to come, plus the iconic K1 and the arrival of an NG15 tender loco planned for the not too distant future.

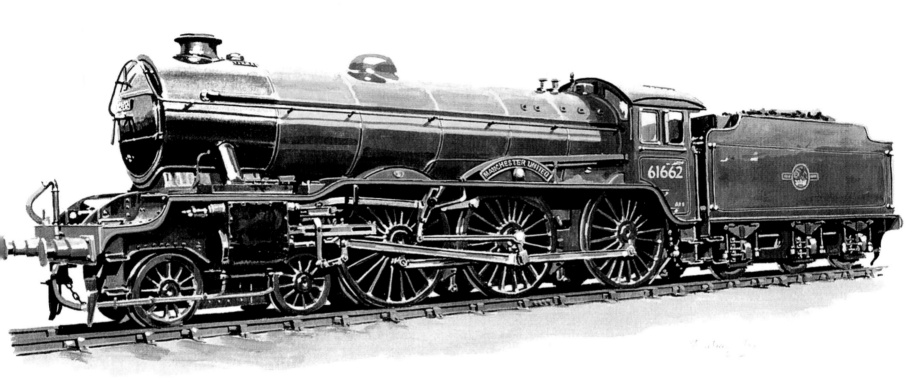

Ex-LNER Class B17 4-6-0 No. 61662 *Manchester United*

I am lucky to be associated with a number of new-build locomotive projects, both large and small. These are groups of individuals with a vision, and in some cases they have completed some amazing tasks. Two separate groups are each aiming to build an example of a Gresley B17 4-6-0, and I have produced work for both; however, the painting above was a private commission. I have subsequently altered the picture to represent other members of the class, and have painted two other originals in the process: one a short-tendered version; the other a B2.

Restoring locos is a costly endeavour, and preservation groups raise funds by selling merchandise featuring images of the locomotive. Hopefully, before too long we shall have the pleasure of seeing one or more of these locos in steam once more.

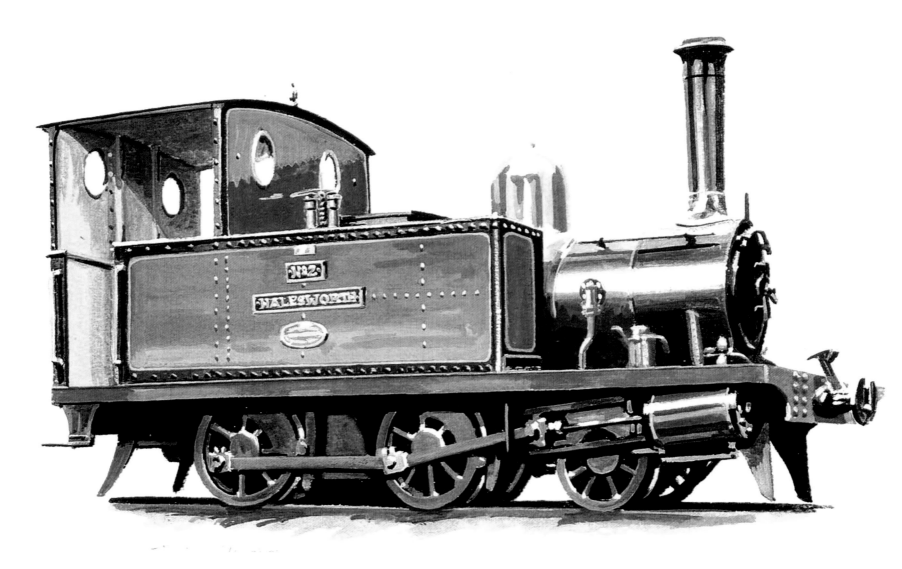

Southwold Railway Sharp, Stewart 2-4-0T No. 2 *Halesworth*

As a young married couple in the 1970s, Barbara and I once visited Southwold in rural Suffolk, where I was both surprised and amused to purchase a set of postcards of cartoons depicting the Southwold Railway as rather ramshackle. Clearly, the line was considered a joke. It was a 3ft gauge line, running between Halesworth and Southwold. All of its locomotives bar one were built by Sharp, Stewart and were similar to the *Halesworth*, having either 2-4-0 or 2-4-2 wheel arrangements. I have painted two of them for an American client who has connections with the area.

There have been moves afoot for some time to recreate the railway, but these have met with considerable local opposition, which I find hard to understand. Notwithstanding this, however, construction has started on a replica locomotive.

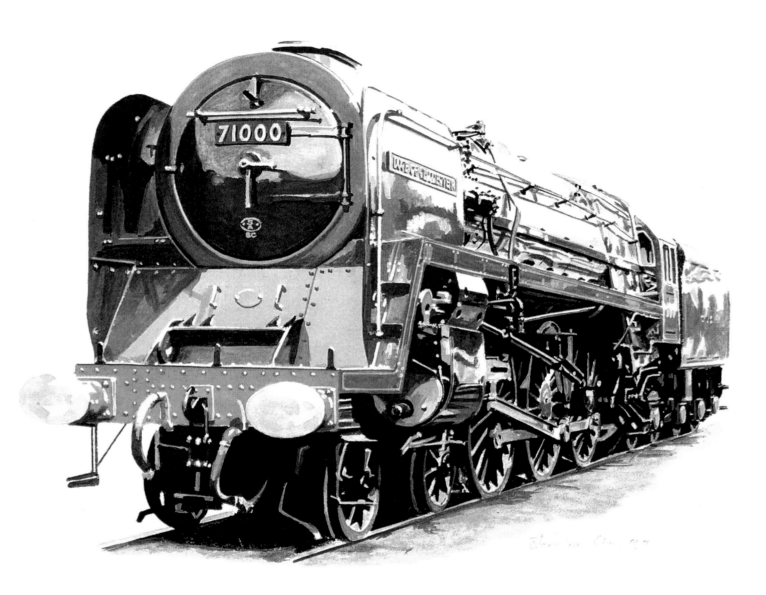

British Railways Class 8P 4-6-2 No. 71000 *Duke of Gloucester*

The *Duke of Gloucester* is my favourite locomotive. For me, it is the ultimate of the Standards, although I don't think I ever saw it in service. Built in 1954, nominally as a replacement for the written-off *Princess Anne*, it is, effectively, a Super-Britannia and has an extra cylinder and Caprotti rotary valve gear. Upon withdrawal it was earmarked for the national collection; however, parts were removed for retention and the rest sent for scrap. Fortunately, it went to Barry scrapyard and was eventually saved by enthusiasts for preservation. This was dubbed 'project impossible', since so many parts (including the outside cylinders) were missing. I first saw it in a disassembled state, spread around the yard at Loughborough on the Great Central Railway, and witnessed its first runs in 1986. It currently awaits overhaul.

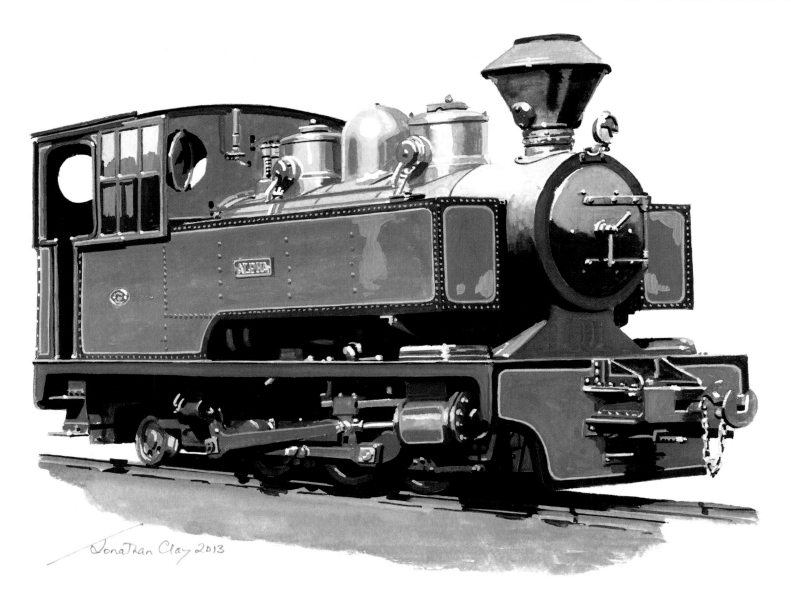

Sittingbourne and Kemsley Light Railway Bagnall 0-6-2T *Alpha*

The preserved railways run through a wide variety of landscapes, from the bucolic to the industrial. The Sittingbourne and Kemsley fits into the latter category, and is the remaining part of what was once an extensive 2ft 6in gauge system owned by Bowaters, a paper manufacturer. By the late 1960s it was no longer needed, and the Locomotive Club of Great Britain took over several locos and some of the rolling stock and began to operate a two-mile section of the railway. Some of the locos and stock were sold to Whipsnade Zoological Park and one joined the collection of the Phyllis Rampton Trust. Several remain at Sittingbourne, and three are currently in working order. *Alpha*, however, has been out of use for many years, though attempts are now being made to raise funds for its restoration.

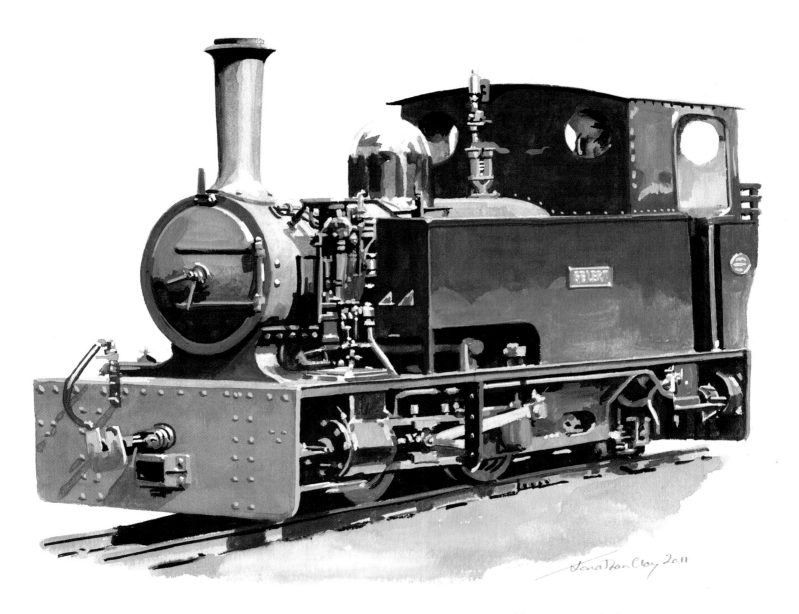

Welsh Highland Heritage Railway Bagnall 0-4-2T *Gelert*

The Welsh Highland Heritage Railway (formerly the 1964 Co.) has been based at Gelert's Farm in Porthmadog since the 1970s. It has built up an interesting collection of locomotives and rolling stock and developed a fascinating museum. Its flagship loco is the former North Wales Narrow Gauge Railway *Russell* (featured later) but *Gelert* is the mainstay of its service. The WHHR is connected to the rebuilt Welsh Highland Railway and *Gelert* has traversed this line as a prelude to future operation. An identical locomotive, *Isaac*, has recently been restored by the Ffestiniog Railway at Boston Lodge for use on the reborn Lynton and Barnstaple Railway in Devon.

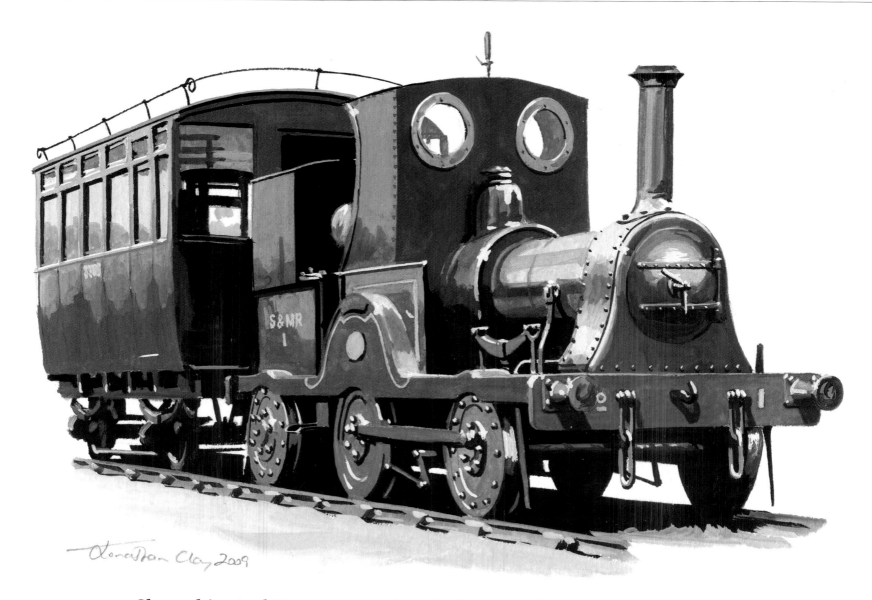

Shropshire and Montgomeryshire Railway Dodman 0-4-2WT *Gazelle*

Colonel Holman F. Stephens was a fascinating man. Having served with the Royal Engineers during the First World War, he later turned his hand to railway ownership and operation. He started by buying up loss-making and sometimes moribund lines and running them on a shoestring. Locomotives and rolling stock were purchased second- even third-hand, and the infrastructure, including stations and facilities, were basic. One of his railways was the Shropshire and Montgomeryshire, and among its engines was *Gazelle*, built by Dodman & Co. as a 2-2-2 for a private owner and used for light traffic. Initially it hauled an old tramcar, and when that fell to pieces a new body was constructed. The loco survives today, nominally as part of the national collection, and currently resides in the Colonel Stephens Museum at Tenterden station, Kent.

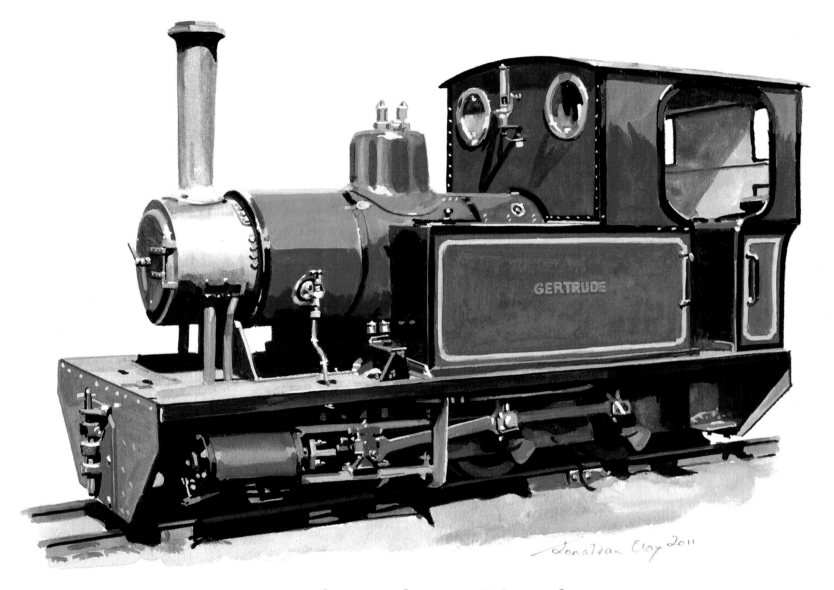

Andrew Barclay 0-6-0T *Gertrude*

Gertrude is one of three identical locomotives built by Barclay for use at Sydenham Ironstone Quarry in Oxfordshire. They were used by Alfred Hickman and Co., and when the quarry didn't expand as envisaged, were transferred to Bilston steelworks in 1925 and later came under the ownership of Stewarts and Lloyds Ltd. The third loco, *Winifred*, was withdrawn first, but the others, *Gertrude* and *The Doll*, survived until 1959, when they joined the many locos saved for preservation by Max Sinclair. *The Doll* currently runs at Leighton Buzzard Narrow Gauge Railway, whilst *Gertrude*, having passed through several hands over the years, is now in the ownership of the Westmacott family. It has been beautifully restored to working order, and is currently on the Welsh Highland Heritage Railway in Porthmadog.

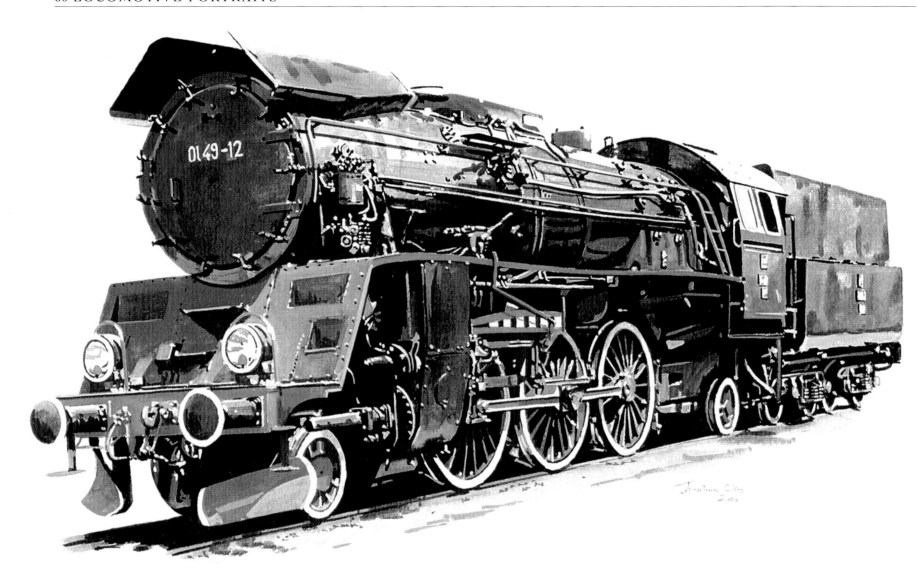

PKP (Polish Railways) Ol49 Class 2-6-2 No. Ol49–12

Whilst not as grand as American locomotive builders, the Europeans also like to do things in a big way. The loading gauge in Europe is generally less restricted than in the UK and, consequently, locomotives tend to dwarf their British counterparts. Polskie Koleje Paſstwowe (Polish State Railways) built 116 of these locos in the early 1950s for fast, light passenger train use, four of which were exported to North Korea. I wonder if they're still there.

Several of the type are still used every day by PKP at its world-famous steam centre in Wolsztyn, though No. Ol49–12 was sold in 1996 to Maldegem Museum Railway in Belgium, where I saw it in steam – a truly impressive sight! It was withdrawn in 2005 when its boiler certificate expired, and is currently in Leszno, Poland, for cosmetic refurbishment, after which it is destined for static display at Rundhaus Europa in Germany.

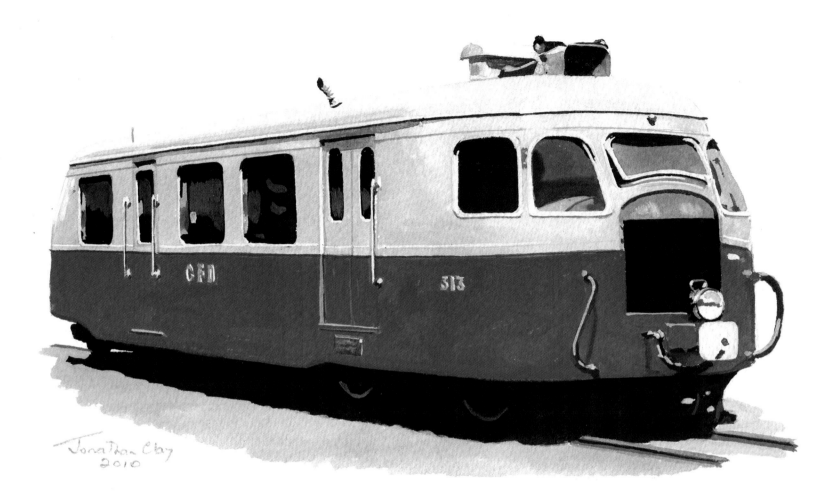

CFD Billard Railcar No. 313

Because France was (and still is) thinly populated, and yet transport links were required, a network of narrow gauge lines was built up in both northern and central France. Those in Pas-de-Calais are well-documented by our friends Martin and Joan Farebrother, and one of the commonly used assets on these lines were railcars. There were many attempts to provide cheap alternatives to the usual recipe of steam-hauled trains. These are recorded in the late W.J.K. Davies's book *The Light Railway Railcars of Western Europe*. Many can still be found in preservation, including No. 313, from the Voies Ferées du Velay. The French were very attached to the concept of the internal combustion powered railcar, and many standard gauge examples also survive in preservation.

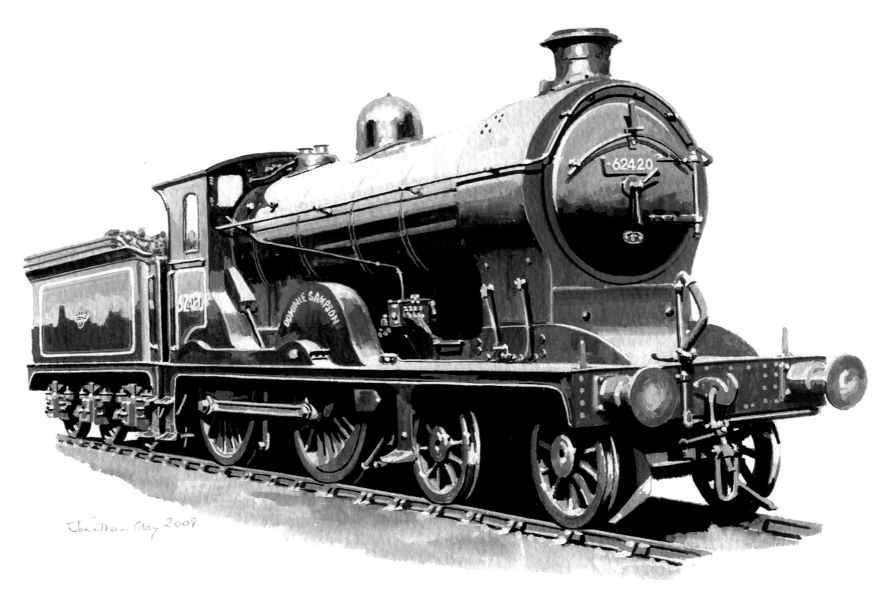

Ex-North British Railway Class D30 4-4-0 No. 62420 *Dominie Sampson*

I include this engine not so much for itself, but for its name. Sir Walter Scott's *Waverley* novels, however impenetrable they may be for us ordinary mortals, are populated by folk with the most curious names, with which the North British Railway christened many of its locomotives, such as *Caleb Balderstone*, *Jingling Geordie*, *Kettledrummie*, *Peter Poundtext* and *Quentin Durward*. Even the LNER got in on the act, when it built a series of GCR-designed D11s with a further selection of wonderful names. In my spotters' books, these locos are described as the Scott class, being one of several types of 4-4-0 built by the NBR. Others included the Glen class, of which *Glen Douglas* is preserved in Scotland.

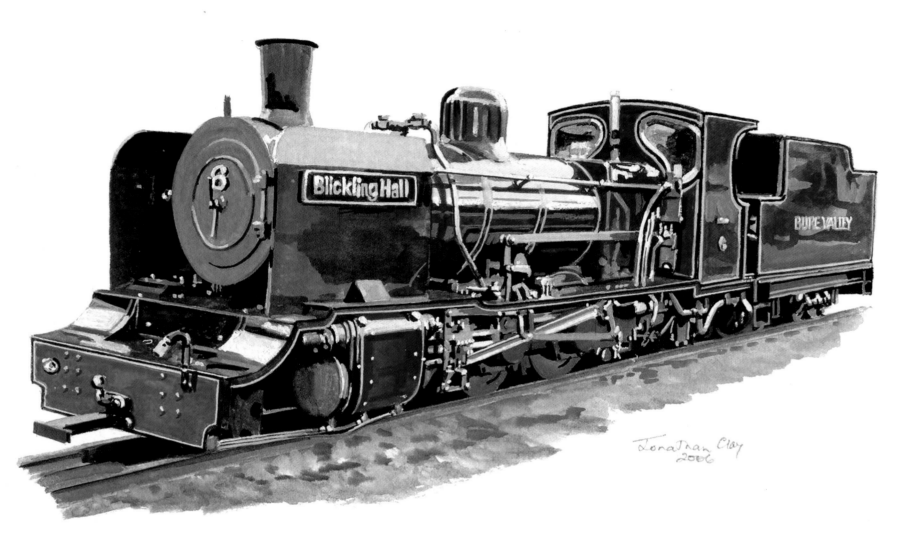

Bure Valley Railway Winson Engineering ZB 2-6-2 No. 6 *Blickling Hall*

15" gauge railways have come a long way since Sir Arthur Heywood's day, and one of the newest is the Bure Valley, running between Aylsham and Wroxham in Norfolk. It was opened in some style in 1990 by Miles Kington, and by sheer coincidence we were there. Initially it used borrowed motive power, most notably from the Romney Hythe and Dymchurch Railway. It subsequently acquired a variety of locomotives, including the guest loco *Sian* from the Fairbourne Railway. However, it was decided that something more substantial was required, and Winson Engineering designed this half-scale replica of an Indian Railway 2ft 6in gauge class ZB. They built three: two (like *Blickling Hall*) as tender engines, and one which was completed as a tank loco. They have required modifications over the years to improve their performance, and now form part of a powerful and reliable fleet for the railway.

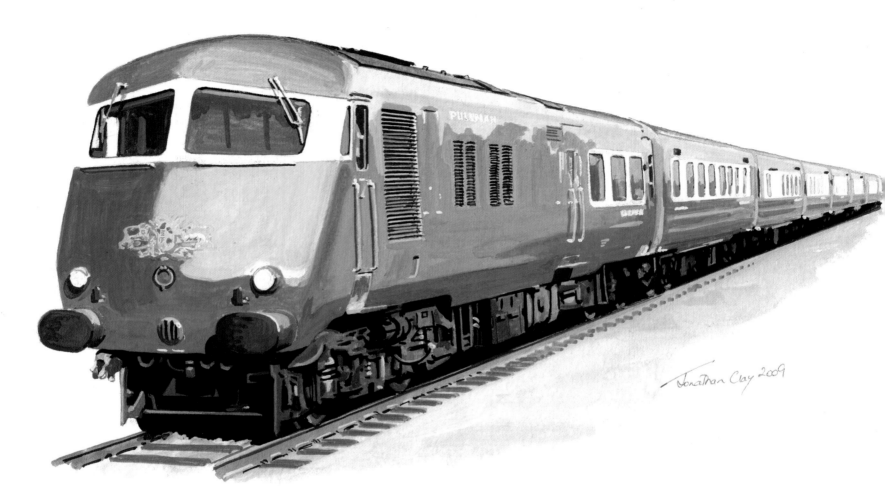

Blue Pullman Diesel Multiple Unit

These were the forerunner of the iconic HSTs, which have provided sterling service on Britain's railways since the mid-1970s. As the name implies, they were designed as fast and luxurious trains for prestigious services. Introduced in 1960, they were of two types. The first was the Midland or Manchester Pullman, consisting of two six-car sets and running between London St Pancras and Manchester Central, and the second type being three eight-car sets for the Western Region, running between London Paddington and Birmingham, Wolverhampton or Bristol. They lasted in service for only thirteen years, and none survives.

In the early 1960s the enterprising kit-maker Kitmaster produced OO scale models, which could be motorised if required, and Tri-Ang produced a ready-to-run version shortly after. These are now highly sought-after. In recent years standards have improved considerably and it is now possible to buy a highly detailed version.

Jonathan Clay 12/01

Darjeeling Himalayan Railway Class C 4-6-2 No. 37

The Darjeeling Himalayan Railway appeared in our childhood encyclopaedias as one of the great railway wonders of the world, and even though many travellers photographed it, no definitive history was produced until 2000 when Terry Martin, after years of research, published *Halfway to Heaven*, following this a few years later with the two-volume *The Iron Sherpa*, which we spoke about when we met at a Darjeeling Society AGM meeting. Sadly he did not live to see its publication. Both books are now rareties.

Most people are familiar with the iconic B class tank locomotives, but perhaps don't realise that there were others on the DHR, including a Garratt, which was surprisingly long lived, and two Class C pacifics, both of which still survive.

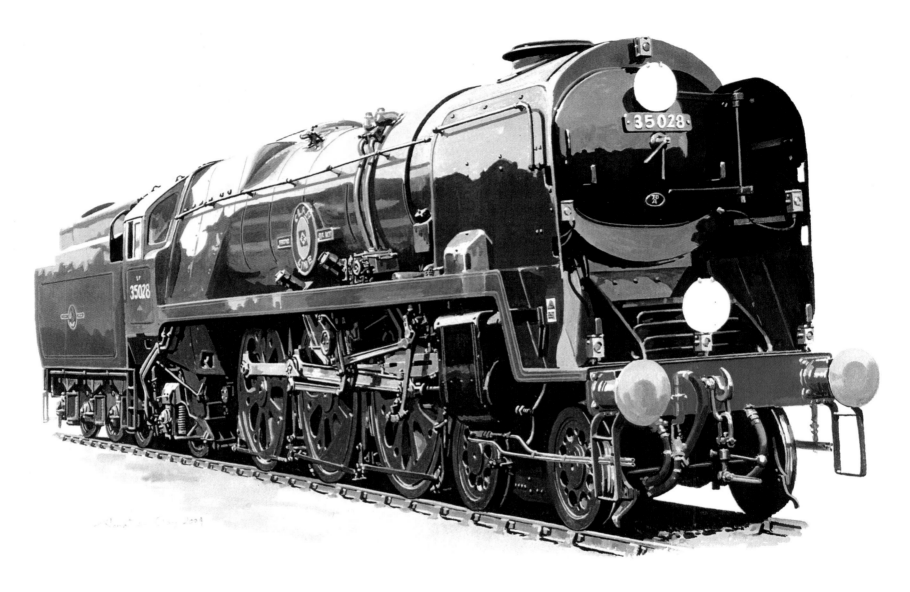

Ex-Southern Railway Rebuilt Merchant Navy Class 4-6-2 No. 35028 *Clan Line*

An earlier painting depicted one of the smaller Battle of Britain class pacifics in its un-rebuilt form, but this is how the Bulleid pacifics looked when they were rebuilt. Out went the troublesome, chain-driven valve gear, to be replaced by the conventional Walschaerts form, and the streamlined casing was dispensed with. This left a loco which looked not unlike a Britannia, and which was much more powerful and reliable.

Due to the phenomenon which was Barry scrapyard, a large number of Bulleid pacifics have survived, though whether they will all be restored remains to be seen. A plan to retro-fit the chain-driven valve gear to, and to streamline, a Merchant Navy surfaces from time to time, but as yet no progress has been made.

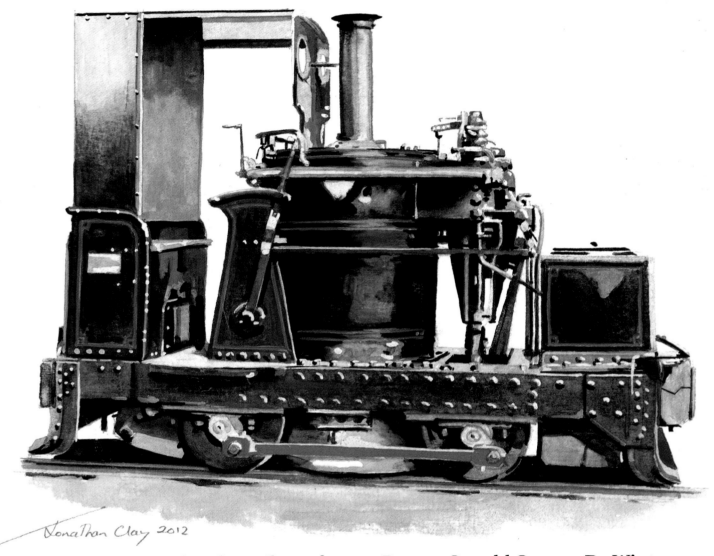

Jonathan Clay 2012

Leighton Buzzard Light Railway, former Pen-yr-Orsedd Quarry, De Winton 0-4-0T *Chaloner*

When in the 1870s the slate quarries of North Wales first required motive power other than horses for their tramway, it was to the firm of De Winton and Co. of Caernarfon that they turned. Large numbers of these basic and rugged vertical-boilered locomotives were built, and several survive today in various states of preservation. *Chaloner* is the only existing working example. It has been a labour of love for its owner Alf Fisher since the 1960s, and he co-wrote the definitive history of the company in 2010. Shortly after this came the revelation that the locomotive had at one time been fitted with a cab, a feature that had hitherto been unknown on these locos. Like others, I wondered if it was some kind of spoof, but Alf assures me that it is genuine (but removable). Because of the simplicity of these locos, quite a few replicas have been built in recent years, more or less following the design of the originals.

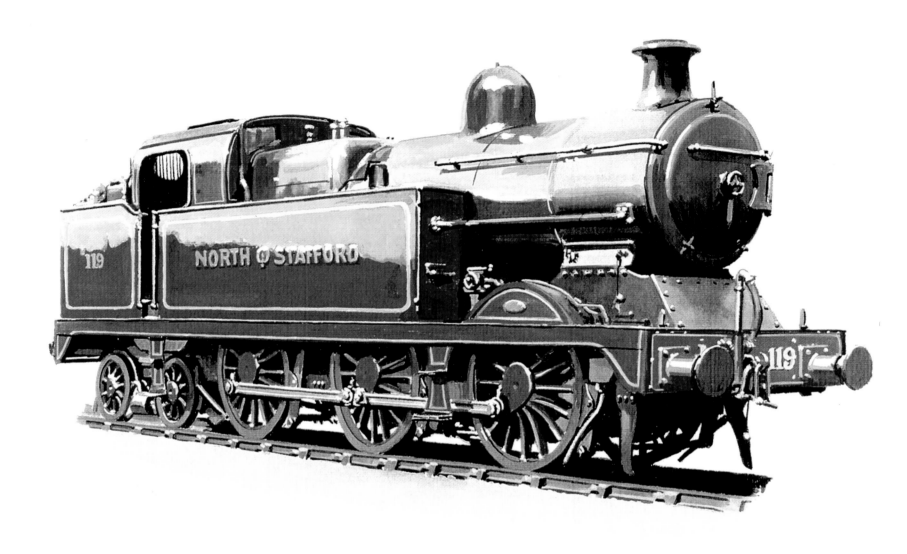

North Staffordshire Railway 0-6-4T No. 119

The North Staffordshire Railway, based in Stoke-on-Trent, operated a number of lines in the Potteries and also ran into Cheshire, Derbyshire, Shropshire and elsewhere in Staffordshire. It is one of the lesser-known pre-grouping companies, and it had control of two narrow-gauge systems: the Leek and Manifold and the Caldon Low Quarry.

At the time of grouping in 1923, the NSR owned 196 locomotives of various types, although only two have survived into preservation. There is a thriving association for supporters of the NSR, and this picture of No. 119 was commissioned by one of its members. No. 2, which is a smaller 0-6-2T version of 119, belongs to the national collection and is usually based at Locomotion in Shildon. It is a fortunate survivor, which was sold out of service by the LMS into industrial use.

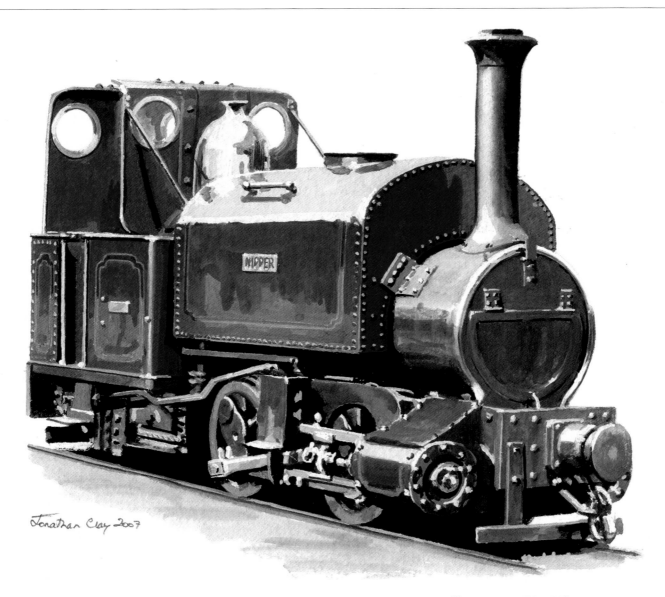

Festiniog and Blaenau Railway Manning Wardle 0-4-2ST *Nipper*

At one time there was another railway at Ffestiniog: the 1ft 11 $^1/_2$" gauge Festiniog and Blaenau, which made an end-on connection with the more famous Ffestiniog Railway at Blaenau Ffestiniog and ran to the small town of Llan Ffestiniog; it also served the slate quarries at Tanymanod. The FBR had a brief existence: it began in 1868 and was purchased by the Great Western in 1883. After conversion to standard gauge it became part of the line from Bala to Blaenau Ffestiniog. Throughout its short existence it had only two locomotives, both identical saddletanks built by Manning Wardle in 1868, and these were later sold into industrial use, after which all trace is lost.

When the line to Bala was closed, a stub was retained for nuclear waste traffic to access Trawsfynydd Power Station, but this was abandoned in the 1980s. I have often thought that it would make a nice extension to the present Ffestiniog Railway, as the line was quite spectacular and can be followed all the way to Bala by road.

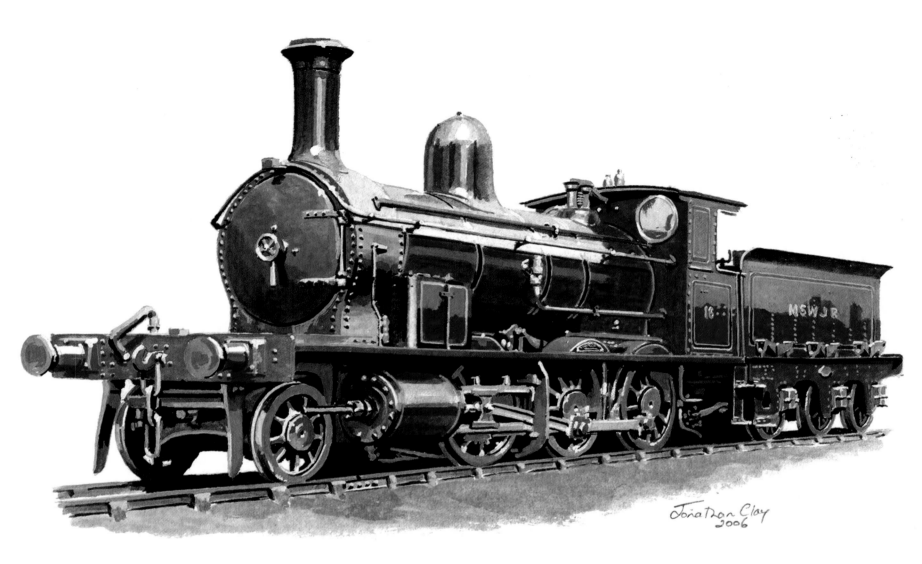

Midland and South Western Junction Railway 2-6-0 No. 16 *Galloping Alice*

The M&SWJR was formed in 1884 by the amalgamation of the Swindon, Marlborough and Andover Railway and the Swindon and Cheltenham Extension Railway. It enjoyed running powers over certain GWR lines, particularly into Cheltenham. It lasted until the grouping in 1923, when it was absorbed into the Great Western, bringing its small stud of twenty-nine locomotives into GWR ownership. Most of the passenger locos were 2-4-0 or 4-4-0 types, with a few tank engines thrown in, and most of the goods locos were 0-6-0s. *Galloping Alice*, however, was one of two 2-6-0s built by Beyer, Peacock and Co., and was intended for use in South America. The customer defaulted in some way and so the locos were bought by the M&SWJR. One was sold into industrial use before 1923, but *Alice* ended up on the GWR, and was subsequently rebuilt in the Swindon style. It lasted until 1930. In my opinion the rebuilt engine was much better looking. It is unclear where the nickname *Galloping Alice* came from, but I suspect it could be attributed to the footplate crews.

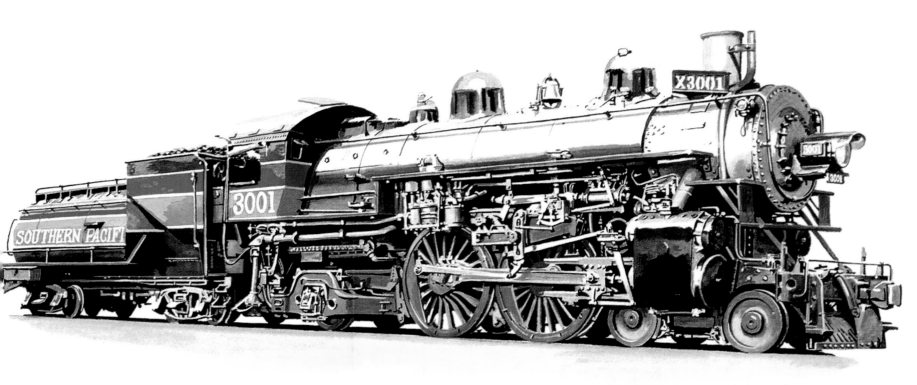

Southern Pacific Railroad Class A-6 4-4-2 No. 3001

Who said American locomotives were dull? Several railroads veered away from the conventional colours of black and silver for their steam engines, and one such was the Southern Pacific. One of its prestige trains was the *Daylight Limited*, which ran between Los Angeles and San Francisco from 1922. In 1937 it became best known for its stunning red, orange and black colour scheme, which extended throughout the train. It was usually hauled by a class MT-4 4-8-4 locomotive, which did carry some shrouding so as to be semi-streamlined.

Occasionally, there was a need for lighter or relief trains, and several of the SP's smaller Atlantics, including 3001, were specially repainted to haul them. This painting was produced for a regular customer who is a big fan of the Southern Pacific.

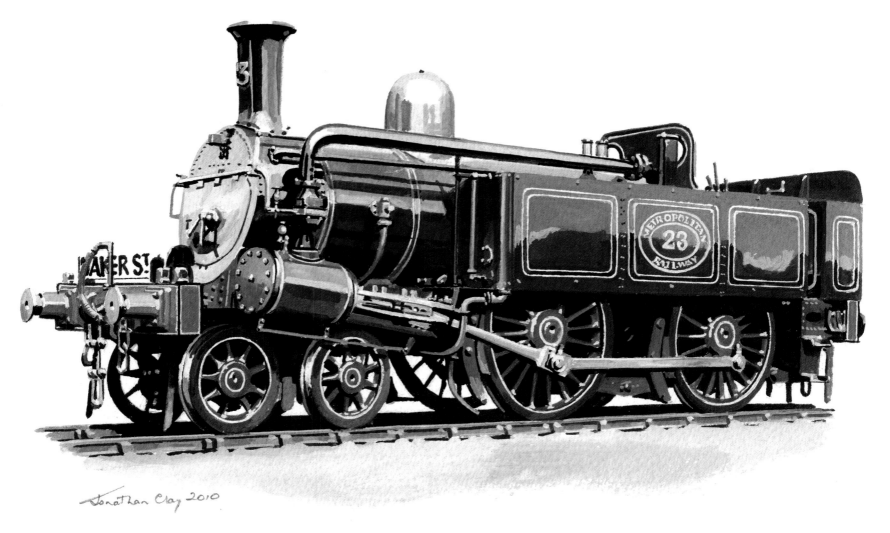

Metropolitan Railway Beyer, Peacock A Class 4-4-0T No. 23

In 2013 steam made a temporary comeback on the London Underground. Special dispensation was given so that steam-hauled trains could run where normally there are only electric trains. Although this may sound like a novelty, there was a time when some underground trains were hauled by steam locos as a matter of course. The Metropolitan and the District railways each operated a class of 4-4-0 tank locomotives, built by Beyer, Peacock & Co. in Manchester. Of course steam engines and confined spaces don't mix well, so the engines were designed with condensing apparatus which could absorb some of the emissions. Since the cabs were open, the crews may also have appreciated this benefit.

Some of these locos were long-lived. After electric traction took over for passenger trains, several were put into departmental use and even hauled trains over LT's surface lines. On withdrawal the last survivor, No. 23, was restored to its original condition, and can now be found in the London Transport Museum at Covent Garden.

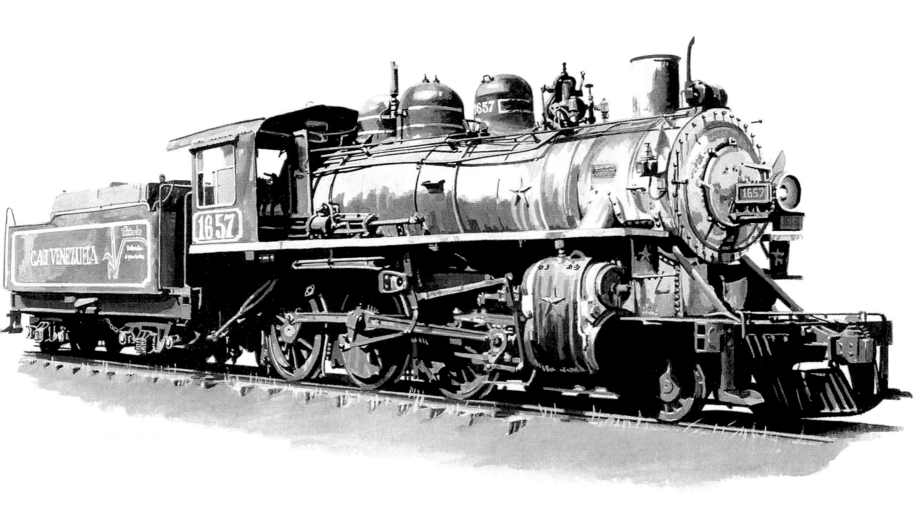

CAI Venezuela (Cuba) Baldwin 2-6-0 No. 1657

If you want to go to Cuba, now is the time. Since the 1950s the country has lived in isolation from the rest of the world, as a result of US reluctance to deal with its leaders. This has meant that new items – such as locomotives and cars – were forbidden, with the result that the streets are full of classic automobiles, their owners having become experts at 'make-do-and-mend'. The same applies to the railways: since it was difficult to purchase new engines or rolling stock, they have had to manage with antiquated equipment, hence the retention of steam traction up to the present day.

I was first introduced to Cuban railways by a fine modeller, Peter Smith, who had built a beautiful scale model of a Cuban sugar-processing factory and its associated railway. I painted several locomotive pictures for him, and when he changed his modelling interests his layout was packed off to Cuba, where it now resides, along with one of my pictures, in the railway museum in Havana.

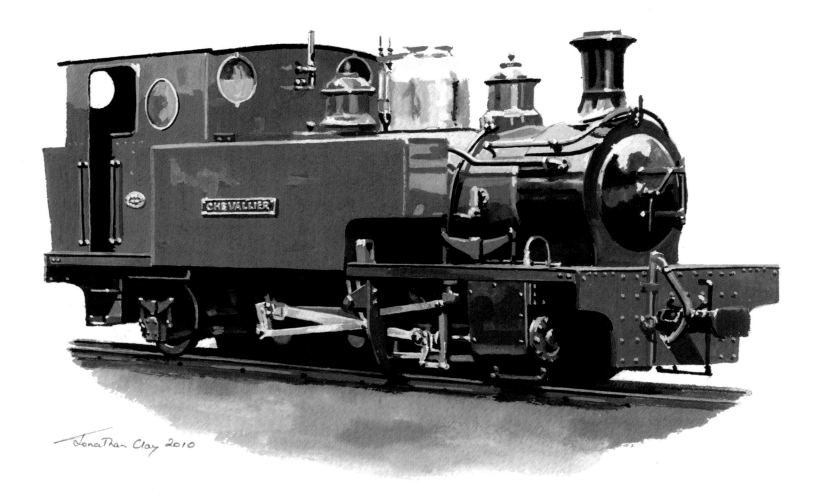

Former Bowaters Manning Wardle 0-6-2T *Chevallier*

The fleet of locomotives used on the narrow-gauge Bowaters Paper Railway at Sittingbourne contained a few one-offs, such as *Chevallier*. It was built for the 2ft 6in gauge Chattenden and Upnor Railway, which was operated by the Royal Navy before finding its way to Sittingbourne. When enthusiasts took over the railway in 1970 it was sold, with three others, to a railway being established at Whipsnade Zoo. It became the first locomotive to work on the Great Whipsnade Railway.

In 2010 it was comprehensively overhauled at the Flour Mill Workshops in the Forest of Dean, and spent a short time at the Welshpool and Llanfair Railway that autumn. It is still part of the operational fleet at Whipsnade.

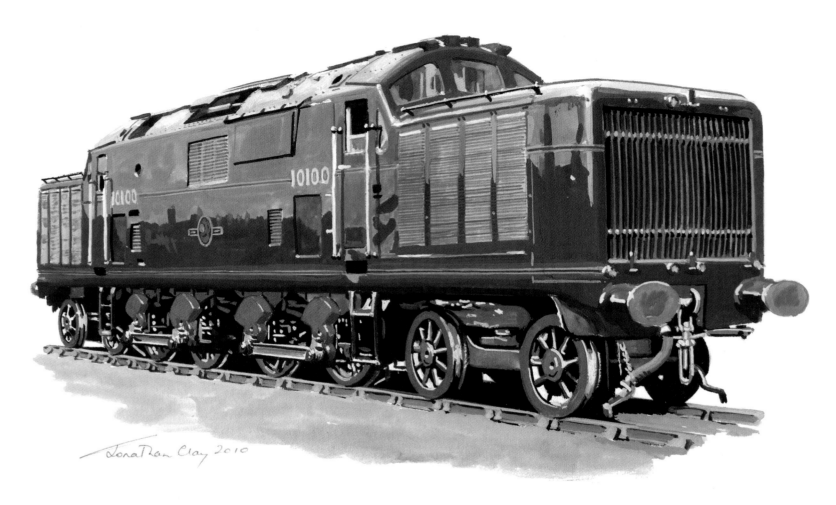

British Railways Fell Diesel-Mechanical Locomotive No. 10100

In the early 1950s there was a great deal of experimentation with diesel traction on British Railways. The LMS had constructed two of the pioneer mainline diesels and the Southern Region of BR produced three slightly larger locomotives. No. 10100 was the brainchild of Lt-Col. L.F.R. Fell, who began the design in company with the LMS. However, it was not completed until 1950, by which time it had become a BR project. Instead of one big diesel engine it had four smaller ones, two in each nose end, in addition to two other engines which were used to run the pressure chargers for the traction engines. What this must have sounded like no one seems to be able to remember, and no film footage appears to have survived. It was originally built as a 4-8-4, but the middle coupling rods were later removed to create a 4-4+4-4. It was, apparently, powerful but very unreliable, and was scrapped in 1960.

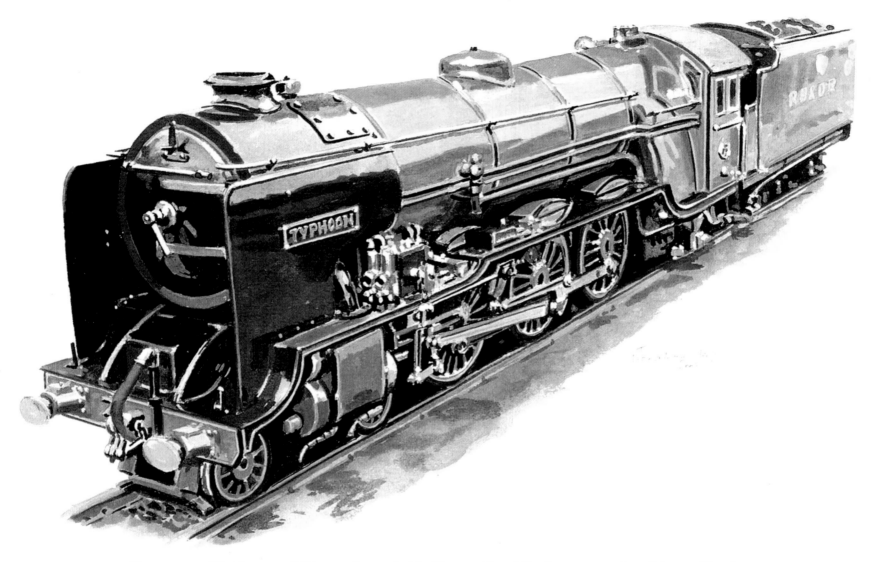

Romney, Hythe and Dymchurch Railway Pacific Locomotive No. 7 *Typhoon*

I would have loved to meet Captain Howey and Henry Greenly. Between them they managed to create a thirteen-and-a-half-mile, 15" gauge railway across Romney Marsh in Kent. Howey also wanted to include his friend Count Louis Zborowski, who ordered the first two locomotives, but sadly he died in a car crash in 1924. The designs were all by Greenly, although he and Howey eventually had a massive falling-out not long after the railway was completed. It is said that Captain Howey was in the habit of closing the railway at short notice so that he and his friends (including Sir Henry Birkin) could race trains! Howey also had a locomotive built from his old Rolls-Royce, which was said to be good for 60mph.

Typhoon was the fourth pacific built, and was one of two having three cylinders, like the Gresley Pacifics, on which they were based. This proved troublesome and so they reverted to a two-cylinder layout. No. 7 continues to provide sterling service on the RHDR today.

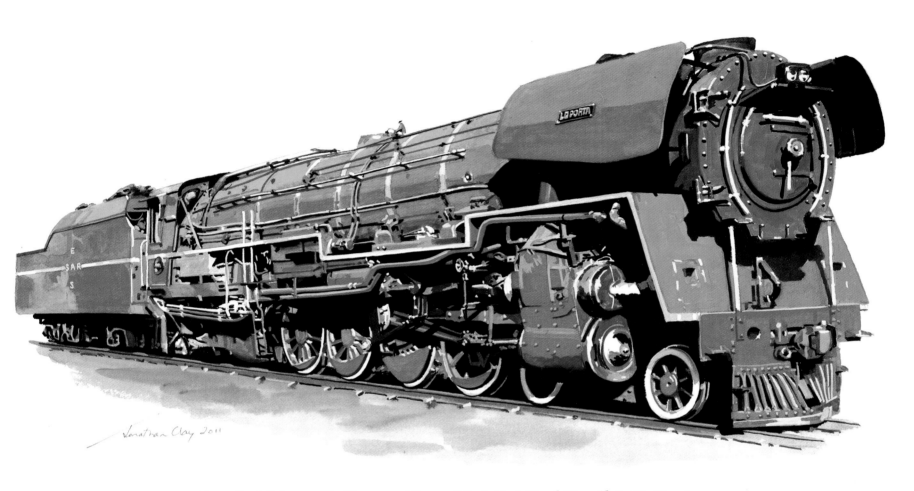

South African Railways Class 26 4-8-4 Red Devil *L.D. Porta*

Whilst most of the world tried to rid itself of steam locomotives after the Second World War, there were those who continued to experiment with them, convinced that their power and efficiency could be enhanced to match or better the results attained with diesel and electric traction. One such was the Argentinian locomotive engineer Livio Dante Porta, who worked wonders with the steam engines of Argentina and Patagonia before moving to the USA in the 1980s to work on the abortive ACE project. His ideas for improvement were applied in Brazil and Paraguay, and he even attempted to develop a steam bus in Argentina.

The pictured loco was rebuilt from a South African Railways Class 25 by David Wardale, who was heavily influenced by Porta, and the finished result was considerably more powerful and a great deal more efficient than the original. It was named *L.D. Porta* as a tribute.

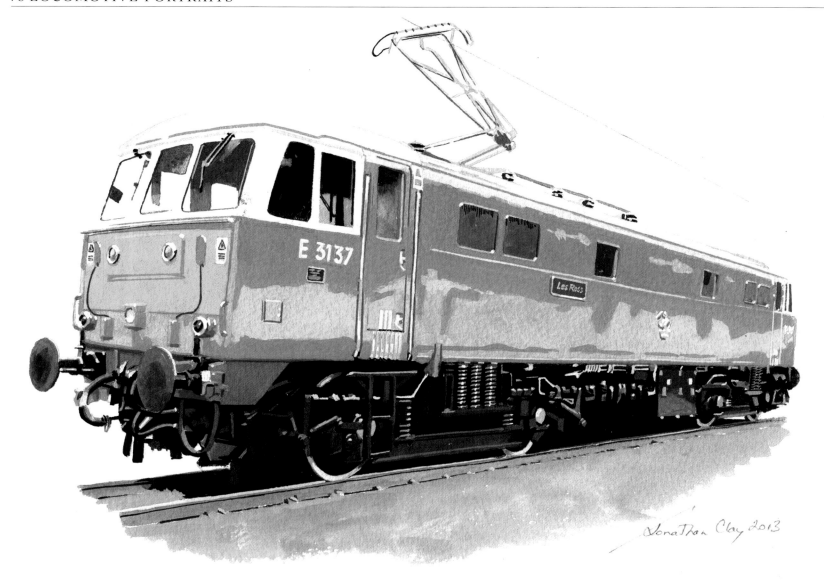

British Railways Class 86 Bo-Bo Electric Locomotive No. E3137 *Les Ross*

I have attended the Warley Model Railway Club exhibition at the NEC in Birmingham many times and, about ten years ago, was surprised to have a microphone shoved under my nose with the exhortation: 'Now then, Jonathan, tell us a bit about yourself.' Holding the microphone was a lovely chap called *Les Ross* and, although I didn't realise it at first, I was on a live BBC broadcast. Les was a radio presenter for many years and a local celebrity. When he retired a couple of years later he broadcast his final show from New Street station, where he was surprised to discover a locomotive had been named after him. When it was withdrawn and put into store he asked if he could buy it. This he did, and he has spent a great deal of money on it over the last few years, with the result that it is now mainline registered, and is hired out to other railway companies as well as operating enthusiasts' charters. This is the second picture I have painted of this loco; the first was in its original Virgin Trains livery.

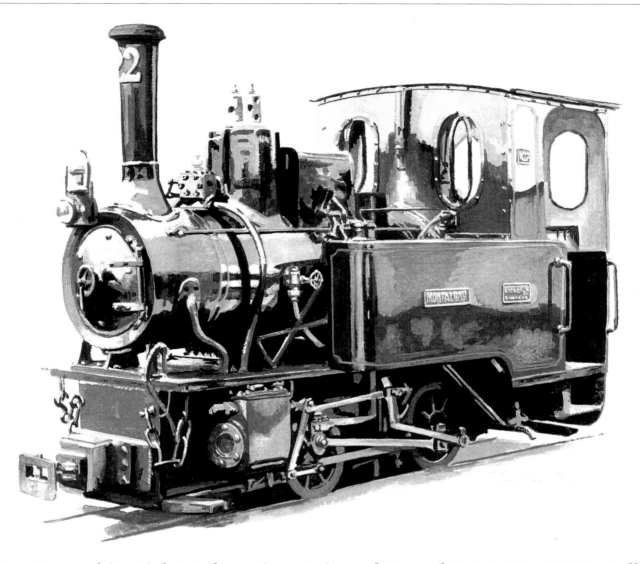

West Lancashire Light Railway Orenstein and Koppel 0-4-0T No. 22 *Montalban*

This locomotive is one of a pair discovered in Spain in the 1970s by members of the West Lancashire Light Railway. 'Monty', as it is affectionately known, is more like a family pet. It belongs to two friends of mine, Margaret and Keith Nicholls, and I have had the pleasure of driving it on several occasions.

The West Lancs is a wonderful little line, and I have retained my membership since we moved to the south. I have also helped out occasionally when they were short-handed, and one occasion sticks in my mind. The boiler inspector's visit tends to be the week before Easter, and one year several of us turned up bright and early to check over and light the fires in all the steam engines. Whilst we were waiting for the pressure to build up, the BBC turned up and started filming. Eager to please, Keith moved *Monty* to the water tower and began to fill the tanks, aided by yours truly on the valve handle. Keith was so distracted by the camera that he didn't tell me to shut off the water flow until it was too late. The water gushed out of the tank filler and Keith was absolutely drenched. Still, it made good TV!

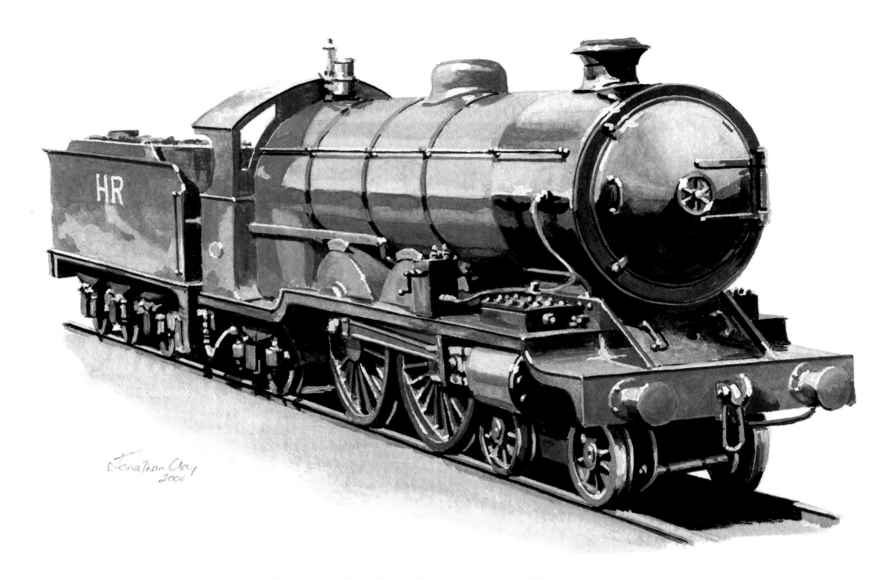

15″ gauge Bassett-Lowke Class 30 4-4-2 No. 31 *Count Louis*

In the 1950s our holiday guest house in Barmouth looked directly over the bridge, the bay, and a narrow strip of land on the opposite side of the estuary. Occasionally we would see a small plume of smoke and steam rising up from the other bank, which came from a locomotive of the Fairbourne Railway. To reach the railway, a small motor boat was provided for onward transport to the village of Fairbourne. The locomotive I remember most vividly was *Count Louis*, though I little realised its historical significance. It was built in the 1920s for the racing driver Count Louis Zborowski, though he died before it could be delivered. It spent sixty years at Fairbourne until the FR was regauged in the 1980s, when it became a museum piece. It spent some time in pieces at the Bure Valley Railway, finally being restored to steam under the aegis of Tyseley Museum in the 2000s. It now runs on the Evesham Vale Light Railway in Worcestershire.

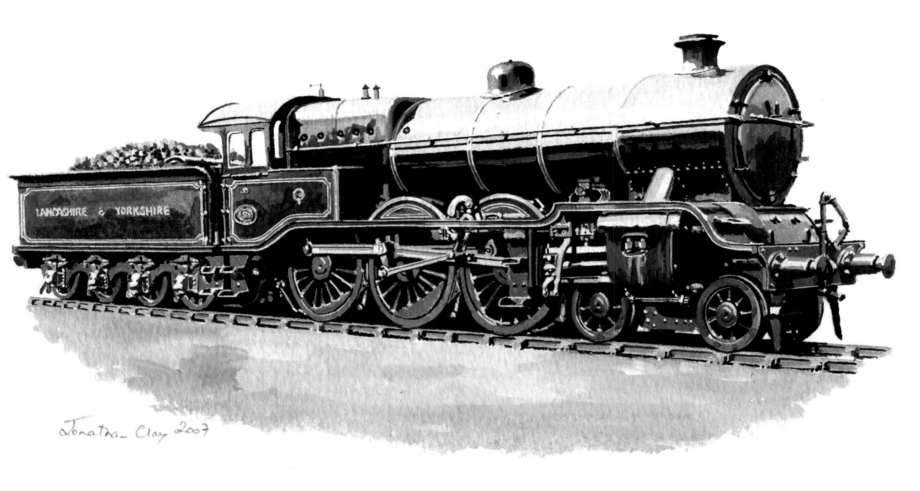

Lancashire and Yorkshire Railway Hughes 'Dreadnought' 4-6-0 No. 1511

Being a Lancashire lad, I'm quite a fan of the old L&Y, though I can't remember seeing many of its locos as a boy, and only a handful survive. I recall being taken around Horwich works and seeing the narrow gauge system there, which is still visible in some of the buildings. Like the Midland, the L&Y was a 'small loco' railway, relying mainly on 0-6-0s for goods work and 4-4-0s for passenger trains. Unlike the Midland, the 'Lanky' realised that bigger locos were required for heavier trains, rather than double-heading, and consequently developed these 4-6-0s and the similar Baltic tanks, although the latter were only built in LMS days. In my youth I saw a magazine article about a projected 2-10-0 for the L&Y, based on a Belgian design and nicknamed 'the Lanky Flamme'.

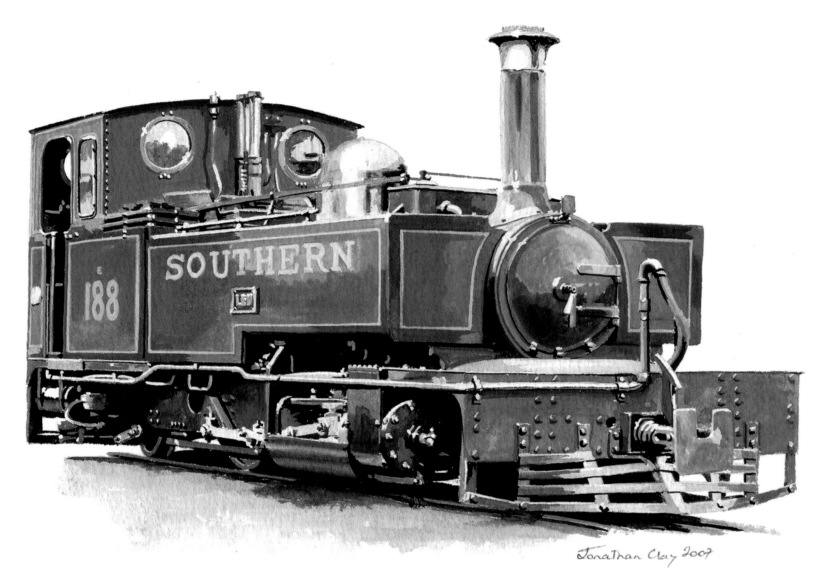

Lynton and Barnstaple Railway Manning Wardle 2-6-2T No. E188 *Lew*

When the Lynton and Barnstaple Railway closed in 1935, most of its motive power was scrapped with undue haste, with only *Lew* surviving, along with a handful of carriages. The latter have mostly been restored or modified, and can be seen on both the Ffestiniog and the resurgent Lynton and Barnstaple railways.

The story goes that in 1936 this loco was sold and shipped to deepest, darkest Brazil. The letters 'ALC', and the word 'Pernambuco' were written on the side tanks, and the loco was loaded onto the S.S. *Sabor*, which was bound for the Brazilian port of Recife. Since then nothing has been seen or heard of it, in spite of several attempts to discover its fate. The story seems to be ongoing, and perhaps it may one day be discovered in a remote part of the Brazilian rainforest.

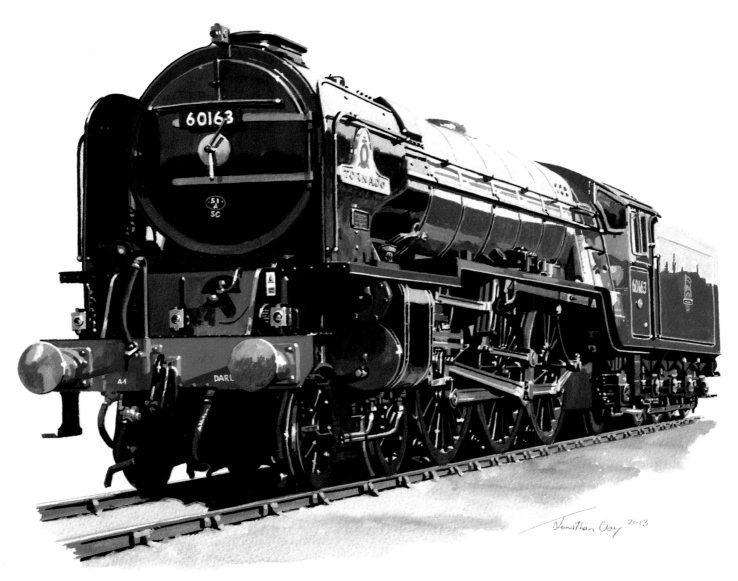

LNER A1 Peppercorn Class 4-6-2 No. 60163 *Tornado*

At one time I was sceptical about constructing new steam locomotives. Some narrow-gauge lines had built their own, but a standard-gauge loco was another matter. My opinion changed in a nanosecond the day I walked into the workshop in Darlington, where *Tornado* was being built for the A1 Steam Locomotive Trust. It was nearly finished, and turning a corner and seeing it 'in the flesh' for the first time made me stop and blink. Viewed from ground level, no one could fail to be impressed by the scale of the project.

I felt the same four years later when it appeared at Llangollen in 2012. Sitting on Glyndyfrdwy platform as it simmered there, I was struck by the fact that this was a brand new loco, built from scratch. Now I am a convert, and am associated with several of the new-build groups. The A1 Steam Locomotive Trust is currently planning to build a P2. It is to be a 2-8-2, numbered 2007, and called *Prince of Wales*.

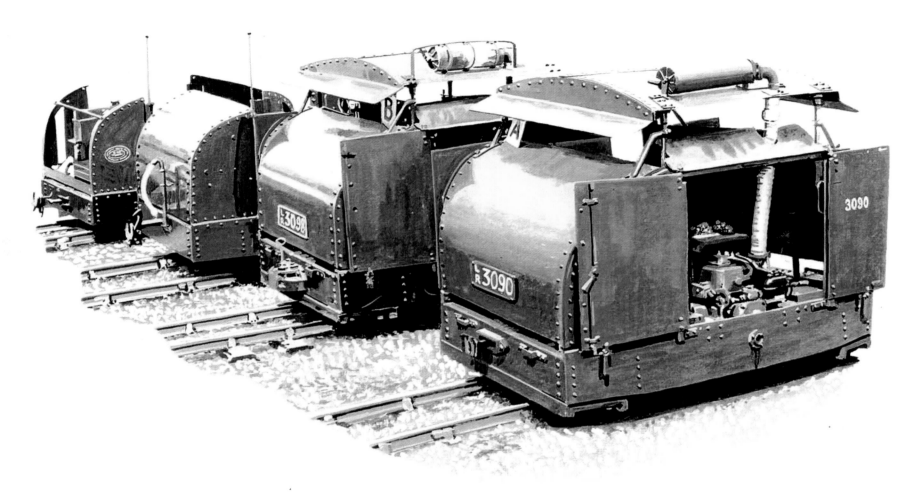

67. 'Tin Turtles'

During the First World War it was realised that the movement of munitions, troops, and other supplies was more effectively done by railway than by horse or lorry, and the Ministry of Munitions developed a requirement for small petrol tractors to be built for the War Department Light Railways. They were of two types; the smaller 20hp version, and the larger, 40hp variety, like those above. These were built in several forms: the 'open' type had just a roof supported on four pillars; the 'protected' type added doors and visors; and the 'armoured' type was completely enclosed, with only slits for the driver to see where he was going – just like a tank!

After the war many were put to use in industry in both the UK and France, and several survive. This painting was specially set up at the Ffestiniog Railway, and shows four of the UK-based locos. The one on the far left has been on the FR for many years, and is affectionately known as Mary Ann.

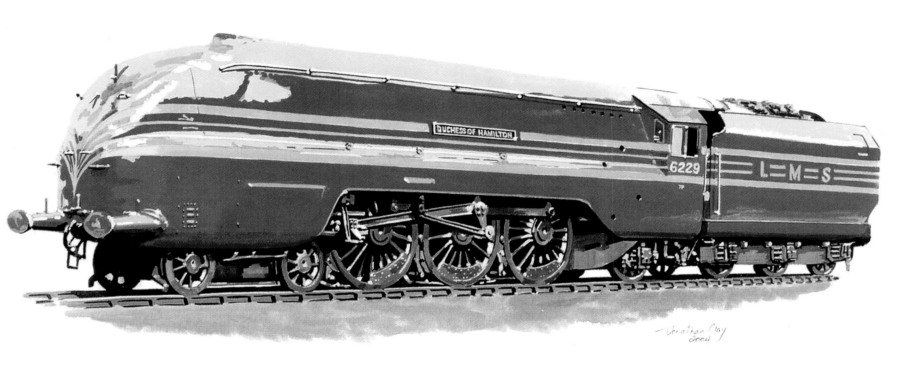

LMS Streamlined Coronation Class 4-6-2 No. 6229 *Duchess of Hamilton*

Along with the LNER, the LMS joined in the quest for speed on the prime Anglo-Scottish routes in the 1930s. And like Sir Nigel Gresley with his A4s, Sir William Stanier and his colleagues went down the streamlined route. The Coronation Class Pacifics were enlarged versions of the Princesses and were the principal type of locomotive to haul passenger expresses on the West Coast route. Some were later built without the streamlining and, having suffered the poor maintenance conditions of the Second World War, all the streamlined locomotives had their cladding removed by the early 1950s. These were easily recognised because they had a flattened top to the smoke-box, which led to their nickname of 'Semis'. These were later replaced by round-topped smoke-boxes, so that the class presented a more or less uniform appearance.

Three survive: 46235 *City of Birmingham* is incarcerated in a museum in the city of that name; 46233 *Duchess of Sutherland*, which is main line registered; and 6229, which has had the streamlining beautifully restored, although it is currently a static museum exhibit.

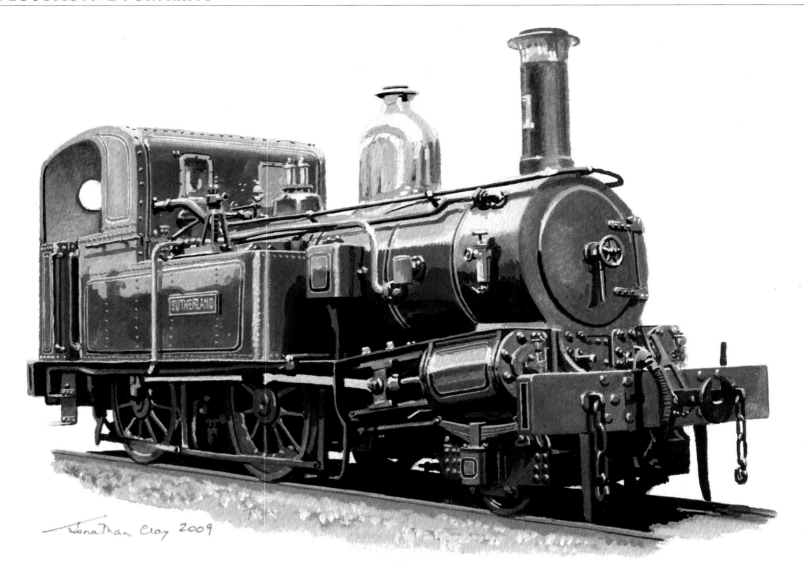

Isle of Man Railway Beyer, Peacock 2-4-0T No.1 *Sutherland*

We've only been to the Isle of Man once, about twenty years ago. It was early in the year and the overall impression of the island is that it could all do with a coat of paint! Driving round the TT course in my little Fiat at 30mph frightened the life out of me, so God only knows what it must be like on a motorbike at speeds of up to 200mph. However, we did see one steam locomotive: No. 11, *Maitland*. All the locos on the Isle of Man Railway (with one exception) were 2-4-0Ts built by Beyer, Peacock of Gorton, Manchester, and grew ever larger with each delivery. All but two survive, and the frames of one of those still exist, so it's possible that it may one day be restored.

Sutherland was the first Beyer, Peacock loco and, although nominally a museum exhibit, it was restored to steam a few years ago. However, it used the boiler from another loco which has since been returned to service.

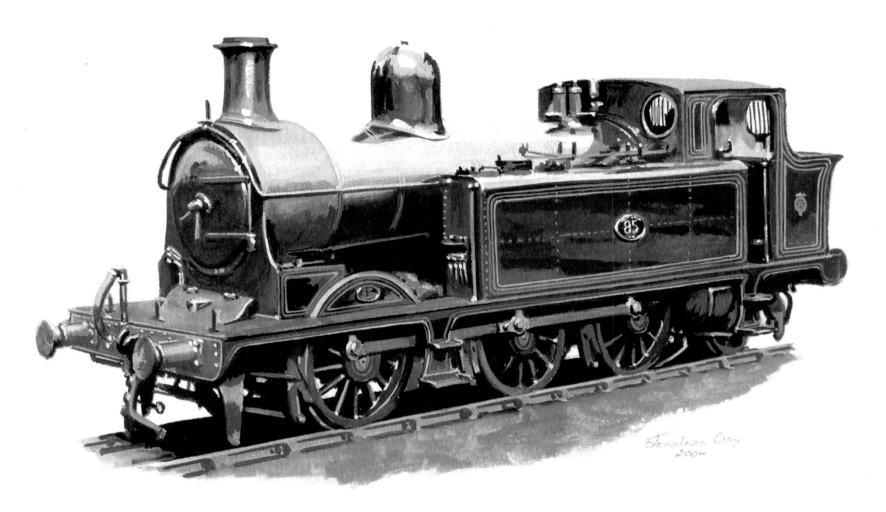

Taff Vale Railway 0-6-2T No. 85

I'm not very familiar with South Wales, having been there once in my late teens and once for a weekend visit to a model railway exhibition in the Rhondda Valley about ten years ago. However, I knew there were a number of small railway companies based in and around South Wales, most of which owed their existence to heavy industry, particularly coalmining. These were all absorbed into the Great Western Railway in 1923, bringing a wide variety of motive power to the GW fleet. Many of these had long lives and made it into my first Ian Allan ABC.

Having been taken over by the National Coal Board in the 1950s, two TVR locos have survived. No. 28 has been cosmetically restored in GWR livery for the Gwili Railway and No. 85 has proved to be a useful and powerful workhorse on the Keighley and Worth Valley Railway.

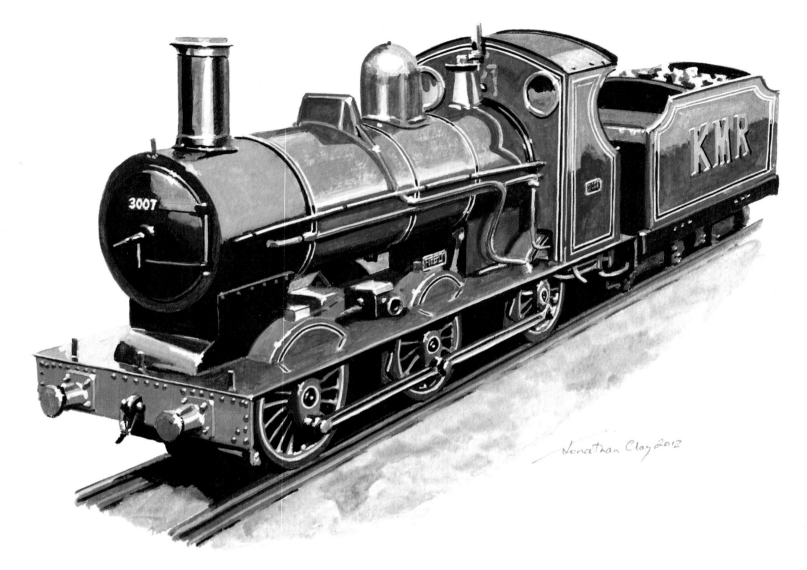

Kerr's Miniature Railway Bullock 0-6-0 No. 3007 *Firefly*

As a fan of miniature railways, I am intrigued by the Surrey Border and Camberley Railway and its engineer, Charles Bullock. The 10 $^1/_4$" gauge SBCR was only two miles long and had an operating life of barely two years when the outbreak of war closed it down in 1939. It has acquired an almost mythical status amongst enthusiasts and, to date, still awaits the writing of a comprehensive history, although a brief version has been published, along with a book about Bullock and his locos, most of which still survive, including a miniature Gresley Pacific, currently in India.

Firefly was built as a miniature version of a GWR pannier tank, but it was later converted to a tender loco and ran for many years at the Hastings Miniature Railway. It now runs on the Kerr's Miniature Railway at Arbroath in Scotland, but was taken back to Hastings for a brief visit in the spring of 2013.

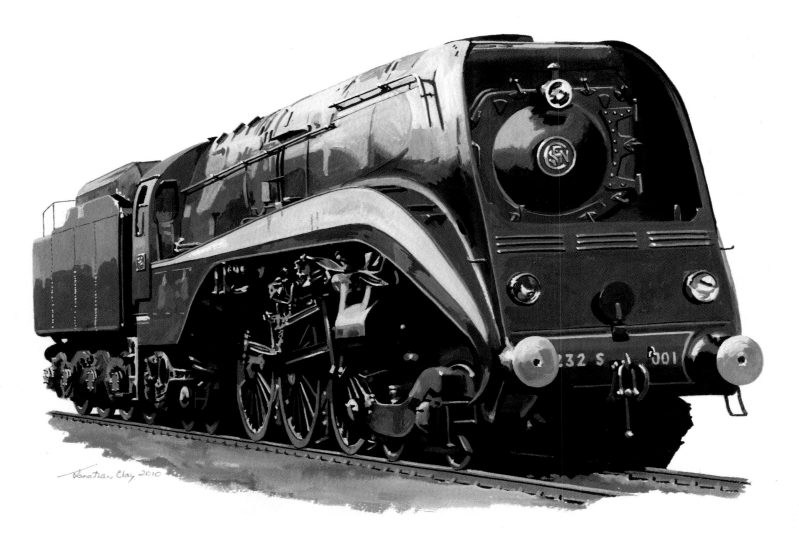

SNCF Class 232S 4-6-4 No. 232 S 001

I knew my dad had been in France during the Second World War, but he was reluctant to talk about it. However, we were taken to France and Belgium when I was quite young, to meet some of the friends he had made there. We spent some time in Roubaix and Lille, where he took a lot of photographs of French locos, including this one, though I have only recently learned of its significance as one of a small batch of experimental locomotives. Only after my mother died did we learn about my father's time in France. Reading his wartime letters – of which there are hundreds – it is clear that he took part in the Normandy landings.

The 232s were a small and experimental group of semi-streamlined locos. Each of the class of six was slightly different, although they were quite long lived. The last and largest survives in preservation at the Cité du TrainMulhouse, France.

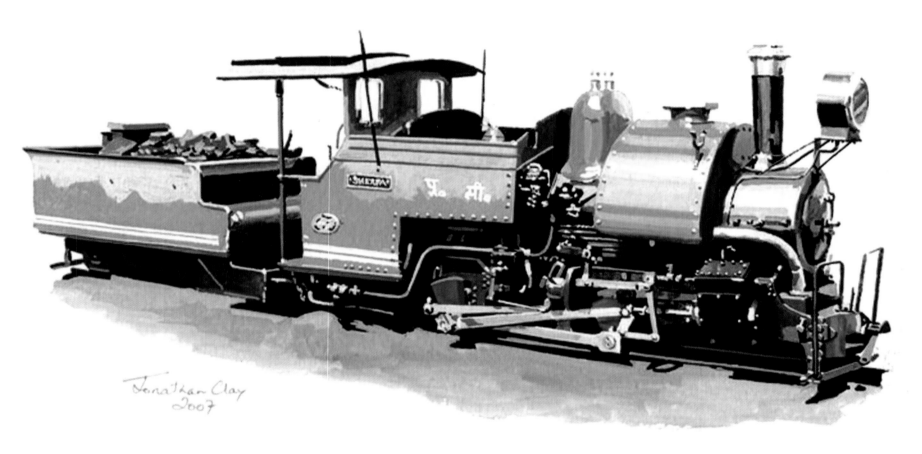

Fairbourne Railway ex-Darjeeling Himalayan Railway B Class 0-4-0 *Sherpa*

The Darjeeling Himalayan Railway is best known for its iconic B class locomotives, of which thirty-four were built between 1885 and 1927 by a number of builders in the UK and USA. One was even streamlined for a short time in the early 1940s, though this seems to have been something of a 'tongue-in-cheek' exercise. Through the efforts of the Darjeeling Himalayan Railway Society and others, the railway has achieved World Heritage Site status. The line suffers more than its fair share of extreme climactic conditions and is frequently closed because of landslides and rockfalls.

Many of its steam locos survive, both on the DHR and elsewhere in India. One is in the UK and runs on the privately-owned Beeches Light Railway. Fortunately, we can also see this half-size replica on the Fairbourne Railway in North Wales.

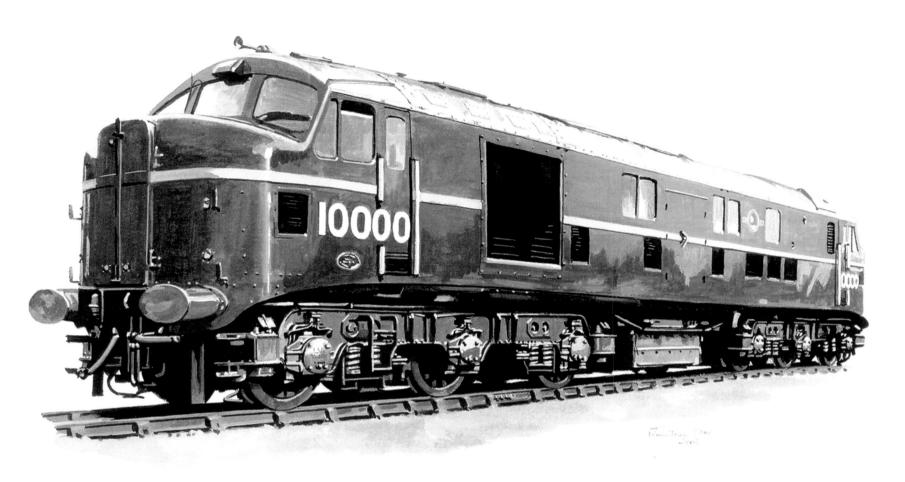

Ex-LMS Co-Co Diesel-Electric Locomotive No. 10000

Before any thought was given to the mass dieselisation of Britain's railways, No. 10000 was the first successful mainline diesel locomotive in the UK. It was completed in December 1947 and was followed six months later by No. 10001. It was tried out in a variety of locations, along with the SR trio of diesel locomotives, and seemed to work well. I recall seeing the pair hauling the *Royal Scot* whilst we were on holiday at Hest Bank in the mid-1950s. No. 10000 ran until 1963 and was unceremoniously scrapped in 1968.

This is a locomotive which really should have been preserved. Fortunately, the Ivatt Diesel Recreation Society has recently been set up to rectify the omission of this loco in preserved ranks and, having obtained an identical power unit, is endeavouring to build a replica.

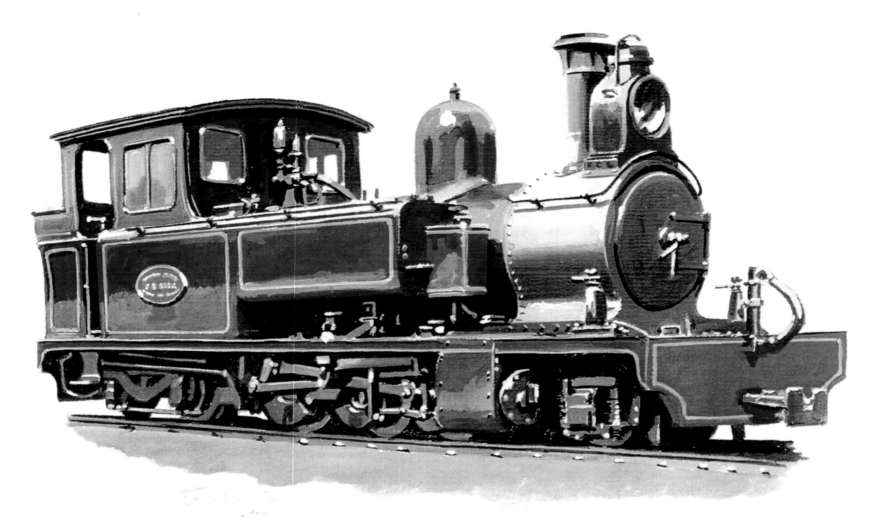

Leek and Manifold Valley Light Railway Kitson 2-6-4T *J. B. Earle*

With all the railway restoration projects that have been started in the last sixty years, I'm still surprised that no one has attempted to recreate the Leek and Manifold, particularly since the trackbed survives in its entirety and is well maintained. The 2ft 6in gauge line opened in 1904 and was closed under the ownership of the LMS in 1934. Three years later, after the track was lifted, the permanent way was turned into a foot– and cycle-path.

Throughout its existence the L&M had only two locomotives, both inspired by the engineer E.R. Calthrop, who had been instrumental in constructing the Barsi Railway in India. They were built by Kitsons of Leeds, though whether they were designed by Calthrop is open to doubt. Sadly, both were scrapped when the railway closed; the other, named *E.R. Calthrop*, having hauled the demolition trains.

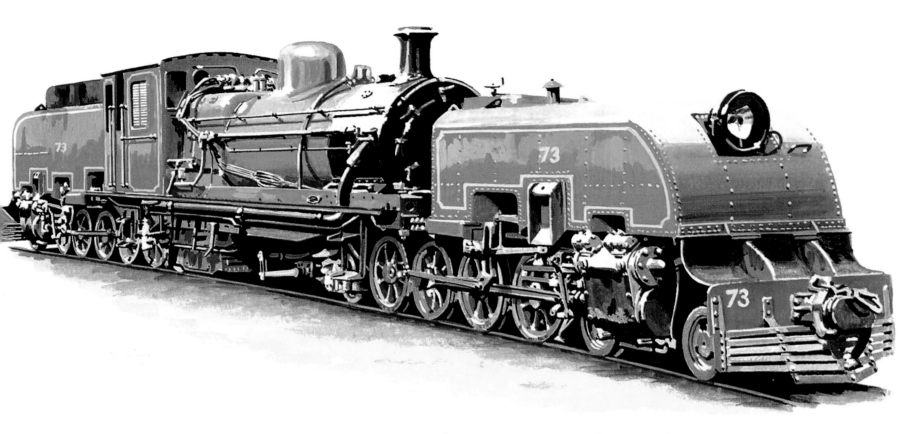

Sierra Leone Government Railway 4-8-2-2-8-4 Garratt No. 73

Several years ago I had occasion to meet Colonel Steve Davies, then head of the Museum of Science and Industry in Manchester. He told me of his time with the British Army in Sierra Leone, and showed me a lot of photographs he had taken of the surviving equipment of its railways. Whilst there he was instrumental in setting up the Leone National Railway Museum in 2005 and began the preservation and restoration of artefacts. These include a Hunslet tank locomotive, identical to the one at Welshpool, another small steam loco and four Hudswell Clarke diesel locos, as well as some rolling stock. The flagship of the collection is this Garratt, which is one of several built for the SLGR by Beyer, Peacock. It carries the unofficial name *Queen of Tonga* in honour of a royal visit to Sierra Leone.

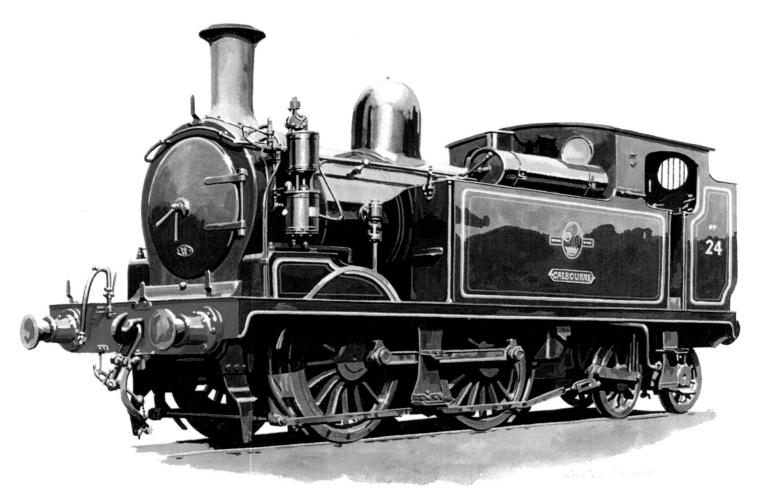

Ex-LSWR Class O2 0-4-4T No. 24 *Calbourne*

I have long been interested in the Isle of Wight railways, which were somewhat different to those on the mainland. When steam prevailed, the lines needed only small tank engines, and relied on twenty-three class O2 locos, all of which had previously worked on the mainland, being progressively transferred from the early 1920s. Unlike the mainland locos, they were fitted with enlarged bunkers. *Calbourne* is the only survivor of the sixty class 0-4-4T locos built at Nine Elms.

In the 1950s and 1960s, all but one of the lines on the Isle of Wight were closed, the one remaining service line, which runs from Ryde to Sandown, has been operated since electrification in 1967 by pensioned-off tube stock from the London Underground.

A group of enthusiasts purchased *Calbourne* in 1967 with a view to restoring and using it on a preserved heritage line they hoped to open along a stretch of abandoned track. By 1992 they had restored the loco – by then 101 years old – to full working order and painted it in Southern Railway green. They had also by then reopened over five miles of track. Another overhaul saw *Calbourne* emerge in 2010 in the BR standard black livery in which it is pictured above. In 2012 the loco took a holiday from the Isle of Wight Steam Railway and returned to the mainland for the first time in nine decades, in order to visit other preserved lines.

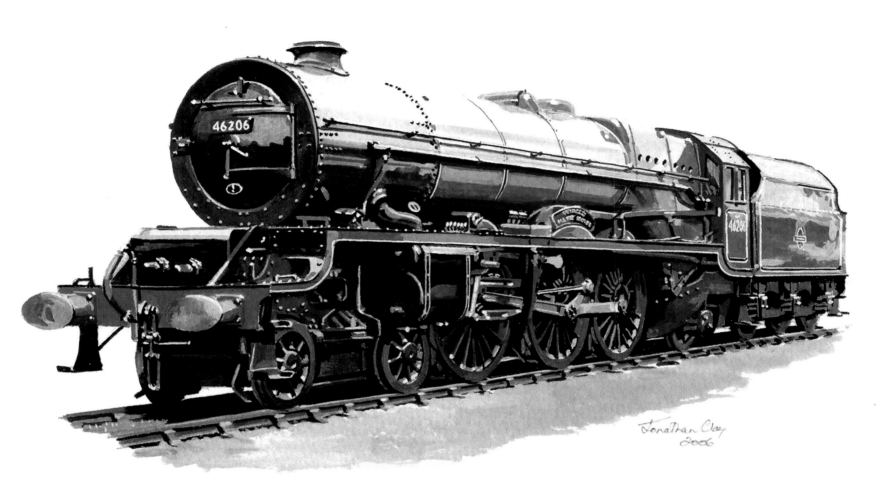

LMS Princess Royal Class 4-6-2 No. 46206 *Princess Marie Louise*

The Princess Royals were once the most powerful and prestigious locomotives on the LMS. My introduction to them came via my first Tri-Ang train set. Included therein was a black version of No. 46201 *Princess Elizabeth.* Although this model was rather crude, and very much out of scale, it was my prized possession for years, and was later joined by a BR green version on our model railway.

The Princess Royals were a small class of thirteen (including the Turbomotive) which were soon superseded by the Duchesses. *Princess Marie Louise* was scrapped, and only two examples, 6201 *Princess Elizabeth,* 6203 *Princess Margaret Rose,* preserved. When I was asked to produce this painting, I chose to depict it in BR blue, a livery carried by only two of the type.

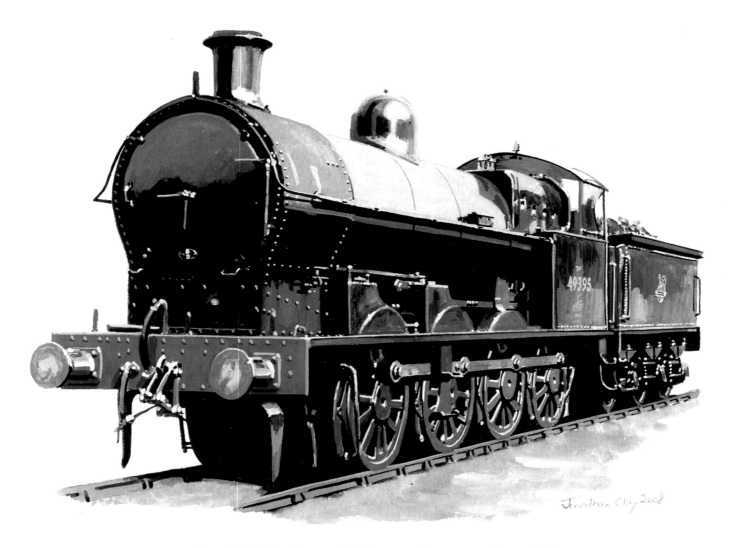

Ex-LNWR Class G2 Super D 0-8-0 No. 49395

What a lovely noise these engines make! I well remember them wheezing and coughing on long goods trains in my trainspotting days. Designed by Bowen-Cooke for the LNWR, they were constantly improved as time went on, and many lasted into BR ownership and into the early 1960s.

No. 49395 was seen to have historic significance and was nominated to become part of the national collection. It was stored at various locations through the 1960s, 70s and 80s, though it spent quite a long time in the open, causing it to deteriorate markedly. Enter the impresario and railway enthusiast Pete Waterman, who took it upon himself to provide funds for the loco's restoration in the 2000s. It was returned to working order and has visited many preserved railways since. Having seen it working several times, I can confirm that it still sounds like a Super D should. When its boiler certificate expired in January 2014 it was expected to become a static museum piece, but Mr Waterman has stepped up to the plate again, and we can look forward to a further spell of activity.

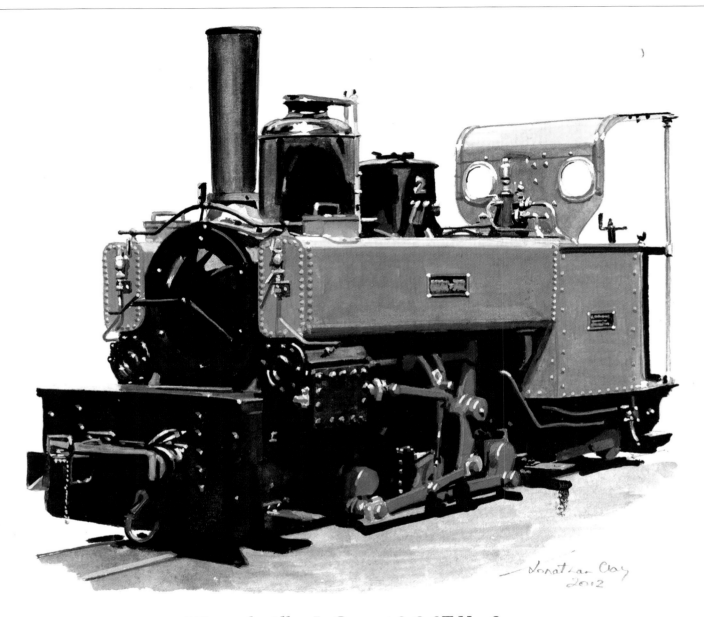

Minas de Aller L. Corpet 0-6-0T No. 2

Corpet, the French company which built this locomotive, still exists, having gone through several manifestations in its history, though the word Corpet is usually somewhere in its name. It built locomotives large and small, right up to the SNCF's magnificent, if experimental, streamlined 4-6-4s.

No. 2 was one of five built for a Spanish mining company, of which three survive. Two are in Portugal, but No. 2 has been lovingly restored to original condition and working order at the Statfold Barn Railway, near Tamworth in Staffordshire. It has very unusual Brown's valve gear, which means that the coupling rods are driven indirectly from the cylinders by way of a substantial, rocking shaft. Another strange feature is the regulator handle, which is in front of the cab sheet, and which means you have to lean out and around to drive the engine.

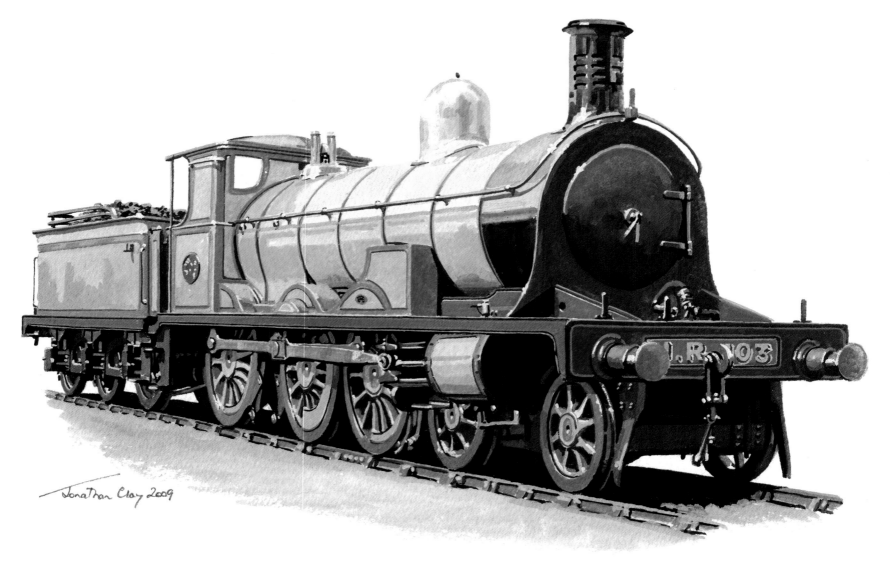

Highland Railway Jones Goods Class 4-6-0 No. 103

In the late 1950s a very enlightened British Railways had the bright idea of restoring some of its preserved collection of locomotives to working order. As well as *City of Truro, Glen Douglas*, and a couple of others, No. 103 was selected from the national collection. I was an avid watcher of the TV series Railway Roundabout, and this loco featured on more than one occasion, being used for enthusiasts' specials, largely in Scotland.

The Jones Goods were the first type of 4-6-0 in this country. Fifteen were built, and 103 is the sole survivor. It has been preserved since 1934, and during its working period appeared in the film *Those Magnificent Men in their Flying Machines*, shortly before it was retired from active service in 1964. It has been a museum piece ever since, painted in the quirky Stroudley Improved Engine green livery of both the Highland Railway and the LBSCR. It is now in the Riverside Museum in Glasgow.

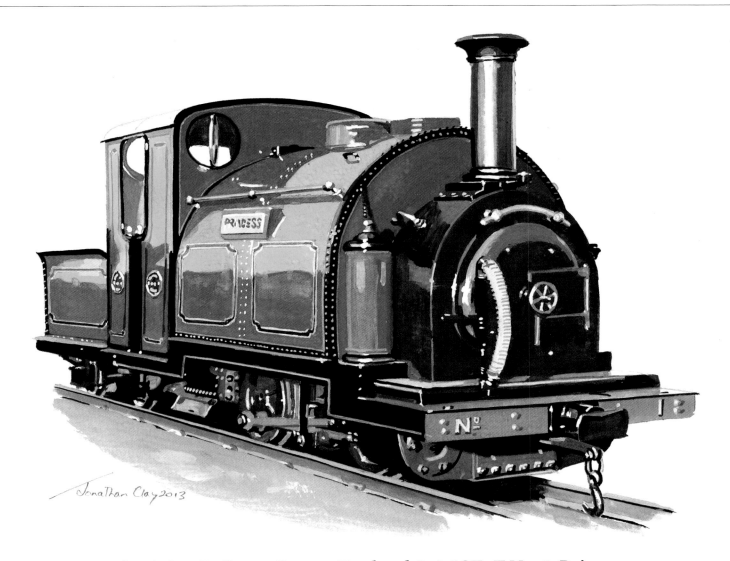

Ffestiniog Railway George England 0-4-0ST+T No. 1 *Princess*

Princess was one of the first narrow gauge engines I saw. Although No. 2, *Prince*, was restored to steam in the mid-1950s, *Princess*, along with the other two survivors, *Palmerston* and *Welsh Pony*, was kept sheeted over near the Boston Lodge works of the Ffestiniog Railway. I have a photograph of my brother, dressed in his primary school uniform, hanging out of the cab of one of them, pretending to be an engine driver. *Princess* then appeared on display at Harbour station, later moving to a plinth at Blaenau Ffestiniog. More recently it has been the centrepiece in Spooners bar and restaurant at Porthmadog.

In 2013, with the 150th anniversary of steam on the FR, *Princess* was removed from its resting place and given a very comprehensive cosmetic makeover, and even regained its original tender. It was displayed at several FR events that year, and even spent some time as a mobile advert for the Ffestiniog, appearing at both Paddington station in London and Heuston station in Dublin. Because of its historical significance, there are no plans to restore it to working order.

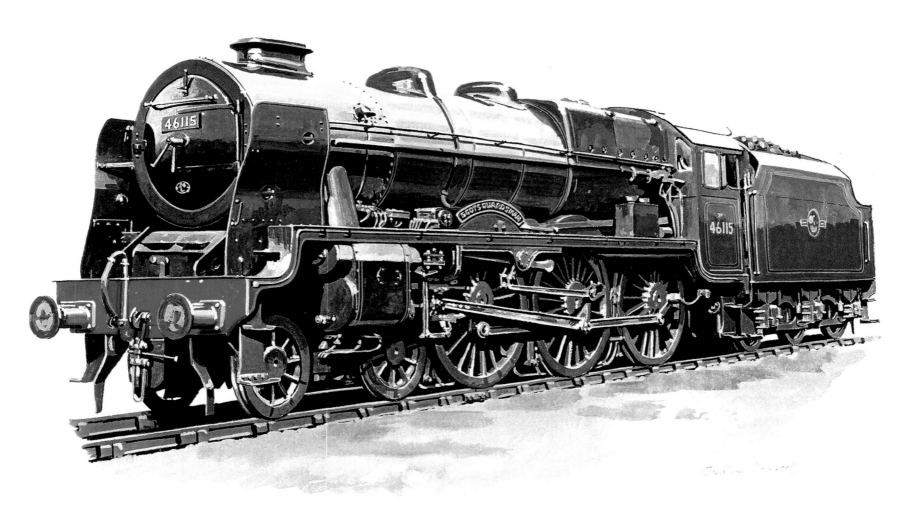

Ex-LMS Royal Scot Class 4-6-0 No. 46115 *Scots Guardsman*

I first saw this locomotive not in BR service, but in preservation at Haworth yard on the Keighley and Worth Valley Railway in about 1968. It had been bought privately, directly out of service, with the intention that it would be restored for the line. However, this was not to be, and it later moved to Dinting Railway Centre in Cheshire, where it was restored to working order and post-war LMS black livery. Strangely, it made only two excursions onto the BR main line before it became a static exhibit once more. It was then somewhat peripatetic, eventually ending up at Tyseley in Birmingham. It was not restored there, but was moved to the West Coast Railways Centre at Carnforth, where it became shrouded in secrecy, like all things to do with Mr Smith's empire. Rumours of its reappearance were rife throughout the 2000s, and when it finally made its first test run in 2008 it was in a patchwork of colours, including grey primer. Thankfully, it has been excellently restored to BR green livery, and is now a familiar sight on the main line.

County Donegal Railway Walker Railcar No. 12

Ireland is a wonderful place. North or south, it doesn't matter. I'm just sad that I discovered it thirty years too late. As a youngster I had a little book about narrow gauge railways, with lots of black-and-white pictures. I was particularly taken with the Tralee and Dingle Railway and the CDR, little thinking I would one day travel over part of the original T&D, and behind one of its original locos.

About ten years ago we visited the Ulster Folk and Transport Museum at Cultra, near Belfast. It holds a most amazing collection of Ireland's railway history, and even has a CDR railcar, steam loco and diesel tractor.

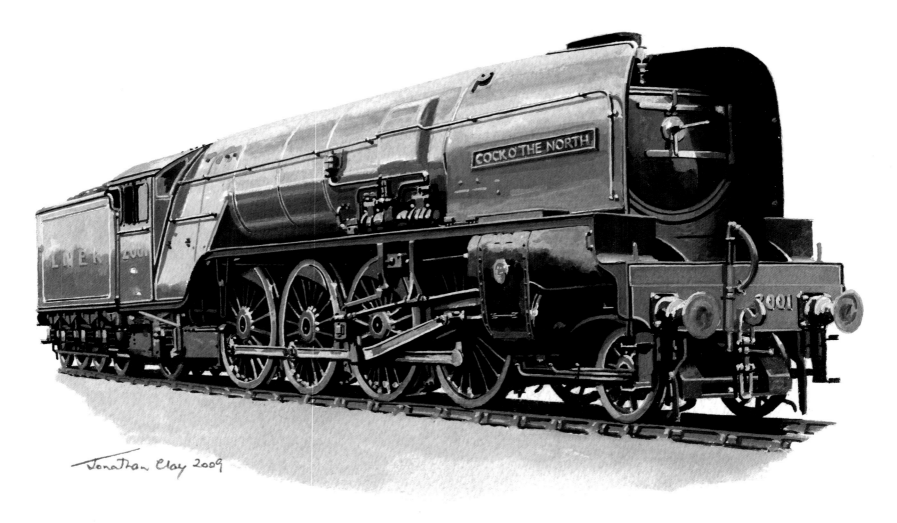

LNER Class P2 2-8-2 No. 2001 *Cock o' the North*

After the success of *Tornado*, it was discussed for a long time what would follow. The idea of a new P2 kept cropping up, and currently there are two separate projects in hand. The first would replicate No. 2001 although, as the seventh loco of the type, it would have a different name, and as we now know, royal approval. I was torn between including 2001 or its replica, 2007, for which I had been asked to provide the launch painting. With any new-build project there are naysayers, and this one seems to have attracted more than its fair share. The original locos were not regarded as successful because of their long wheelbase, and spent most of their time in Scotland, where they were less hard on the track. The last four were semi-streamlined, looking like this for the most part, with an A4 front grafted on. They were subsequently rebuilt as pacifics by Edward Thompson, which resulted in very ugly, but rather more successful locomotives.

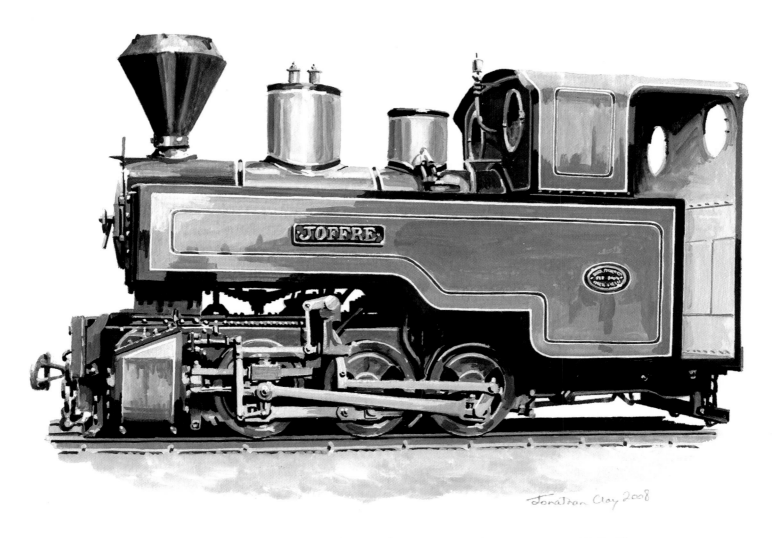

West Lancashire Light Railway Kerr, Stuart 0-6-0T *Joffre*

The Joffre locomotives were constructed in answer to a requirement of the French Government Artillery Railways, a total of seventy being built in 1915–16. They are based on a Decauville design, of which several examples survive. Some were sold off after the First World War, and five were discovered in a quarry in Pas-de-Calais in the 1970s. These were all bought by British enthusiasts and repatriated. Joffre was bought by the West Lancashire Light Railway near Southport, and has been restored to the very highest standard, returning to steam in 2012.

The remaining four have experienced differing fortunes over the years, one returning to steam on the Lynton & Barnstaple Railway (though considerably altered in appearance) and another restored for use on the Apedale Valley Light Railway. A fourth is stored at Statfold and recently, a further locomotive was discovered in Gabon.

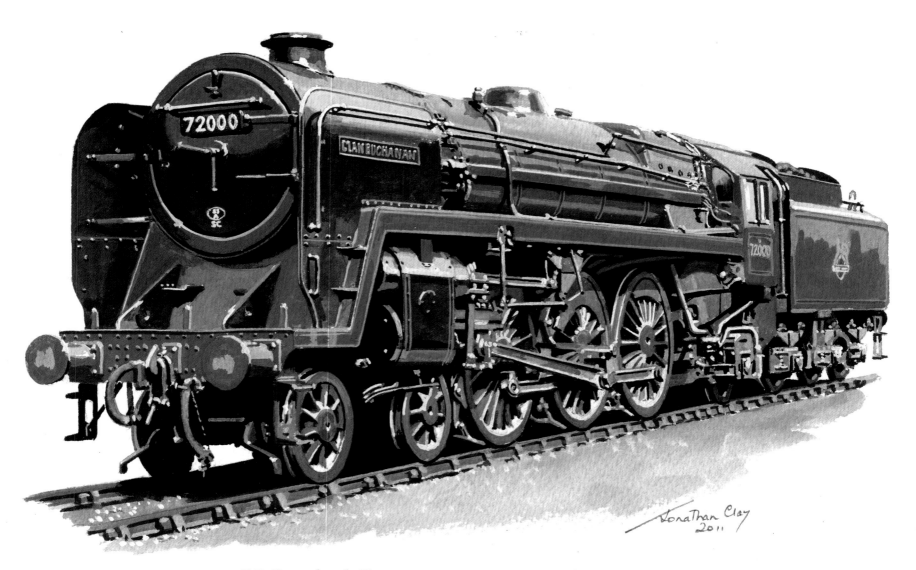

BR Standard Class 6 4-6-2 No. 72000 *Clan Buchanan*

It still baffles me why these locomotives were built. They are effectively a Britannia with a smaller boiler. I guess it must have been a weight issue, though a smaller boiler must mean less power, which is self-defeating! I remember seeing one of these on a special train, I think at Longridge, before the line closed. They seem to have spent much of their time in Scotland, which, given their names, is not surprising.

They were very well proportioned and, given my liking for the Standards, I felt obliged to include one of the two I have painted. Several years ago a group was set up to build a new one, No. 72010 *Hengist*. A set of frames was cut, but were faulty and had to be scrapped. The construction is going ahead at a private site, where quite a number of components have been made and assembled. Hopefully it won't be too long before we can see another Clan on the main line.

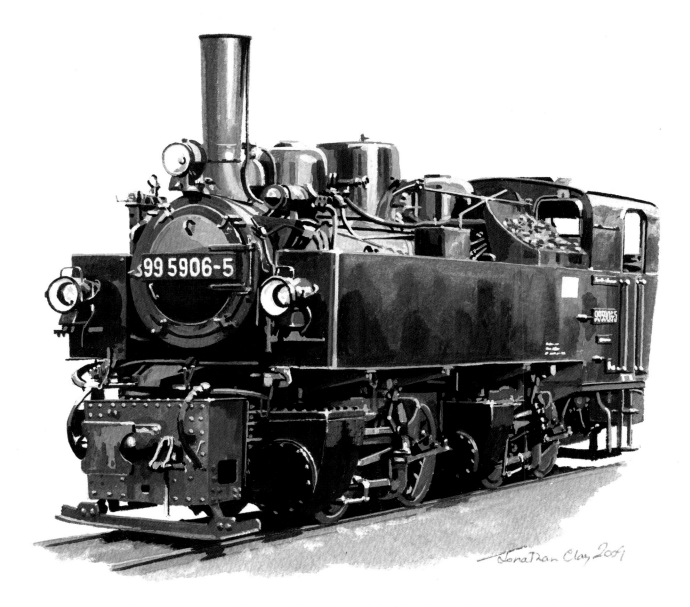

Harz Narrow Gauge Railway Mallet 0-4-4-0T No. 99 5906

It is an ambition of mine to visit the railways of the Harz Mountains in central Germany. I have painted pictures of each type of steam loco in use there, from the large 2-10-2 tanks down to the smallest Fifi 0-6-0T. Only recently have we been able to see this kind of articulated loco in action in the UK, and that is thanks to the efforts of Graham Lee and his cohorts at Statfold Barn Railway. They have so far restored two of those which have been imported. In fact, they are only the second and third Mallets in this country, as most other articulated locos have been Garratts or Fairlies.

The Harz has several of this type, one of which is painted in its original green livery. They seem to be used for special occasions, the railway relying on the newer and larger tank locos for service trains.

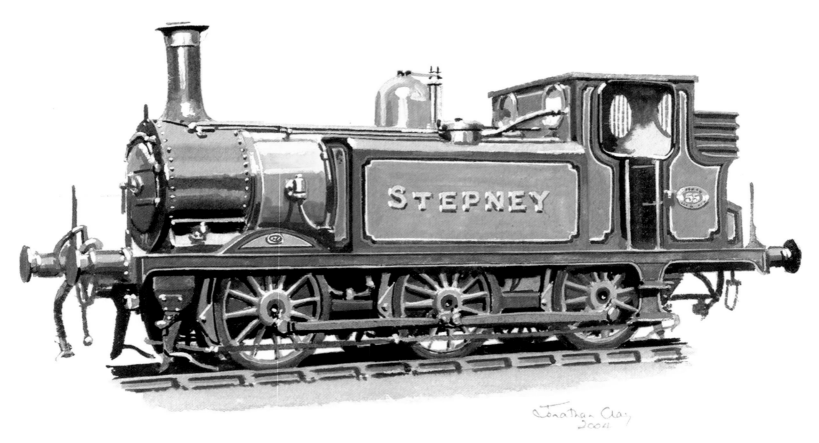

London Brighton and South Coast Railway Terrier 0-6-0T No. 55 *Stepney*

The diminutive size of the Terriers made them ideal for use in places like Hayling Island, the Isle of Wight, and on some of the Colonel Stephens lines, but only recently have I seen one at close hand. In the cab of *Martello* at Shildon, I was amazed that the firehole door was below the level of the footplate. It must be very awkward to fire one, since you have to be virtually on your knees to do so.

Stepney has been made famous by the Rev. Awdry's railway books, which reminds me of an amusing occurrence. Copyright is a sensitive subject with us artists and, so it seems, with publishers. A delegation from Britt Allcroft visited the Bluebell Railway and complained that having a locomotive called *Stepney* was an infringement of their copyright. When it was pointed out that the loco was well over 100 years old, and had been called *Stepney* from new, said delegation left with their tails between their legs.

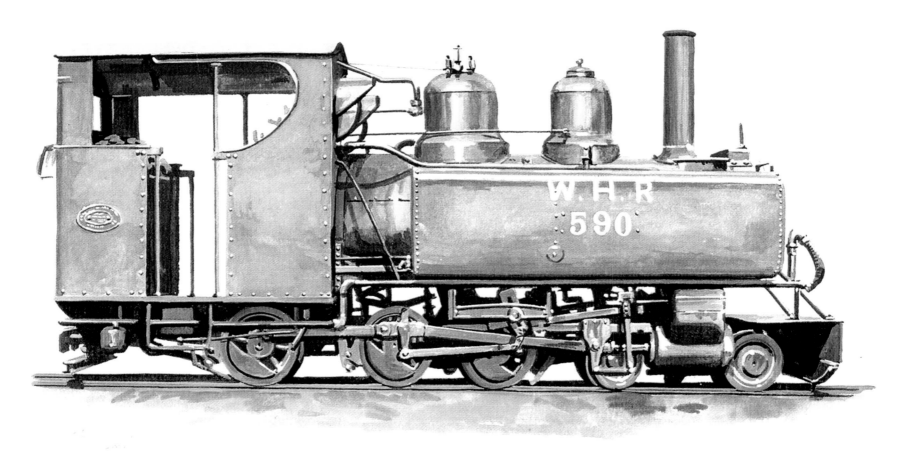

Welsh Highland Railway Baldwin 4-6-0T No. 590

When the WHR was formed in 1923 from the remnants of the old North Wales Narrow Gauge Railway, it was somewhat short of motive power, even though it was physically connected to the Ffestiniog, and occasionally used its engines. Fortunately the ending of the First World War had released a large number of 2ft gauge locomotives from War Department service. Several British lines ended up using American Baldwin tank locomotives, including those at Ashover and Snailbeach, along with a few industrial lines. No. 590, built in 1917, was sold to the Welsh Highland Railway in 1923, but it was a rough rider and so ended up being confined to slower, freight trains. By 1942 it was in such poor condition that it was scrapped. Two pieces have survived: one of the original side tanks (which was being used for oil storage) and a builder's plate, which is at the NRM.

In the 1980s two Baldwin 4-6-0T were imported from India, and one – 794, owned by the Imperial War Museum – is being restored by the Welsh Highland Heritage Railway to represent this type of locomotive, so a replica of No. 590 will one day be in running order.

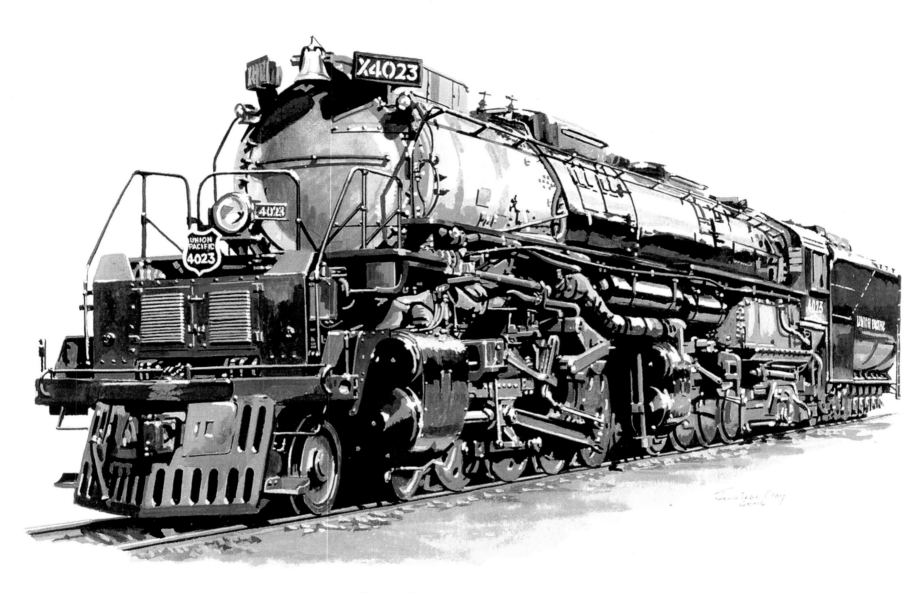

Union Pacific Railroad Big Boy 4-8-8-4 No. 4023

The Union Pacific Railroad Big Boys were the biggest steam locomotives in the world. Twenty-five were built for the UP between 1941 and 1944, and they were, effectively, a slightly larger version of the Challengers, although the 4000 class was specifically designed for freight haulage. This was due to the heavy loads to be pulled and the steep gradients between Green River, Wyoming and Utah. They were the only locos within the USA with a 4-8-8-4 wheel arrangement. Eight have survived, of which seven are on static display in the USA; the eighth (No. 4014) has been repurchased by the UP and is being restored to working order.

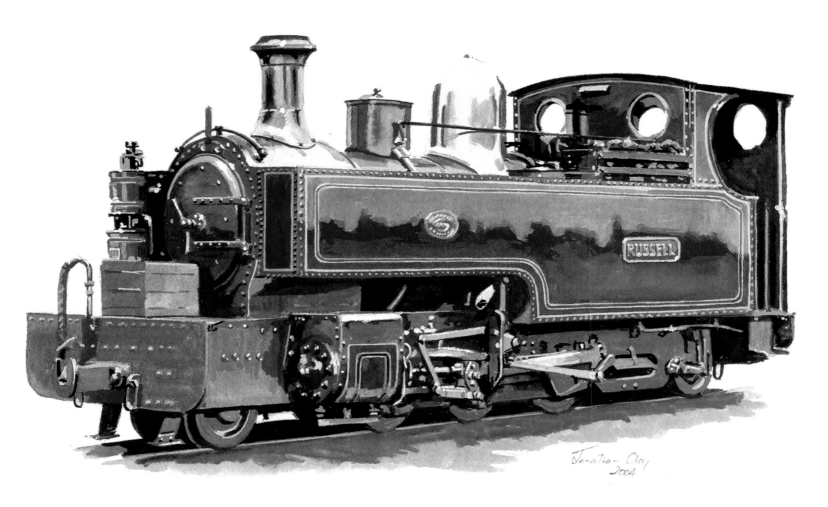

Welsh Highland Railway Hunslet 2-6-2T *Russell*

I first saw *Russell* in 1958, outside the narrow gauge railway museum at the Talyllyn Railway's Tywyn Wharf station. It is the sole surviving original locomotive from the original North Wales Narrow Gauge Railway. The Welsh Highland Railway was closed in 1937 and, instead of being scrapped, *Russell* was left in the shed until requisitioned by the military in 1941, after which it was sold into industry and by the 1950s ended up at Fayle's Tramway in Dorset. It was then bought for preservation and moved to Tywyn. Over the next twenty years or so it led a nomadic existence, as it was slowly restored by the nascent WHR. I saw it again at Carnforth in the early 1970s, and produced some prints to aid its restoration, thanks to the kind offices of that late, great gentleman John Keylock. Its restoration, started by the railway at Gelert's Farm, was completed by Alan Keef Ltd., in Herefordshire, and the locomotive was launched back into service in August 2014.

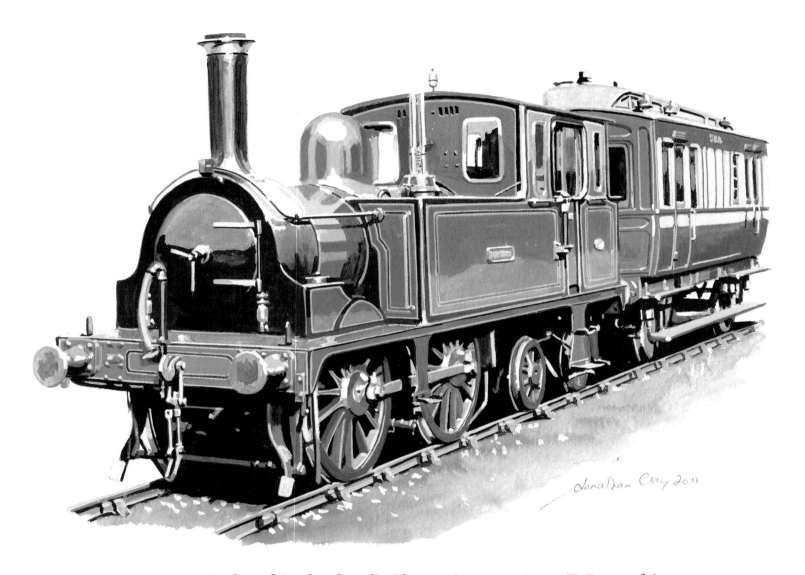

Duke of Sutherland's Sharp, Stewart 0-4-4T *Dunrobin*

Dunrobin was built in 1895 for the Duke of Sutherland, who used it to haul his private train at Dunrobin Castle in Scotland until the 1920s. It remained in Scotland until 1950, when it was sold to Captain Jack Howey and placed on display at New Romney, on the Romney, Hythe and Dymchurch Railway, where, as a youngster of about seven, I saw it. Though kept in a shed, it was occasionally brought out and run up and down a short length of track. When Captain Howey died in 1963 the locomotive and its four-wheel saloon (No. 58a, built in 1908) were put up for sale and shipped to Canada, where they operated for forty years, giving rides to tourists at the Fort Steele historic park. They were purchased in 2010 by the Living Museum of the North at Beamish, County Durham, repatriated to the UK, and are both currently under restoration, the locomotive at the Severn Valley Railway and the carriage at Beamish.

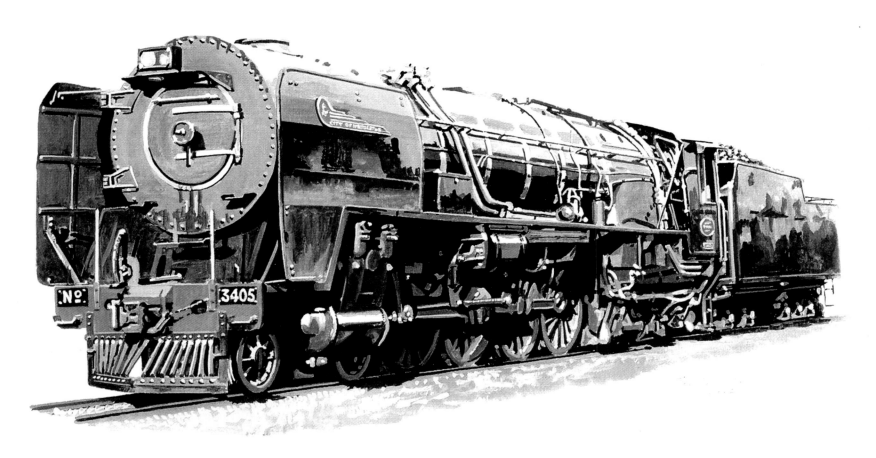

South African Railways Class 25NC 4-8-4 No. 3405 *City of Newcastle*

This picture was a commission from an expatriate South African, and I was fortunate to be able to use photographs of the preserved example at Quainton Road in Buckinghamshire in its composition. There are several South African 'Cape Gauge' (3ft 6in) locomotives in the UK. Considering the narrowness of the gauge, the size of some has to be seen to be believed. I once saw a Black Five next to a GL Garratt in the Museum of Science and Industry in Manchester, and the Garratt was much bigger.

 Some Class 25 locos were originally designed as condensing locos, having a massive tender in which to condense exhaust steam during long journeys in arid conditions. Many were later rebuilt as non-condensing (hence 'NC'), but retained the very long tenders, with semi-circular water tanks fitted.

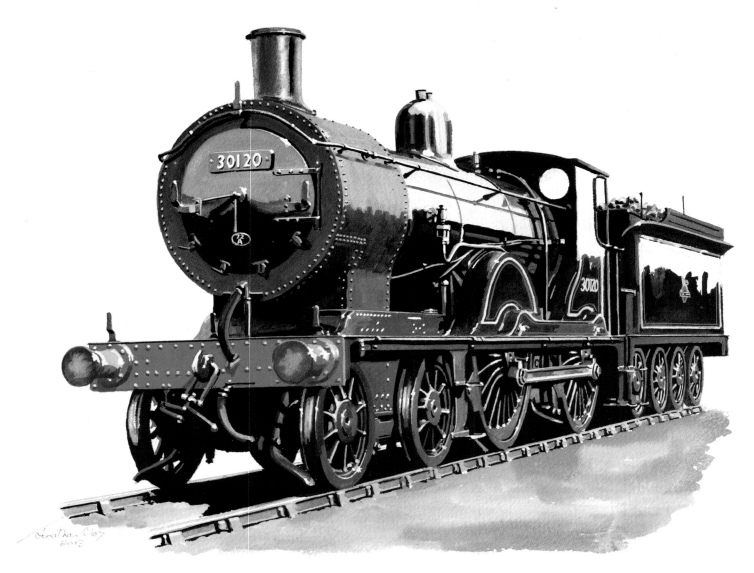

Ex-LSWR Class T9 4-4-0 No. 30120

Sixty-six of these Drummond-designed locomotives were built for the London and South Western Railway between 1899 and 1901. It demonstrates the art of locomotive development after that date, since they were considered the most powerful locomotives on the LSWR at the time. Many of them lasted until BR days, and 30120 was claimed for preservation in the national collection. Like several of the preserved Scottish locos previously mentioned, it was restored to working order in 1961 and used to haul enthusiasts' tours, although painted in an inaccurate LSWR light green livery. After its second withdrawal from service it was moved about between several locations before ending up at the Mid Hants Railway, where it was overhauled again and painted in SR, and later BR, livery. In the late 2000s it was overhauled yet again. Now owned by the NRM, it is on long term loan to the Bodmin and Wenford Railway, from where it pays occasional visits to other preserved lines.

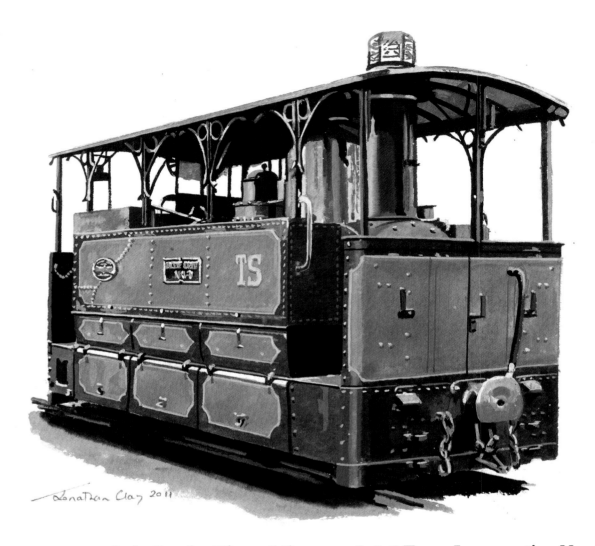

Tramway de la Sarthe Blanc-Misseron 0-6-0 Tram Locomotive No. 60

Some time after we bought our French home I discovered there had once been a metre gauge roadside tramway from Lens to Frévent, which ran within a short distance of our house. The *Tortillard*, as it was colloquially called, stopped running in 1948, though quite a few of its structures survive to this day,

I have attended several enthusiasts' events in France, notably at Froissy, and on the Baie de Somme lines. At Froissy I was introduced to several members of an organisation called MTVS, which has a base at Valmandois, near Paris, and amongst its collection is this tram locomotive. The main difference between No. 60 and the locos found further north was that the latter had covered-in ends with windows. For more information about these railways, you can do no better than refer to the books by my friends Martin and Joan Farebrother, who have done considerable research in this area.

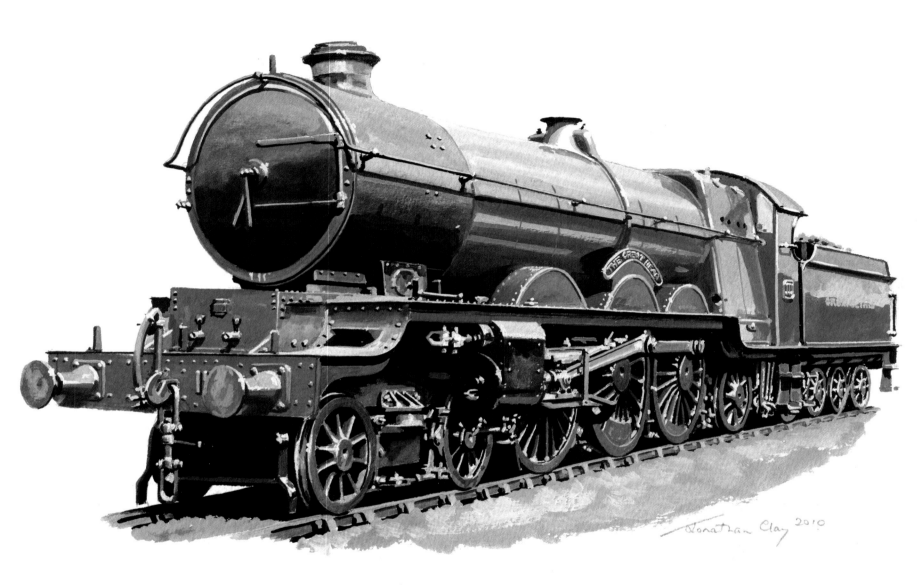

Great Western Railway 4-6-2 No. 111 *The Great Bear*

The Great Bear was the first 4-6-2 to run in Britain, and the only one built by the GWR. It was constructed in 1908, to provide the company with the biggest loco in the country, and was largely a publicity exercise. In fact, it was a bit of a failure, being very heavy and shy to steam, so it could only be used on certain lines.

It was rebuilt in 1924 as a 4-6-0, and transformed from a Pacific to a Castle class, retaining its number, but becoming *Viscount Churchill* in the process. It is said that G.J. Churchward was upset at this conversion, as Nigel Gresley had just stolen a march on the GWR by building the first LNER pacific. Churchward is alleged to have wanted to sell No. 111 to the LNER. Unfortunately it was scrapped in 1953 and all we have left are models, photographs and the occasional painting.

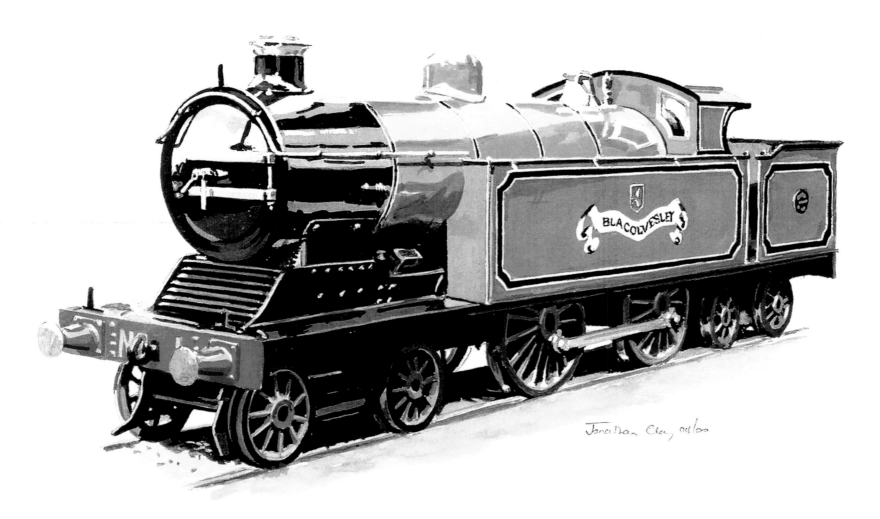

Bassett-Lowke 4-4-4T Petrol Locomotive *Blacolvesley*

In 1903 a 15" gauge railway was built for Charles Bartholomew of Blakesley Hall in Northamptonshire. It connected the hall with the local railway station, and since Mr Bartholomew, a civil engineer, was fascinated by all things mechanical, he was a pioneer in the introduction of internal combustion powered locomotives. The railway initially employed two Cagney 4-4-0 USA steam locos, and the first internal combustion engine, named *Petrolea*, was supplemented in 1909 by *Blacolvesley*. It was built by Bassett-Lowke and, as can be seen, bore a striking similarity to that firm's Little Giant locomotives, although it was powered by a petrol engine. It became the mainstay of the estate railway until it closed in the mid-1940s.

It then went through the hands of several owners until it was acquired by Dr Bob Tebb, who has restored it superbly and to as near original condition as possible, even though its original NAG engine had been replaced by an Austin 8hp one. It is now the oldest surviving internal combustion railway loco in the world, and is kept at Ravenglass on the Ravenglass and Eskdale Railway. Dr Tebb published his definitive history of the Blakesley Miniature Railway in 2009.

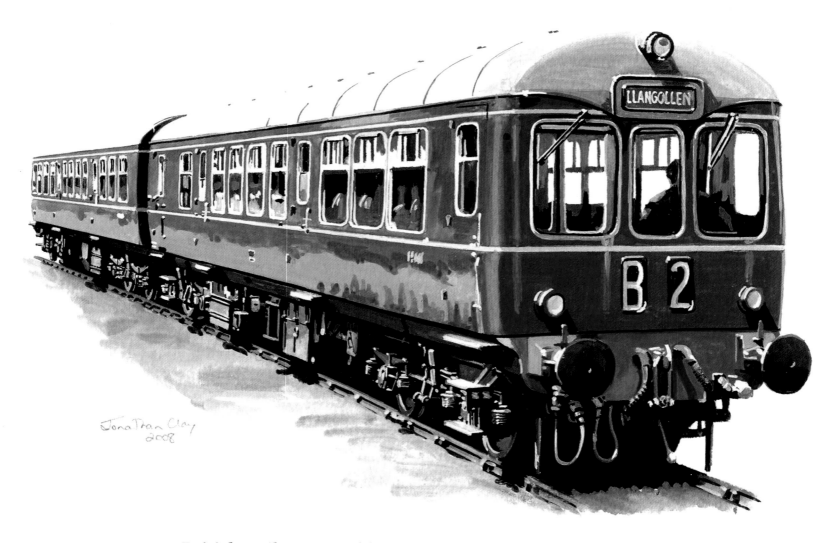

British Railways Wickham Class 109 Diesel Multiple Unit

The DMUs were developed in both the UK and Germany in the 1930s; however, they did not come to prominence until the 1950s and 60s, to replace lightly-loaded steam trains, and my first experience of them was travelling from Blackburn to Manchester for college every day. Various manufacturers produced their own versions, and some of the standard types were those designed and built by Wickham of Ware (better known for its inspection trolleys), whilst any which were non-standard didn't last very long. Those in East Lancashire tended to be the better-known BRCW and Metro-Cammell units. Of the five units built, two ended up being sold to Trinidad and Tobago, and may still be there. The one pictured survived into preservation in Britain and can now be found on the Llangollen Railway. Having been on board, I can say it is a very impressive piece of restoration.

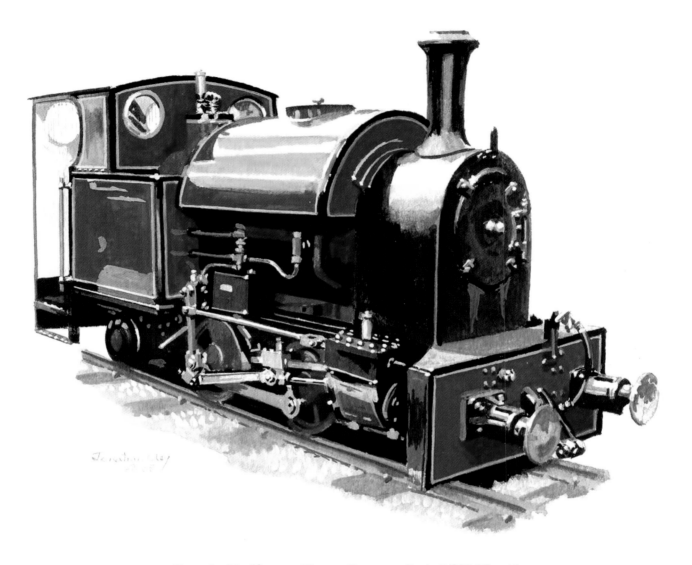

Corris Railway Kerr, Stuart 0-4-2ST No. 7

This was one of the first new-build projects I became involved with for the Corris Railway Society. The line itself, from Machynlleth to Aberllefenni in the Corris Valley in Mid Wales, was closed under the auspices of British Railways in 1948, after severe floods had damaged the bridge over the Afon Dyfi, which was said to be not worth repairing. The remaining two locomotives remained sheeted over in Machylleth yard until purchased by the Tallyllyn Railway, where they remain. A group of volunteers established a base at Maespoeth in 1966 and has succeeded in reopening part of the railway, though at first it had to rely on diesel power. It was decided that what was really needed was a steam loco, so one was built to represent the Kerr, Stuart Tattoo type as typified by the original No. 4. The loco was completed in 2005 and has run successfully ever since. It has even visited the Tallyllyn Railway to meet up with its counterpart. Now the society is busy constructing a second loco – a Hughes/Falcon saddletank, similar to No. 3.

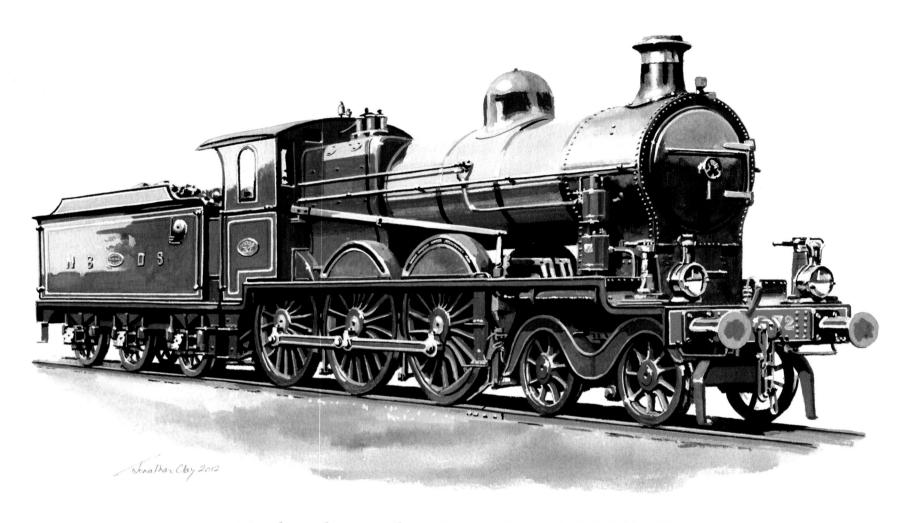

North Brabant Railway Beyer, Peacock 4-6-0 No. 32

Until recently I knew little about Dutch railways. However, I was fortunate to meet John Simons, a gentleman who is involved in several preservation projects in the Netherlands, including the continuation of the Breda works of Backer and Rueb, who built a number of steam tram locomotives in the late 1890s and early 1900s. One or two of these survive in museums.

It is not just the British who are building new locos; John is leading a project to recreate the locomotive above. The originals were built by Beyer, Peacock in Manchester and known as 'Dutch Imminghams'. The Dutch are working closely with several of the UK new build groups. Hopefully, this beautiful machine will be running in 2018, and there is a suggestion that it could visit the UK.

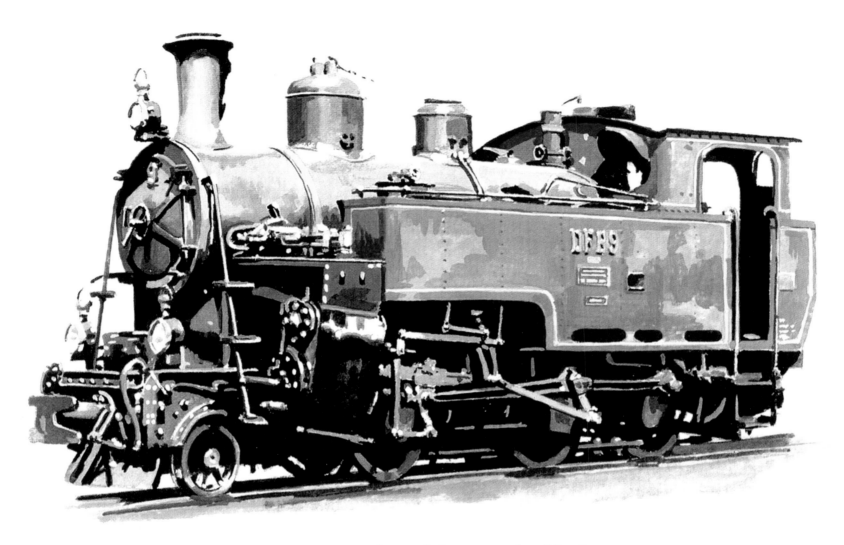

DFB 2-6-0 Rack Tank Locomotive No. 9

The Dampfbahn Furka-Bergstrecke in Switzerland is a heritage rack railway run by enthusiasts. It was originally operated by the Oberalp-Bahn, but heavy snowfall each winter obliged the line to be closed for the season and it was even necessary to remove one of the bridges to prevent damage. The line was abandoned after the construction of the Furka Tunnel and its locomotives were sold to Vietnam.

I first learnt all this when I was commissioned to paint a picture of two of the locomotives. Whilst working in Vietnam my client came across one of them, abandoned in the jungle, and I painted that one first. Some years later, in Switzerland, he spotted a similar engine, but in restored condition, only to learn that it was the same one he had seen in Vietnam!

The heritage rack railway organisation is restoring two more Swiss locos which were brought back from Vietnam, although these ones had originally been built for service in South East Asia.

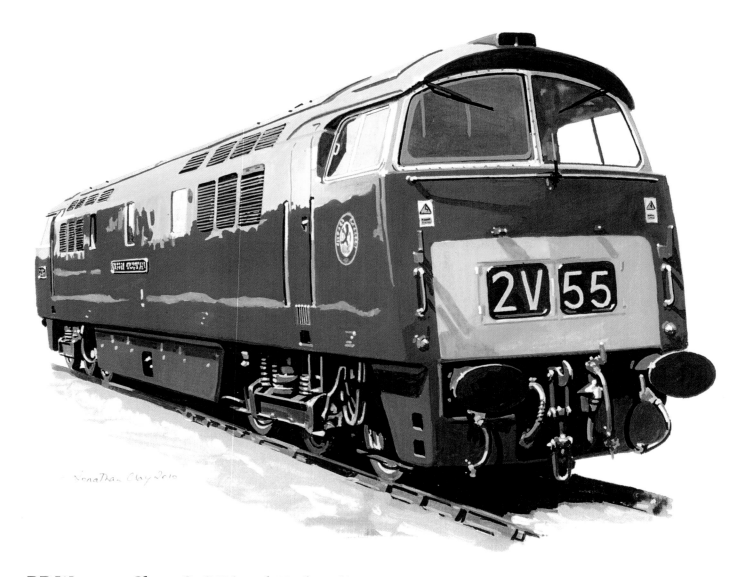

BR Western Class C-C Diesel Hydraulic Locomotive No. D1015 *Western Champion*

Like the Great Western Railway before it, the Western Region of BR liked to do things its own way. When modernisation began in the 1950s, most of the prototype diesel classes were diesel-electric. That is, the diesel engine was used to power a generator which then drove electric motors coupled to various axles. Not so the WR; its locos employed diesel-hydraulic propulsion, based on a concept pioneered by German railways, which meant the diesel engine drove a fluid flywheel transmission. The Westerns employed two engines and transmissions, and were the most powerful of the type to be built. Six have been preserved, and are popular attractions on preserved railways. D1015, however, is registered for main line use, and although it is usually used for enthusiasts' tours, it has also powered revenue-earning trains, both passenger and goods.

Harrogate Gasworks Peckett 0-6-0ST

This is another loco that I first saw on the Ffestiniog Railway in the 1960s. In the early years of preservation the FR was on the lookout for suitable motive power to run on its restored line, and the Harrogate Peckett was one which it purchased with a view to restoring it for use. This never happened, however, and it was kept in the yard at Glan-y-Mor, sometimes under a tarpaulin. Further thought was given to using it in the 1970s, but this also foundered, after an exploratory towed trip up the line to check clearances.

It was then sold to the Bredgar and Wormshill Light Railway in Kent, where it was restored to working order, in the process of which it gained a taller cab and chimney – the originals, designed for Harrogate Gasworks tunnel, proving rather restrictive for tall drivers! It has subsequently found its way to the Statfold Barn Railway, and has recently made special appearances at the Ffestiniog and Welsh Highland Railways.

Manchester Ship Canal Co. Hudswell Clarke Diesel Locomotive No. 4002
Arundel Castle

Arundel Castle was one of two locomotives built in 1958 by Hudswell Clarke for the Manchester Ship Canal Railways, both of which survive. Hudswell Clarke was a traditional supplier of steam locomotives to the MSC, so it is not surprising that its products were chosen to replace steam. The pair were diesel-electric, though the subsequent smaller types of Hudswell diesel locos employed mechanical transmissions.

By the early 1980s traffic on the canal had dropped alarmingly and the railway fell into disuse, although the associated system at Trafford Park Industrial Estate seems to be extant, although largely disused. *Arundel* Castle is now in working condition at the East Lancashire Railway, whilst its sister locomotive No. 4001 *Alnwick Castle* lays unused and rusting outside Winfield's outdoor pursuits emporium near Haslingden.

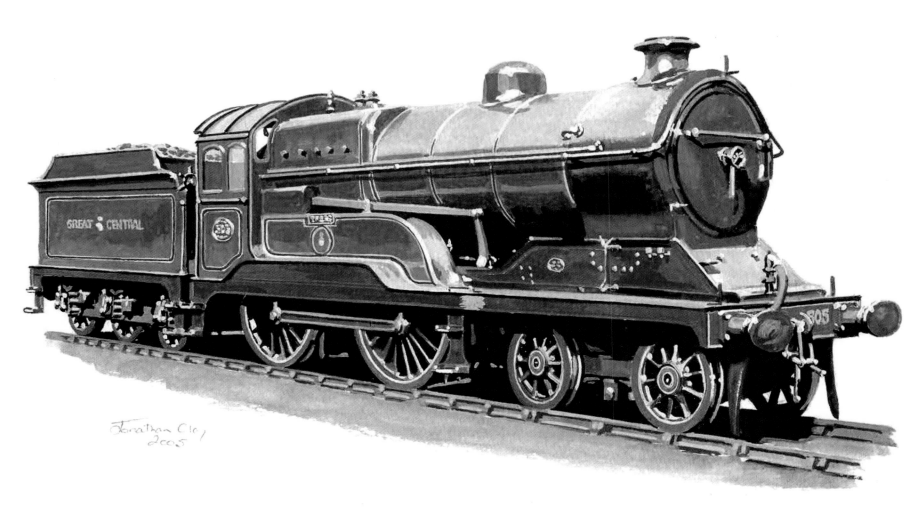

Great Central Railway Director 4-4-0 No. 505 *Ypres*

This was a commission for one of two brothers, each of whom are building 10 ¹/₄" gauge versions of Great Central locomotives. When I worked for a number of years in the Manchester district of Gorton, where a lot of the Great Central locos were built, I occasionally travelled to and from the adjacent station at Ashburys, so I guess I have travelled on part of the GCR. (As an aside, I worked just around the corner from the Crossley engine factory, which was still in business at the time.) The GCR is the great lost route of Britain, running as it did from the capital to Manchester via the East Midlands. Happily, the preserved Great Central Railway occupies part of the route around Loughborough, and the one surviving Director, No. 506 *Butler-Henderson*, spent some time there, and was even returned to steam. Now it resides at Barrow Hill Roundhouse near Chesterfield, and is part of the national collection. *Ypres*, however, was scrapped in 1953.

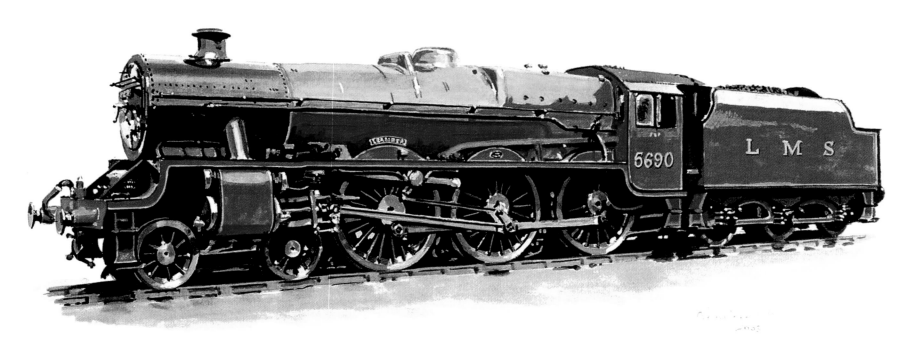

LMS Jubilee Class 5XP 4-6-0 No. 5690 *Leander*

Leander was built in 1936 and named after a warship. After withdrawal from service in 1964 it was one of two Jubilees which found its way to Barry scrapyard in South Wales. After being rescued and returned to steam in the 1970s by Brian Oliver, it spent several years at the much-missed steam centre at Dinting, near Glossop in Derbyshire, along with sister locomotive *Bahamas*. It was later sold to Dr Peter Beet and stationed for a time at Carnforth, along with his other locomotives. It has had various homes since then, spending periods out of use between overhauls.

After the death of Dr Beet, *Leander* has remained in the family and is currently back at Carnforth. Its current heavy overhaul by West Coast Railways has just been completed and it is now painted in British Railways lined black livery. Another Jubilee, No. 45699 *Galatea*, is also based at Carnforth and, like *Leander*, is registered for main line use. One more Jubilee survives: No. 45593 *Kolhapur* is awaiting overhaul at Tysleley in Birmingham.

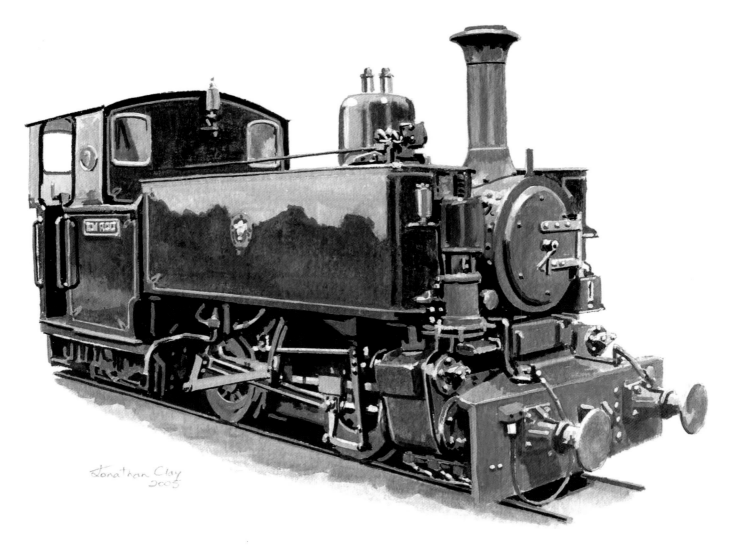

Talyllyn Railway Barclay 0-4-2T No. 7 *Tom Rolt*

It is fitting that this locomotive bears the name of one of the greats of railway preservation. Tom Rolt was one of a handful of enthusiasts who got together in 1950 and saved the Talyllyn Railway, which was threatened with closure. His book *Railway Adventure* is a fascinating chronicle of the efforts to save the railway and is a must-read for any railway enthusiast.

The Talyllyn relied for most of its existence on just two locomotives, and it soon became obvious that, as a tourist railway, the line would need more motive power. This was obtained from a variety of sources including the closed Corris Railway. When the opportunity arose to buy a locomotive from the Irish Turf Board, this locomotive was chosen and taken to Tywyn. However, it was 3ft gauge and needed complete reconstruction, which involved regauging to 2ft 3" and fitting side tanks and a new cab. For many years it was supposed to be called *Irish Pete*, as a nod to its origins, but common sense prevailed in the end. Two sister locos, both in original condition, are preserved in Ireland.

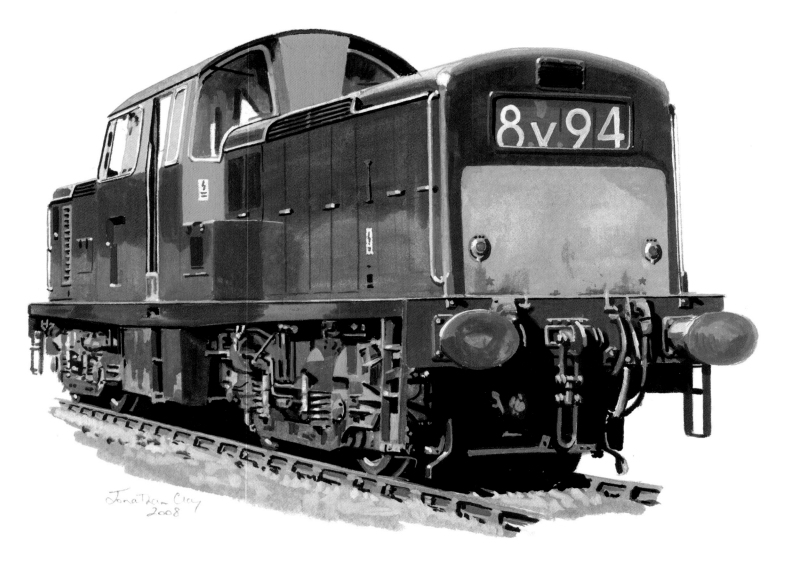

British Railways Clayton Type 1 (Class 17) Diesel Locomotive

Although the Claytons weren't the shortest lived diesel locomotives on British Railways, they came pretty close. They were ordered for a requirement that soon disappeared. Between 1962 and 1965, 117 were built by the Clayton Equipment Company, and had all gone by 1971. They were built as Type 1 locomotives, and the centre cab was intended to cure the visibility problems encountered with other locomotives of the same power rating, notably the Class 20s.

Fortunately one has survived, two having been sent to the Derby Research Centre. The loco pictured was sold into industry, firstly to Hemelite at Hemel Hempstead and later to Ribblesdale Cement at Clitheroe, where I first saw it, painted in the company's white-and-orange livery. It is now maintained in working order and BR livery at the Chinnor and Princes Risborough Railway in Oxfordshire.

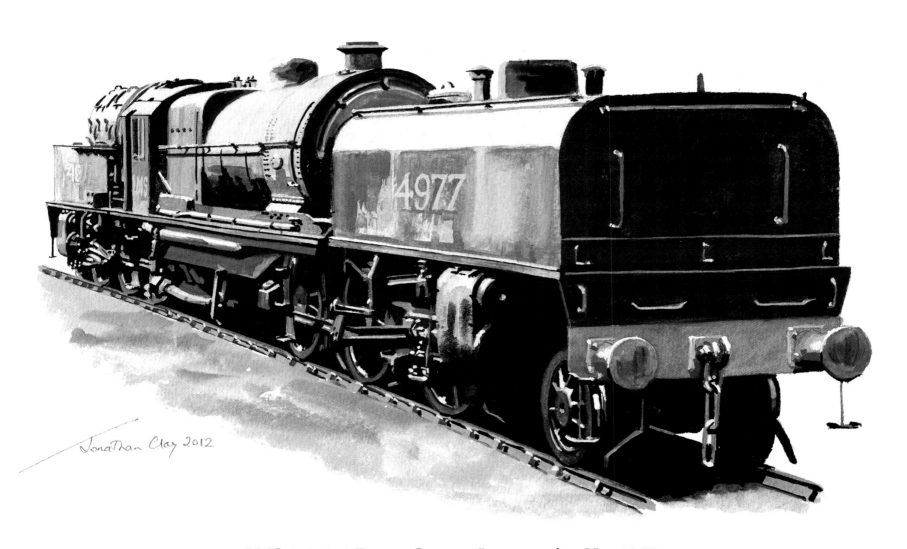

LMS 2-6-6-2 Beyer-Garratt Locomotive No. 4977

In the early 1960s, we of the Tri-Ang and Hornby Dublo generation were quite excited when Kitmaster kits were announced. They weren't motorised, but the model railway press was full of ideas of how to do it. When I got my kit of the LMS Garratt I spent quite a long time working out how to do it. The easiest way seemed to be to use two Tri-Ang 2-6-2 chassis with the back end cut off. Sadly, I could only afford one, so the project foundered, and I don't know what happened to the part-built loco.

The real Garratts were an attempt by the LMS to avoid double-heading by smaller locos, this being a legacy of the Midland Railways 'small loco' policy. I never got to see one of these in action, but they must have been impressive. They were all gone by the end of the 1950s, and only five standard gauge Garratts exists in preservation, one in the UK and four in Australia. Fortunately, we can still see Garratts in action on the Welsh Highland Railway.

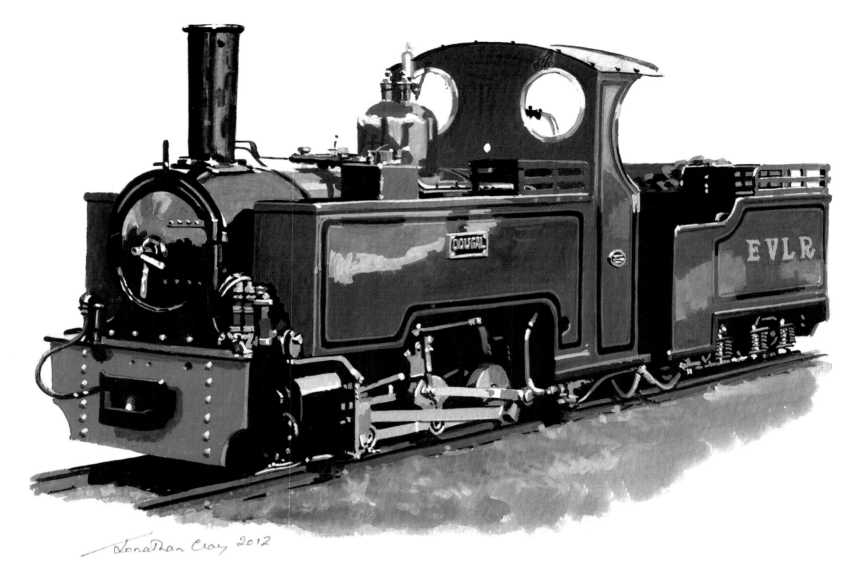

Jonathan Clay 2012

Evesham Vale Light Railway Severn-Lamb 0-6-2T Locomotive *Dougal*

Some locomotives blur the distinction between miniature and narrow gauge, and this is one. Prior to the 1970s miniature railways were content to employ scaled-down models of full-size locomotives. However, because human beings couldn't be scaled down in the same way, designs were put forward for what are essentially narrow-gauge outline locos. The best examples of this are the Trevor Guest locos *Sian* and *Katie* of the Fairbourne Railway, built to the designs of E.W. Twining.

Dougal was built in 1970 and is one of several similar locomotives built by Severn Lamb for pleasure railways. It ran at Longleat in various liveries until 2004, when it was bought by Jim and Helen Shackell for use on the Evesham Vale Light Railway, where it was fitted with a new and larger boiler and repainted as above.

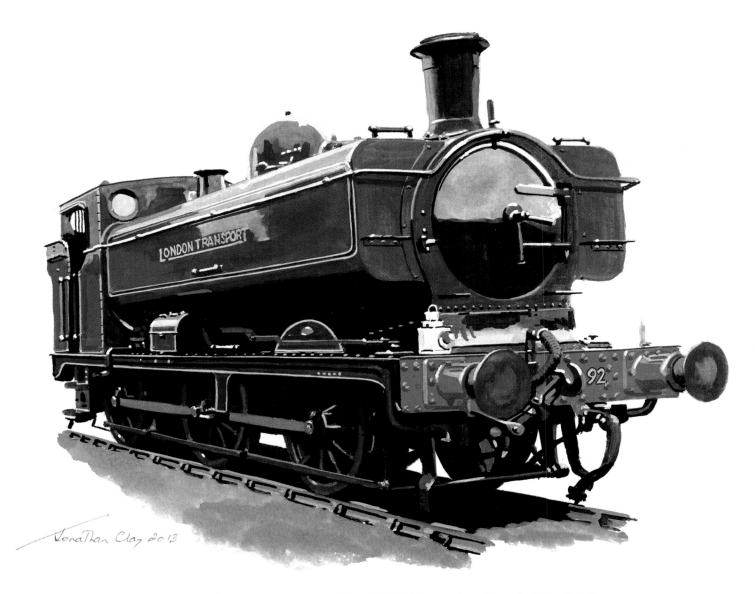

London Transport Ex-GWR Pannier Tank No. L92

There are a few locomotives in my collection that I have painted more than once: for instance, I have produced five pictures of *Tornado*. But other examples aren't so obvious. No. 5786 was one of the ex-GWR pannier tanks purchased by LT in the 1950s and 1960s to replace older Metropolitan and District Railway locomotives. I first depicted the locomotive in 2010; however, for London Underground's 150th anniversary in 2013, a number of pannier tanks were repainted in their London Transport guise. Afterwards, No. 5786 reverted to its 1960s livery with the LT number L92 and I was asked to paint a second picture for the owner, the Worcester Locomotive Society, which uses L92 on the South Devon Railway.

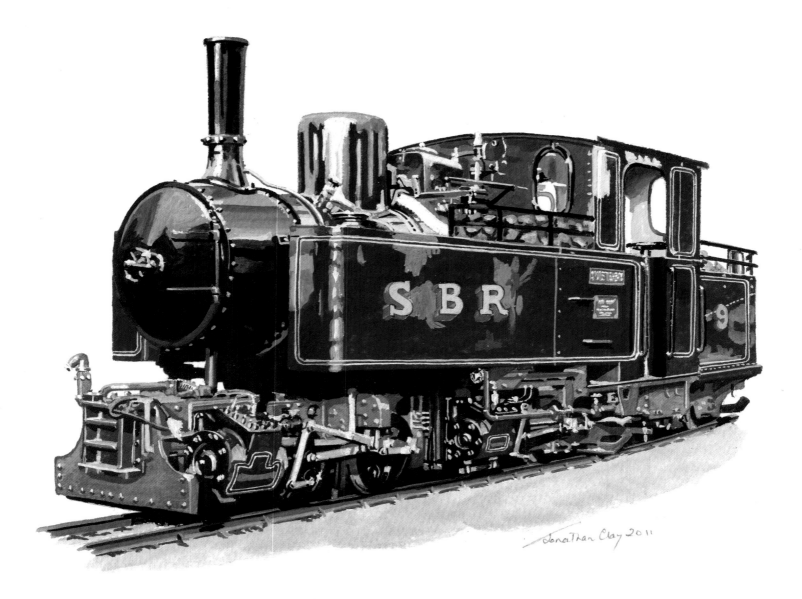

Statfold Barn Railway Jatibarang Brebes Sugar Mill Mallet 0-4-4-0T No. 9

Graham Lee is a very enterprising man. Although his first love is road steam, he seems to take every opportunity to scour the globe for locomotives to restore. At Statfold Barn, near Tamworth in Staffordshire, an excellent engineering works has been established, noted for its quality and timeliness of its restorations.

This articulated loco was built by the German firm of Arn. Jung in 1930 and was one of several brought to Statfold Barn from Indonesia in the mid-2000s. It was returned to working order in 2011, since when it appears in steam at open days on the ever-expanding Statfold Barn Railway and has also run on the Welsh Highland Railway.

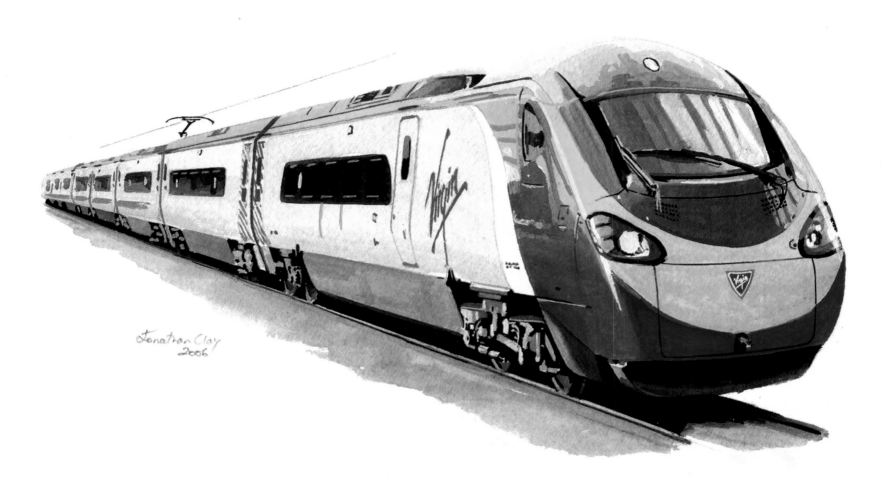

Virgin Trains Pendolino Electric Multiple Unit

This is probably the most modern item of railway rolling stock that I've painted. Officially known as the Class 390, these electric multiple units have become well established as the principal type of express train between London and Scotland on the West Coast main line.

They were built between 2001 and 2012, and employ Fiat Ferrovias tilting train technology, which enables the train to tilt as it rounds curving track, which effectively makes it faster over a given journey. It is not a new technology, since Italian Railways have been using such trains for some time, and prototypes of the British Advanced Passenger Train (gas turbine in the 1970s; electric in the 1980s) also used this system. Even though Pendolinos are capable of travelling at 140mph, signalling limitations on the WCML have meant that they are restricted to 125mph.

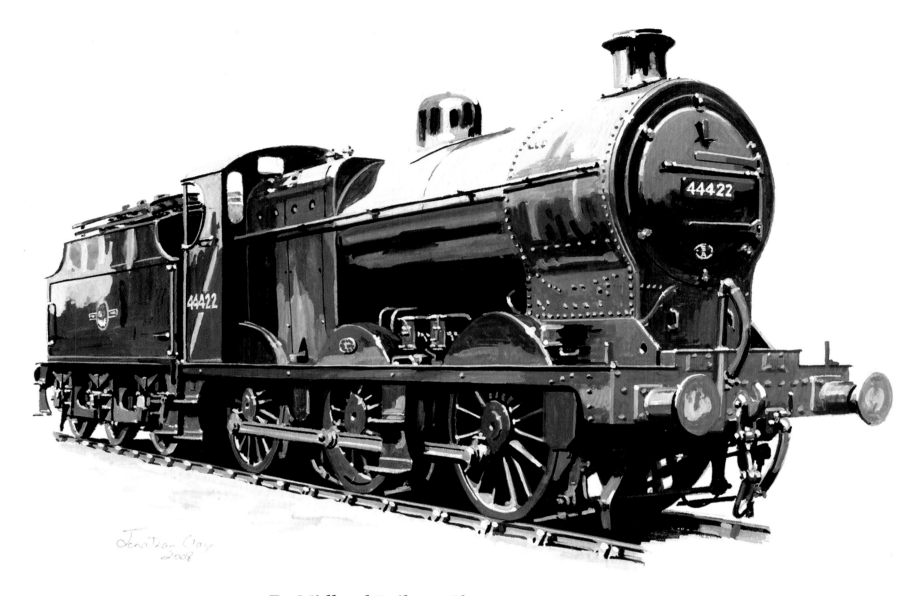

Ex-Midland Railway Class 4F 0-6-0 No. 44422

This locomotive is another from my childhood. The class was very familiar around the north-west of England in the 1950s and 1960s, and they were generally used for the lighter goods trains, although they could occasionally be found pulling passenger trains. No. 44422 was built by the LMS in 1924 to a design created by Sir Henry Fowler of the Midland Railway in 1911. They were so successful that the LMS perpetuated the design and over 700 were built, including five for the Somerset and Dorset Railway.

Four have survived: one from the MR and three ex-LMS. No. 43924 was the first to escape from Barry scrapyard; 44027 is part of the national collection; 44123 is under restoration; and 44422 has been restored to steam and had travelled extensively over the UK's preserved railways.

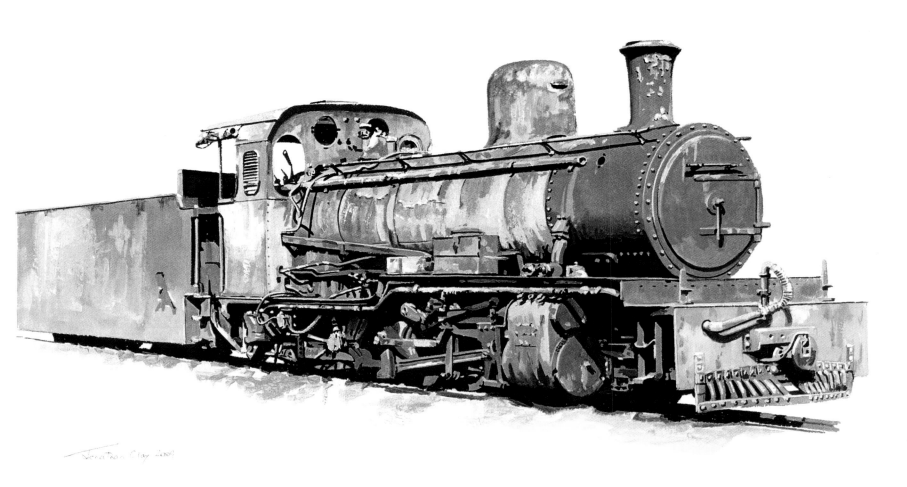

Ex-South African Railways Class NG15 2-8-2

When I was young I could never understand why railway locomotives were so dirty. Surely it wouldn't have been too difficult to keep them clean; after all, isn't that what cleaners were for? I have an aversion to dirt and dereliction, and make a point of painting my locomotives as clean and shiny as possible. Occasionally, though, a customer will insist upon the shabby. This painting formed half of a commission for Dave Kent, one of the leading lights of the Welsh Highland Railway restoration team, who wanted before-and-after depictions of the loco.

The NG15s were South African Railways principal type of 2ft gauge tender locomotive, and most have survived to this day, although they are spread over several continents. The WHR has two, one of which (No. 134) is currently being fast-tracked for restoration.

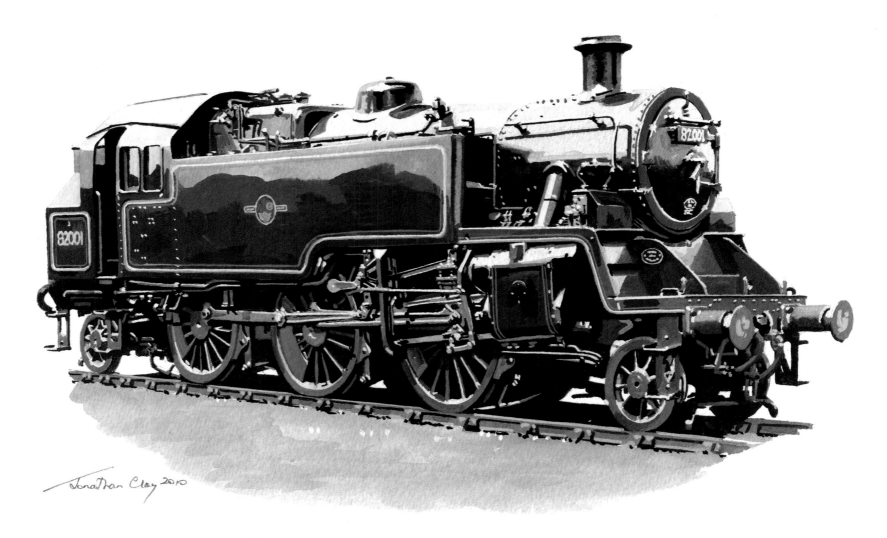

British Railways Standard Class 3MT 2-6-2T No. 82001

The Standard Class 3 tank was immortalised by Tri-Ang in the 1950s, and was one of my favourite locos on my model railway. Even though the real ones were quite modern, none survived into preservation. The last one I saw was an ex-Western Region green example pulling local passenger trains around Preston, Leyland and Chorley.

A lack of survivors does not daunt some people, and a worthy group is currently building a brand new example (No. 82045) at Bridgnorth on the Severn Valley Railway. I have produced two pictures for them, in both green and black liveries, which are used for their publicity and fundraising activities. I have changed my copy to 82001, the pioneer loco, to avoid any confusion. Another group has recently been set up to construct an example of the related 2-6-0 tender locomotive.

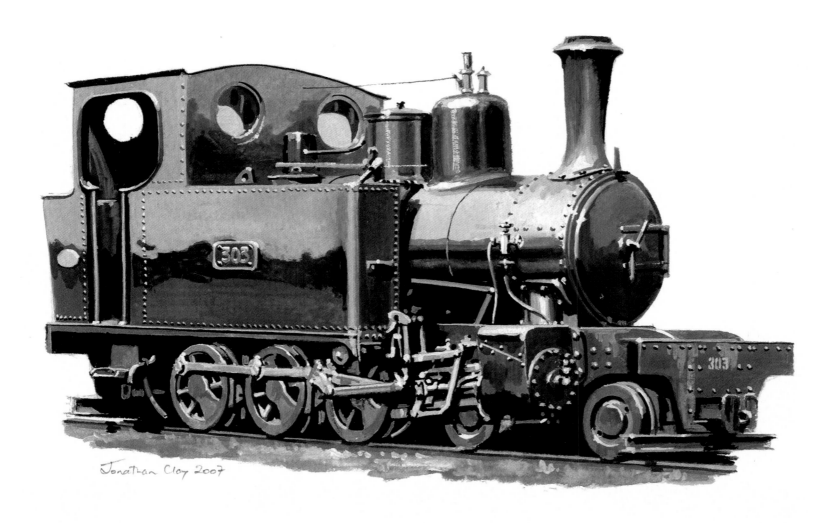

British War Department Hunslet 4-6-0T No. 303

To equip the 60cm trench railways in the First World War, the British War Department ordered a large number of these lovely 4-6-0Ts, although in the end only 155 were built, because Hunslet was unable to fulfil any further orders. The WD then turned to the USA for motive power, principally from Baldwin. After the cessation of hostilities in 1918, many of the locomotives were repatriated, although some remained in France until the 1950s. Several found industrial use in the UK, including on the Lochaber Railway in Scotland and at Harrogate Gasworks. Many travelled much further afield, with examples being used as far away as Argentina, Australia and the Indian sub-continent.

Until recently, there were no survivors in Britain, but thanks to the War Department Locomotive Society, under the capable leadership of Ian Hughes, No. 303 (or Hunslet No. 1215) was brought back home. It is now well on the way to steaming again.

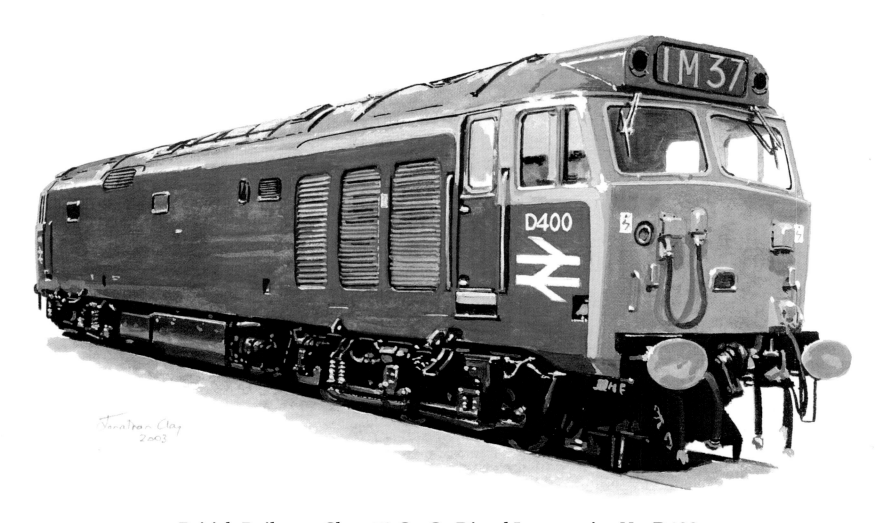

British Railways Class 50 Co-Co Diesel Locomotive No. D400

It's hard to believe that it is nearly forty years since my friend Paul and I spent a day at Hest Bank, photographing the last of the Class 50 hauled passenger trains on the West Coast Main Line. They were introduced in 1968, and were effectively a production version of the English Electric prototype DP2. They looked completely different, however, since DP2 used a Deltic bodyshell. The Class 50s were subsequently transferred to the Western Region, where they were named after warships (D400 became *Fearless*) and in the early 1980s were completely refurbished for further use on the Southern and Western Regions. They were taken out of service in the early 1990s, but eighteen have been preserved. They also have a counterpart in Portuguese Railways Class 1800, which I have ridden behind in the Algarve, one of which is also preserved and fully functional.

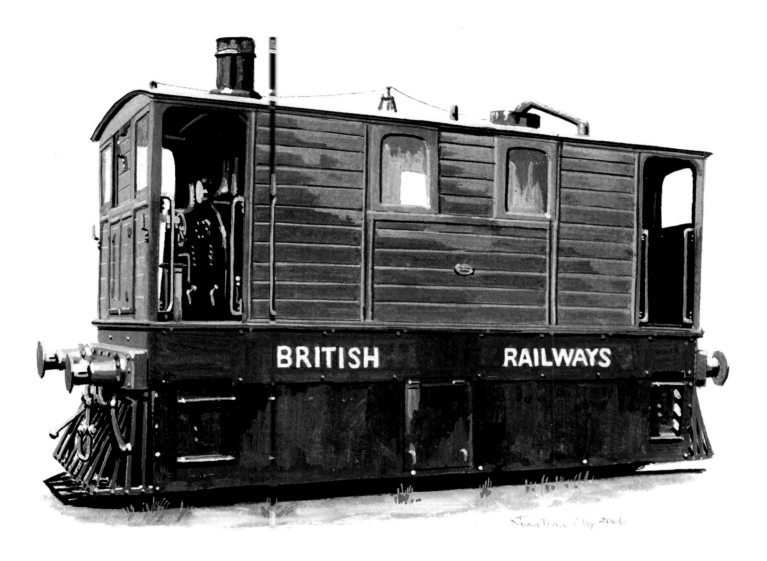

Ex-GER Class Y6 Tram Locomotive

It's Toby the Tram Engine! Most of the locomotives in the Rev. W. Awdry's books are based on real ones: each has a recognisable prototype from Britain's railways. Enthusiasts tend to turn their noses up at the concept of 'Thomas the Tank Engine', but he helped to fire an enthusiasm for railways that has never left me. Preserved railways also have good reason to be thankful: 'Thomas' events attract many people who wouldn't otherwise visit.

So, back to 'Toby': the Wisbech and Upwell Tramway in East Anglia was built by the Great Eastern Railway, and because of its rural, roadside nature, for safety the locomotives were fitted with side-skirts and cowcatchers, and their boilers were clad in van-like bodies.

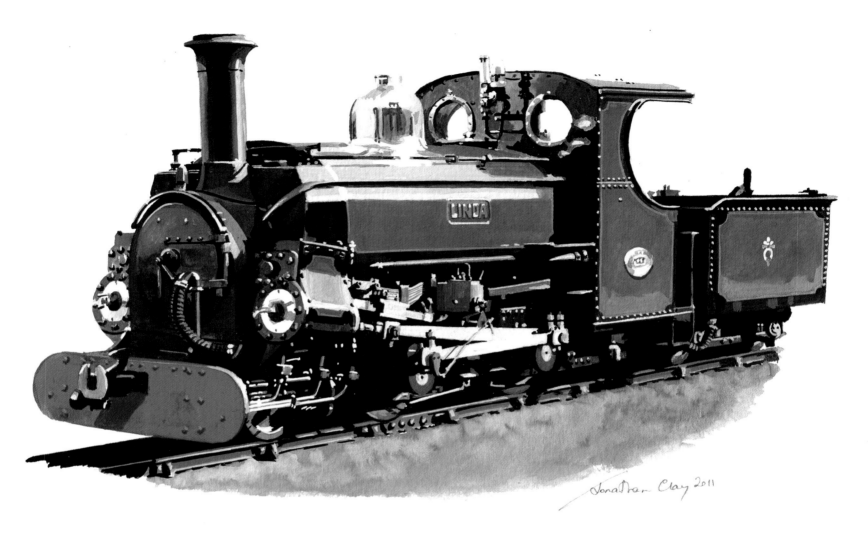

Ffestiniog Railway Hunslet 2-4-0ST/T *Linda*

When the Ffestiniog Railway was reopened in the mid-1950s, it relied on its own locomotives *Prince* and *Taliesin* to pull the trains, but as the 1960s dawned, more motive power was needed. In 1962 the Penrhyn Quarry Railway from Bethesda to Port Penrhyn closed, making its two 'main line' locomotives redundant. These were the Hunslet tank locomotives *Linda* and *Blanche*, both of which found their way onto the Ffestiniog. They have been a mainstay of traffic ever since, although they are now considered a little underpowered to haul trains on their own. However, coupled together they make a very formidable duo. In 2012 they took part in the Welsh Highland Railway's King of the Hills competition, and acquitted themselves very well, especially as compared to the NG16 Garratts!

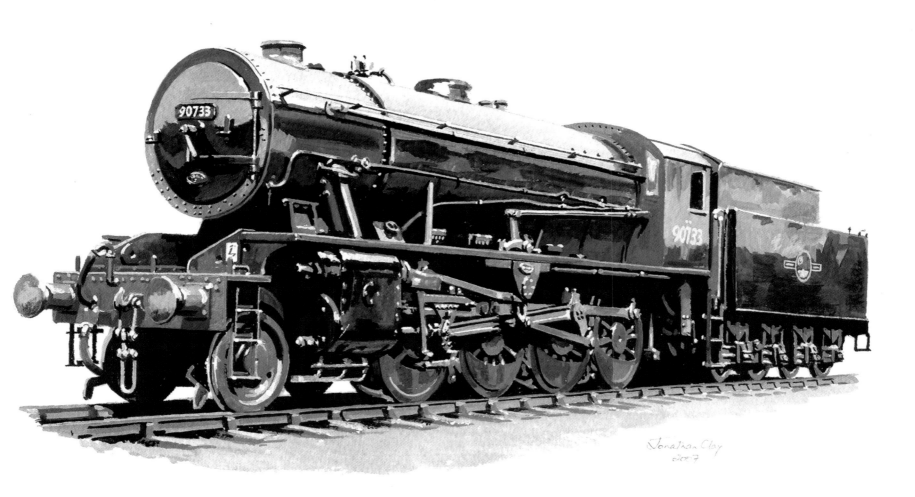

Ex-War Department Austerity 2-8-0 No. 90733

It's pity that one of the genuine WDs didn't survive to be preserved. Designed in the Second World War, 935 2-8-0s were built for use by the British forces overseas. They were simple, basic, rugged machines – in fact, unsung workhorses. Over 700 (2-8-0s and 2-10-0s) fell into BR ownership in 1948, and many were also retained by railways in mainland Europe – notably Greece, the Netherlands and Scandinavia. Several have been repatriated, with locos from Greece going to the Mid Hants Railway and North Yorkshire Moors Railway.

After the war 90733 was bought by Statens Järnvägar (Swedish State Railways) and fitted with a shortened, six-wheel tender and a much larger, insulated cab. In 1973 it was imported to the UK for use on the Keighley and Worth Valley Railway, where it ran in its SJ condition and Swedish livery for a number of years. In the late 1990s it was rebuilt to resemble the BR variants, with a new tender and BR livery, and was relaunched in 2007.

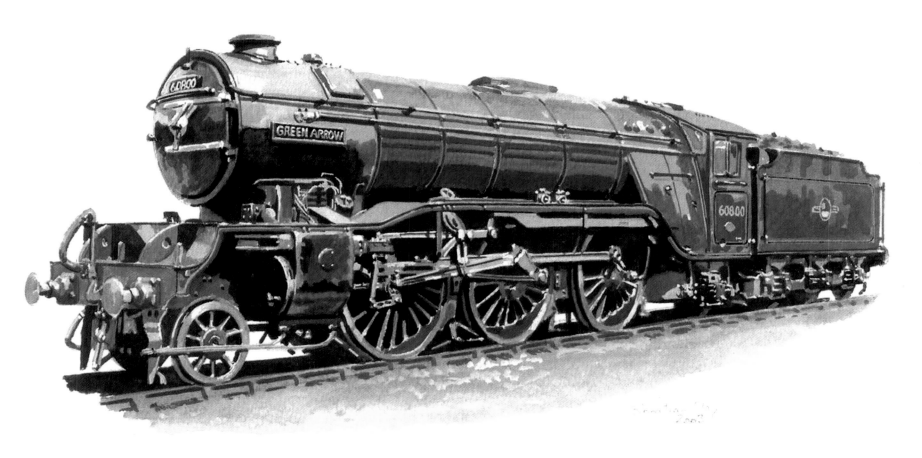

LNER Class V2 2-6-2 No. 60800 *Green Arrow*

I first saw these in Leeds, when staying with my paternal grandmother, and visiting friends at Cookridge, and my dad could distinguish a V2 from an A3 from some distance. Although the 2-6-2 wheel arrangement was common for tank engines, the V2s were the only major standard gauge type, 184 being built between 1936 and 1944 under the aegis of Sir Nigel Gresley. They were designed as a mixed-traffic type, though were often used to substitute for pacifics on passenger expresses.

Green Arrow was the first of the class, and another seven were also named. On withdrawal by BR in the 1960s, it was claimed for the national collection and now resides at the National Railway Museum. It has seen several periods of use on the main line, both in BR livery and, as LNER No. 4771, in LNER green, which it currently wears.

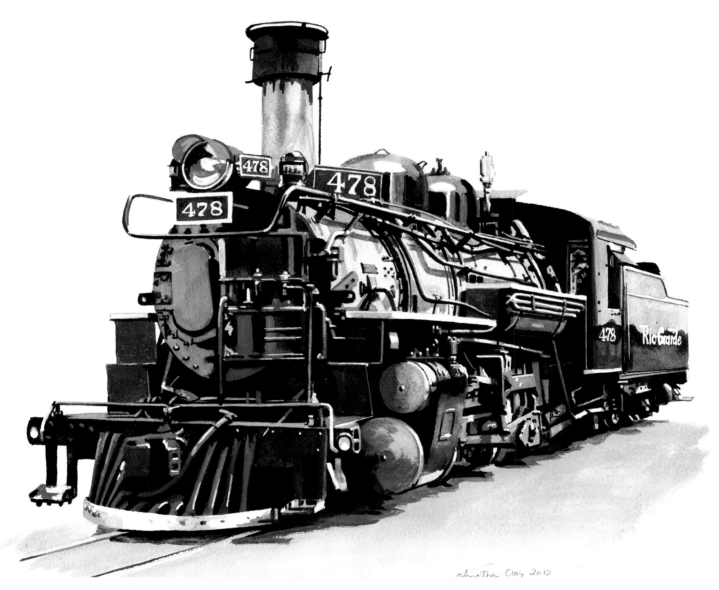

Denver and Rio Grande Railroad Class K28 2-8-2 No. 478

Though there have been several 3ft gauge railways in the United States, the most iconic was the narrow gauge section of the Denver and Rio Grande Western Railroad in Colorado. This was very successful as well as long-lived. Two separate sections were developed as tourist lines in the 1950s; these are run as the Cumbres and Toltec Scenic Railroad and the Durango and Silverton Railroad. In the 1970s the Cumbres section was purchased jointly by the New Mexico and Colorado state governments and the D&S has run in private hands since 1980.

The locomotive fleets are every bit as iconic as the country they operate in. Of the ten locos of this type, three survive on the D&S, whilst examples of the larger, K36 2-8-2s operate on both lines.

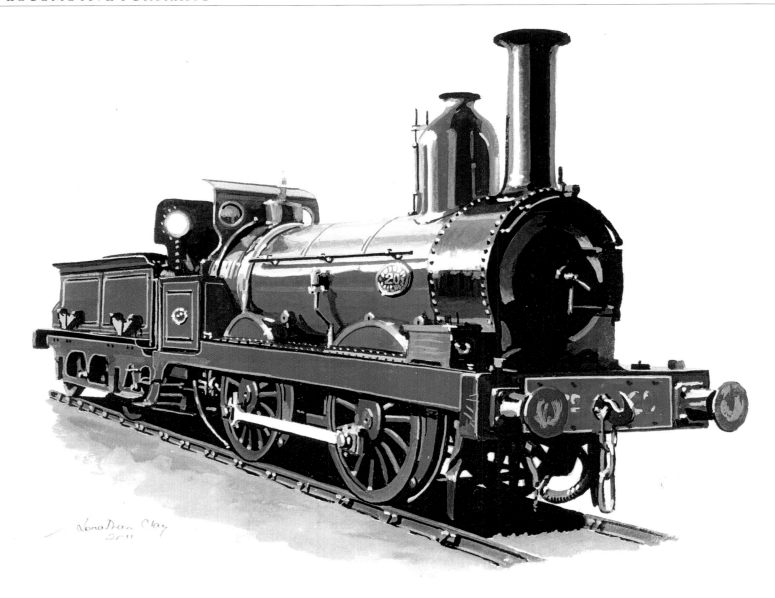

Furness Railway Sharp, Stewart 0-4-0 No. 20

This loco currently looks nothing like the rather forlorn saddle tank which was at Steamtown Museum at Carnforth in the 1970s. No. 20 was one of eight built as Furness Railway Class A5 in 1863. It was later converted to a saddle tank and sold into industry. Later it and No. 25, another surviving A5 (still a saddle tank) were put on display at various educational facilities in Barrow-in-Furness before ending up at Steamtown.

In the 1990s, No. 20 was taken over by the Furness Railway Trust and beautifully restored to its original condition as a tender loco, a task which involved building a new boiler and tender. Although its home is nominally at the Ribble Steam Railway in Preston, it has spent considerable amounts of time working on other preserved railways and is currently at Locomotion in Shildon. It is the oldest working standard gauge steam engine in Britain.

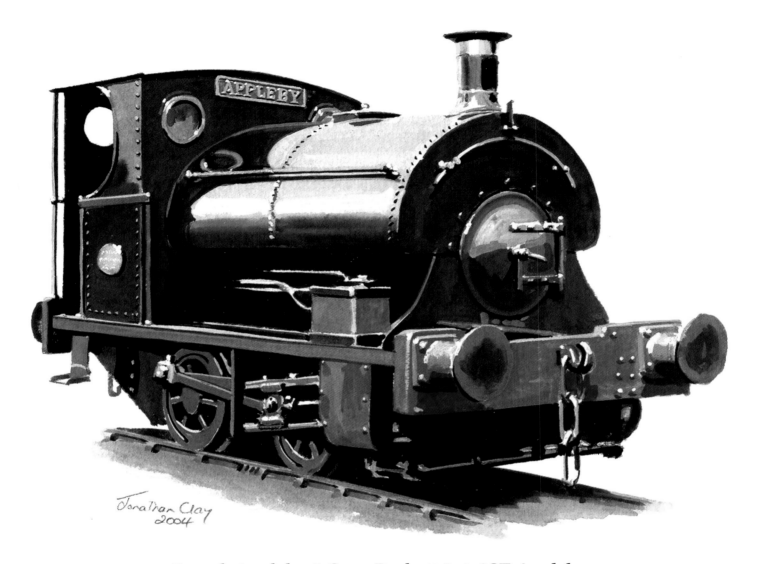

Joseph Appleby & Sons Peckett 0-4-0ST *Appleby*

This is a locomotive from my childhood. Like most towns, Blackburn had a couple of industrial lines operated by small tank locomotives. In addition to the local gasworks and power station, the grain milling firm of Joseph Appleby and Sons had a siding connected to the BR lines near Daisyfield Junction. This ran a very short distance over the road and into the factory. *Appleby*'s usual load was a solitary BR grain wagon, since it was said that's all it could manage. It was common for motorists to stop and wait whilst the loco struggled across the road with its load.

When it came to producing this picture, it wasn't difficult to find photographs to work from. However, neither I nor anybody else who knew of it could remember the exact livery, so the above is a 'best guess'. Incidentally, *Appleby*'s locomotive shed still survives by the side of the road, having had various uses over the years.

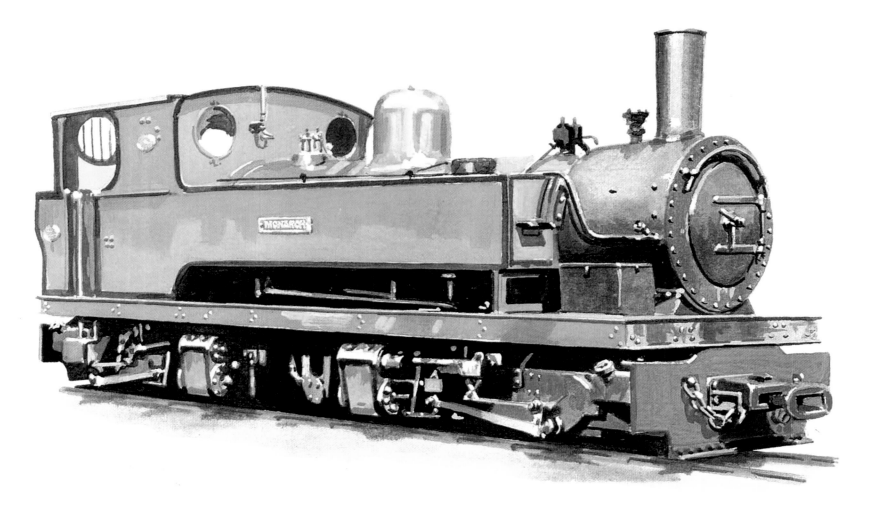

Welshpool and Llanfair Light Railway Bagnall 0-4-4-0T *Monarch*

Articulated locomotives were uncommon in the UK. True, the LMS and LNER had a small numbers of Beyer-Garratts, and there were also a couple in industry. And of course we mustn't forget the Ffestiniog's Fairlies, but that's about it, apart from *Monarch*. Apart from being the last industrial narrow gauge locomotive to built in Britain, when it was constructed in 1953 it was the only Bagnall-Meyer articulated in the country. It was built for Bowaters Paper Mill in Sittingbourne, but worked there for only thirteen years before it was purchased by the WLLR. Once overhauled it was only a limited success, largely due to its circular, marine-style firebox.

It was sold to the Ffestiniog Railway in 1992, with a view to it being rebuilt to 2ft gauge, but after spending a number of years in pieces in Minfford Yard it was sold back to the WLLR, where it was reassembled and cosmetically restored for static display.

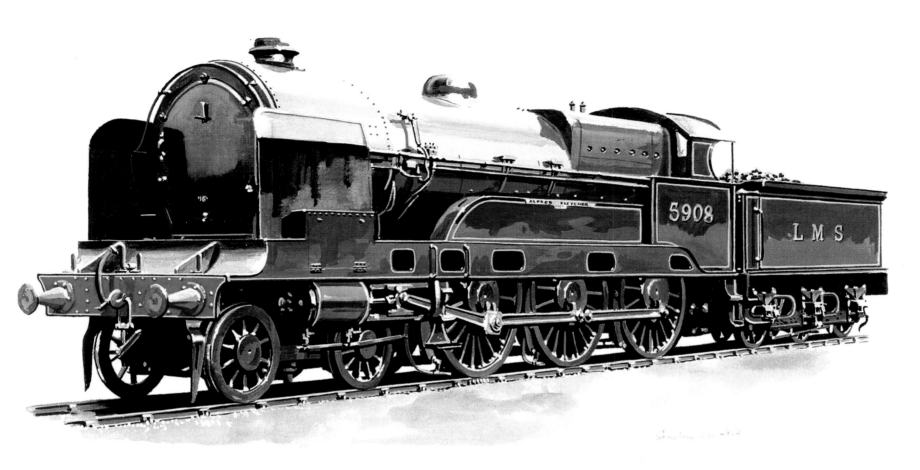

LNWR Rebuilt Claughton 4-6-0 No. 5908

Unfortunately, all the Claughtons had gone by the time I started trainspotting, and they were pretty impressive machines, particularly in their rebuilt form. These four-cylinder locomotives were the principal express engines of the LNWR, and were named after its chairman, Sir Gilbert Claughton. A total of 130 were built between 1913 and 1921. After the grouping in 1923, the LMS took steps to try and improve them, ten being rebuilt with Caprotti valve gear, and twenty being fitted with larger boilers (as the one above). Twelve were selected to be rebuilt into the new Patriot class 4-6-0s, though I doubt if much material was used. The first two Patriots were identified by the large driving wheel bosses, as fitted to the Claughtons.

All but four Claughtons were withdrawn by 1937, three more were gone by 1941, leaving a single survivor to soldier on into British Railways ownership before it, too, was withdrawn in 1949.

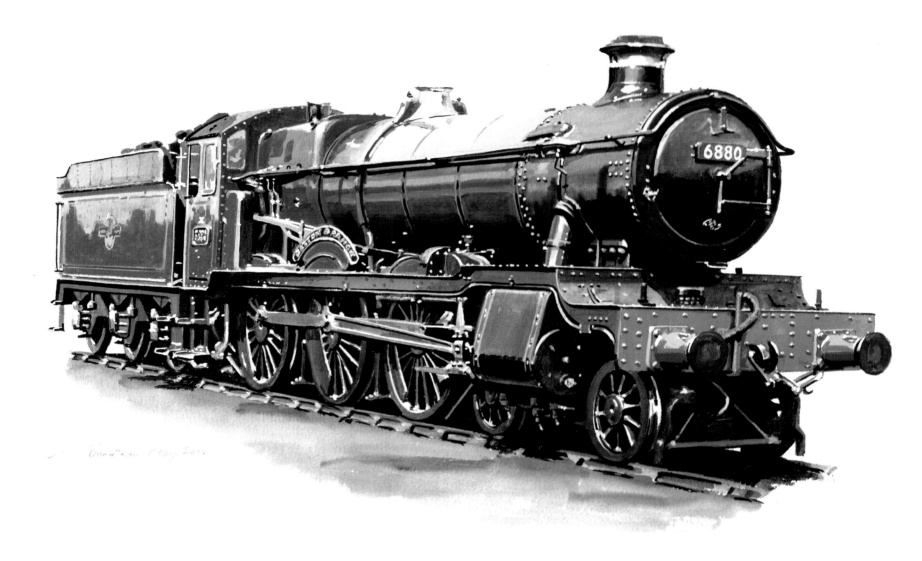

GWR Grange Class 4-6-0 No. 6880 *Betton Grange*

Eighty of the Grange class were built between 1936 and 1939, and they are a perfect example of G.J. Churchward's approach to locomotive standardisation. They were, effectively, a Hall with smaller wheels, or a Manor with a larger boiler. The class was withdrawn by 1965 and was one of only two types of GWR 4-6-0 not represented in preservation. However, a determined group of enthusiasts in Wales, known as the 6880 Society, is determined to build a new one, and I am privileged to have produced this picture for them.

The project began in 1998, using a mixture of old and new components. The basis was a new set of frames, with new cylinders, and a new cab, but the wheels came from a 61XX class loco, the bogie and tender were borrowed from Hall No. 5952 *Cogan Hall* and the boiler from Modified Hall No. 6959 *Willington Hall*. Great progress has been made at Llangollen over the years, with the result that the loco became a 4-6-0 in 2013, and the time can't be far off when we can see the '81st Grange' in steam.

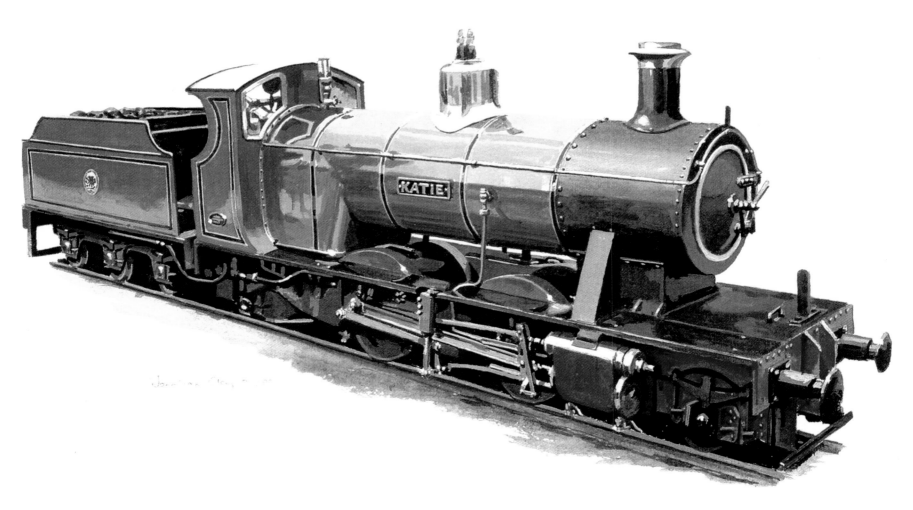

Fairbourne Railway Guest 2-4-2 *Katie*

Another of my favourite locomotives. I first saw *Katie*, and her sister *Sian*, at the Fairbourne Railway in the early 1960s. They were built by Trevor Guest, to the designs of Ernest W. Twining, and are two of the best proportioned miniature or narrow gauge locomotives ever built. With the takeover of the Fairbourne Railway by John Ellerton in the 1980s, and the subsequent re-gauging of the line, *Katie* became redundant and found its way to Haigh Hall in Wigan, where it worked for a number of years. It then moved to the Cleethorpes Light Railway, where it ran until its boiler certificate expired.

It was then bought by my good friend Austin Moss, who has undertaken a very thorough rebuild of the locomotive, including the fitment of a new boiler, It is hoped that when *Sian* reappears from its current overhaul, that the two will visit other 15-inch gauge lines together.

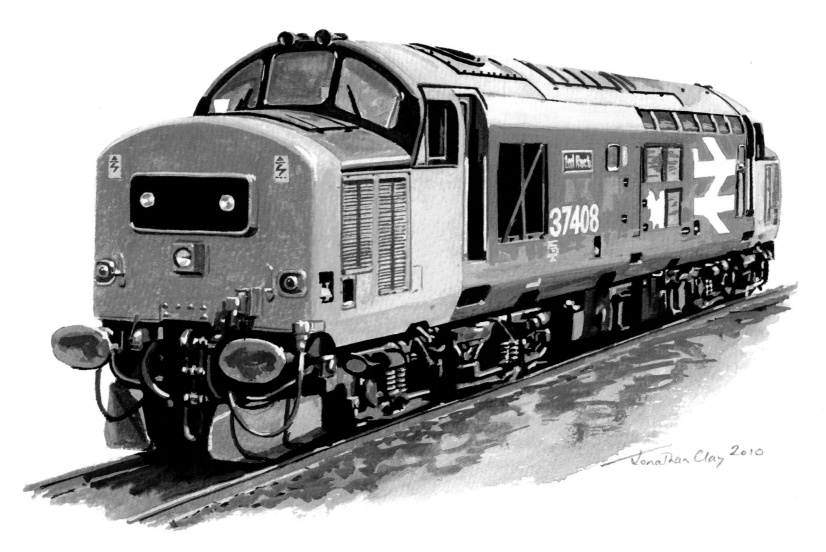

BR Class 37 Diesel Electric Locomotive No. 37 408 *Loch Rannoch*

One of the amusing aspects of interest in 'modern' traction, is the variety of nicknames now associated with diesel locomotives. What to me was always known as an English Electric type 3, or even Class 37, is now known as a 'Growler'! Between 1959 and 1965, 309 were built, and although they were all made to roughly the same specification, rebuilding and alterations over the years has resulted in a bewildering array of variations. Although quite a few are still in everyday service on the main line, many have passed into preservation, and some have even gone from preservation back onto the main line!

37 408 was one of the locomotives of the 37/4 sub-class which worked for a while in Scotland, hence the name and the 'Scotty' dog emblem. Later it was repainted in EWS livery and from 2004 worked in Wales. Sadly, it was involved in a nasty collision in 2005 and scrapped in 2008.

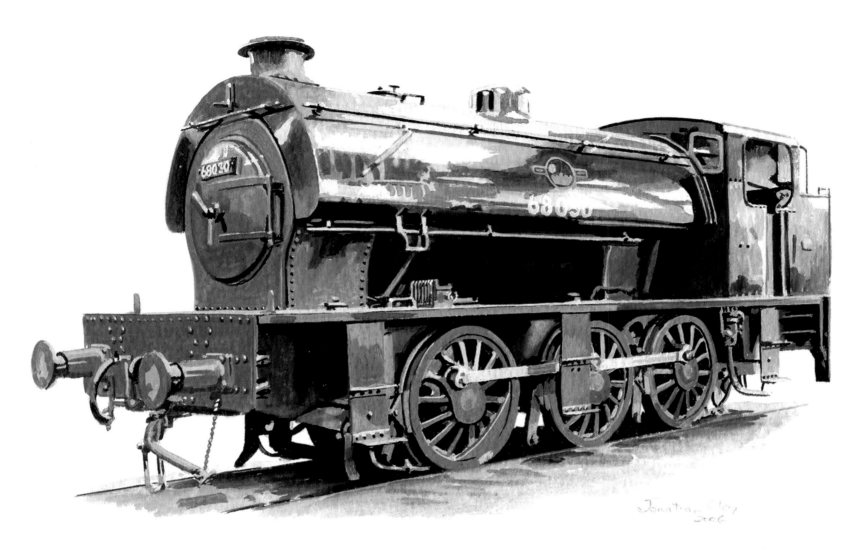

134. Hunslet Austerity 0-6-0ST (BR Class J94) No. 68030 *Josiah Wedgwood*

Austerity 0-6-0 saddletanks were another design borne out of wartime necessity. Just like the WD 2-8-0s, there was a need for a simple shunting engine for use by the Allied forces during the Second World War. Fortunately the Hunslet Engine Company already had a design in production, and they and several other builders turned out 485 of these for the War Department.

Whilst a good number of these found their way into industry, the LNER bought seventy-five, which became its class J94 and which were given enlarged bunkers. After withdrawal in the 1960s, about seventy of the Austerity class survived into preservation, and whilst some are painted as BR examples (including 68030) only two genuine ex-LNER and BR examples survive.

68030 was built in 1952 and worked at the National Coal Board. In 1977 it began working at the Cheddleton Railway Centre, and given the name *Josiah Wedgwood*. It has been hired out to several preserved lines and is currently awaiting overhaul at Llangollen.

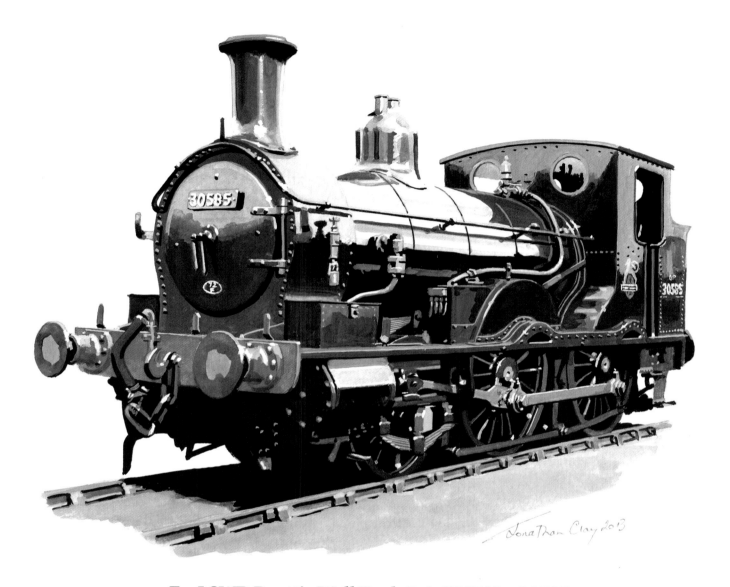

Ex-LSWR Beattie Well Tank 2-4-0WT No. 30585

The Beattie well tanks of the London and South Western Railway are remarkable survivors. Eighty-five were built between 1863 and 1875 for suburban passenger services south of London. After a useful life, most were withdrawn before 1900. However, three survived and worked on the line between Bodmin and Wadebridge. In 1962 they were replaced by lightweight ex-GWR pannier tanks of the 1366 class.

Happily, two out of the three *Beattie* well tanks have been preserved and are currently active. No. 30585 was sold by BR to the Quainton Railway Society in 1963 and underwent a lengthy restoration. Whilst based in Buckinghamshire, where it is nicknamed Beattie, it has visited many other steam lines during gala weekends. The other preserved Beattie well tank, No. 30587, is part of the national collection and is normally based at the Bodmin and Wenford Railway, where both locos have, on occasion, been together in steam.

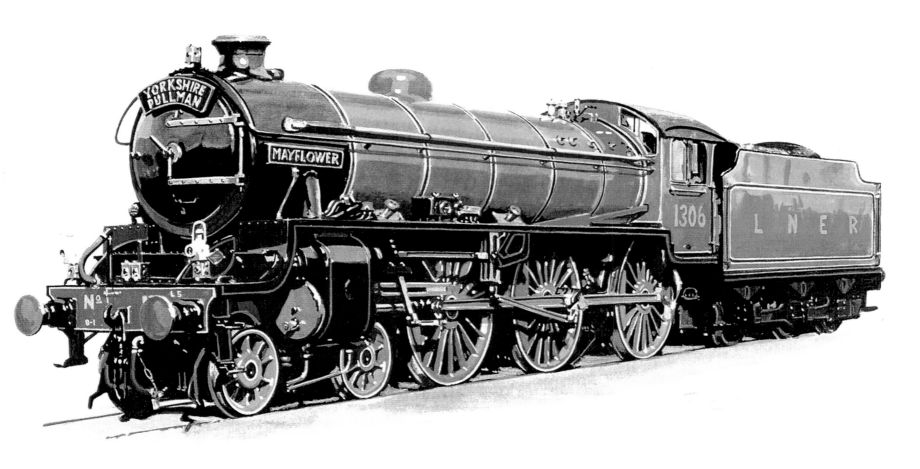

LNER Class B1 4-6-0 No. 1306 *Mayflower*

The B1 was designed as a mixed-traffic locomotive by Edward Thompson in 1942 and was the LNER's equivalent of the LMS Black Five or the GWR Hall classes. Production continued after nationalisation, a total of 410 being built. They were very successful, and two survived after the end of steam on BR. Luckily, No. 61264 was sent to Barry scrapyard, where it was rescued, and subsequently restored to working order. This was no easy task, as the boiler was in a pretty parlous state, and required large sections of new material to be welded in. It is currently main line certified, and can be seen running on the national network.

Mayflower was purchased straight out of service with BR by Geoffrey Boden, who kept it at Carnforth. Later it worked on the Great Central Railway and the Nene Valley Railway before returning to Carnforth to be operated by West Coast Railways. Boden Engineering sold *Mayflower* in 2014, and has been returned to main line for use on rail tours.

Ffestiniog Railway Baldwin 2-4-0D *Moelwyn*

Moelwyn was built in 1918 and served with the French Army during the First World War. Because it had been fitted with vacuum brakes, it is suggested that it occasionally pulled passenger trains, but no evidence of this exists. It was bought by the Ffestiniog Railway in 1925 and used as a shunter on both the FR and WHR. Built as a petrol tractor loco, in the 1950s it was re-engined with a Gardner diesel engine and used occasionally on passenger trains. It was later given an extended front end and a pair of pony wheels to aid its stability. It is still part of the FR's heritage fleet.

I have a black-and-white photograph of *Moelwyn* at Porthmadog Harbour station, my dad standing alongside, his pipe in his mouth. Although named after the mountain of Moelwyn (which can be seen from the railway near Tan-y-Bwlch) the name is also a mild pun on that of the manufacturer: 'moel' translates into English as 'bald', whilst 'wyn' means 'hill'.

LMS Caprotti Black Five 4-6-0 No. 44687

'Not another Black Five!' was a common cry amongst trainspotters gathered on railway platforms in the North West in the 1960s. Not surprising, really, when it is realised that 842 were built, by both the LMS and British Railways. They were not all identical, though, and several variations were included in that total. BR used the type for a great deal of experimentation in the 1950s. H.G. Ivatt introduced things like Skefco roller bearings, on either locomotive or tender, or both. He also built one locomotive (which survives) with outside Stephenson link valve gear. Others had self-cleaning smokeboxes, a feature which was adopted for BR standard locomotives. The most unusual, however, were two small groups fitted with Caprotti valve gear. The first twenty had low running plates and single chimneys; whilst the last two (including 44687) had raised running boards and double chimneys. A total of eighteen Black Fives survive in preservation, of which many have been restored to working order. Sadly, 44687 was scrapped in 1966 and no example of the Caprotti version survives.

BR Warship Diesel Hydraulic Locomotive No. D832 *Onslaught*

The Western class of diesel-hydraulic locomotives were preceded by the Warships, which consisted of two different designs. The first five had six-wheel bogies, and cabs set back behind the nose ends, and were the prototype hydraulic locos for the Western Region. However, the bulk of the Warships were built by BR at Swindon from 1958, and followed closely the design of the Deutsche Bundesbahn class V200 locomotives. They gradually took over the express trains of the WR from Castle class locos. A total of seventy-one were built, but they were short-lived, and were supplanted on these duties by the Western class. The hydraulics seem to have acquitted themselves well, and only succumbed to rationalisation by BR after 1968. Happily, two survive in preservation: No 821 *Greyhound* is on the Severn Valley Railway, and *Onslaught*, which although nominally based at the East Lancashire Railway, is said to be 'enjoying an extended holiday' on the West Somerset Railway. It currently carries BR green livery.

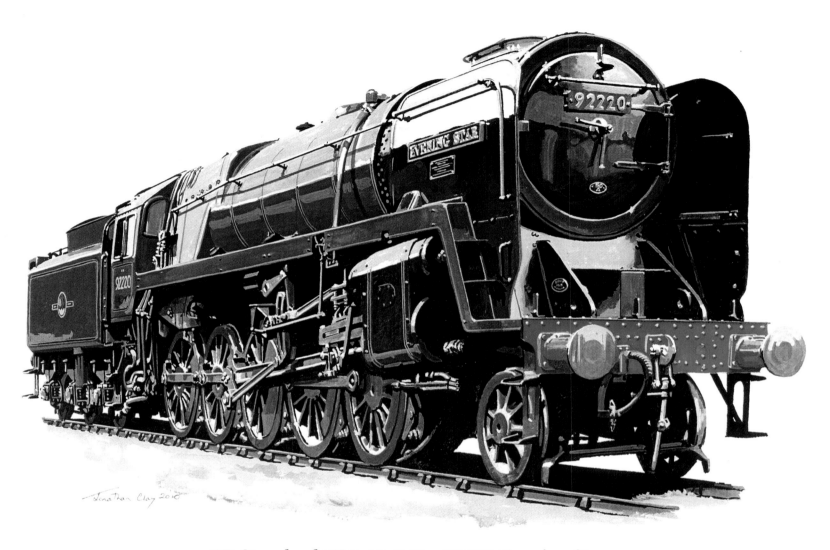

BR Standard 9F 2-10-0 No. 92220 *Evening Star*

It came as a surprise in 1960 when it was announced that the final steam locomotive had been built for British Railways. Although nominally a goods locomotive of class 9F, No. 92220 came in for special treatment in its finish. It was the only member of its class to be painted lined green, the only one to carry a name in BR service, and the only one to have a copper cap to its chimney, in best GWR tradition. Sadly its celebrity wasn't always reflected in its service use. It spent some of its short life on the old Somerset and Dorset lines, but photographs show it in a pretty scruffy state. Its working life was a mere five years, but luckily it had been claimed for the national collection while it was being built.

Evening Star was initially restored to working order in the 1970s and could be seen working on preserved lines and the main line. However, problems with its long wheelbase and flangeless centre wheels have kept it restricted as a static exhibit, principally at the National Railway Museum in York, although it recently spent two years at STEAM in Swindon.

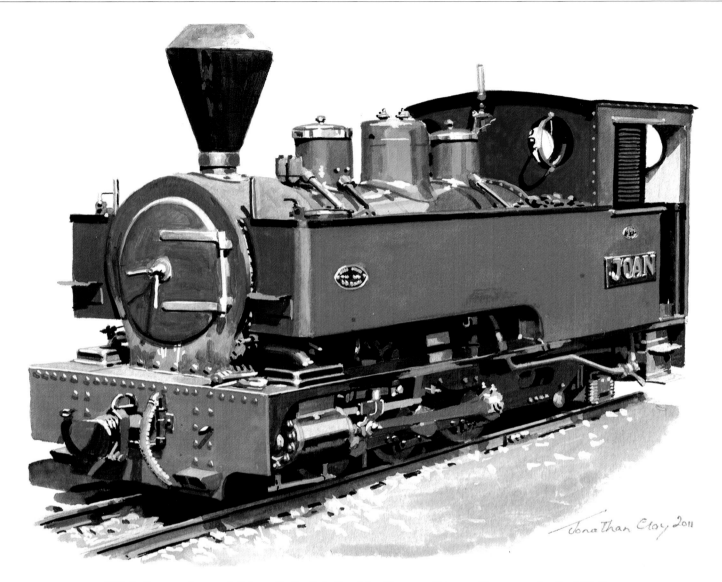

Welshpool and Llanfair Light Railway Kerr, Stuart 0-6-2T *Joan*

The Welshpool and Llanfair managed to operate for its entire working life with just two locomotives. In preservation days, however, there was a perceived need for extra motive power, which was obtained from various parts of the world, including Germany, Sierra Leone and – in this case – the Caribbean island of Antigua. This was largely due to the relative rarity of 2ft 6in gauge railways in the UK (although an engine from the Sittingbourne and Kemsley was used for a while).

Joan was built in 1927 as a modified Matary class locomotive by Kerr, Stuart and Co., and, after long service at an Antiguan sugar-mine, was rescued and brought back to the UK in 1971. It was restored to working order and used in service on the W&L until 1991, when it was taken out of service with major firebox issues, and was not in steam again for twenty years. After receiving a major overhaul and a new boiler, *Joan* was returned to service in July 2011.

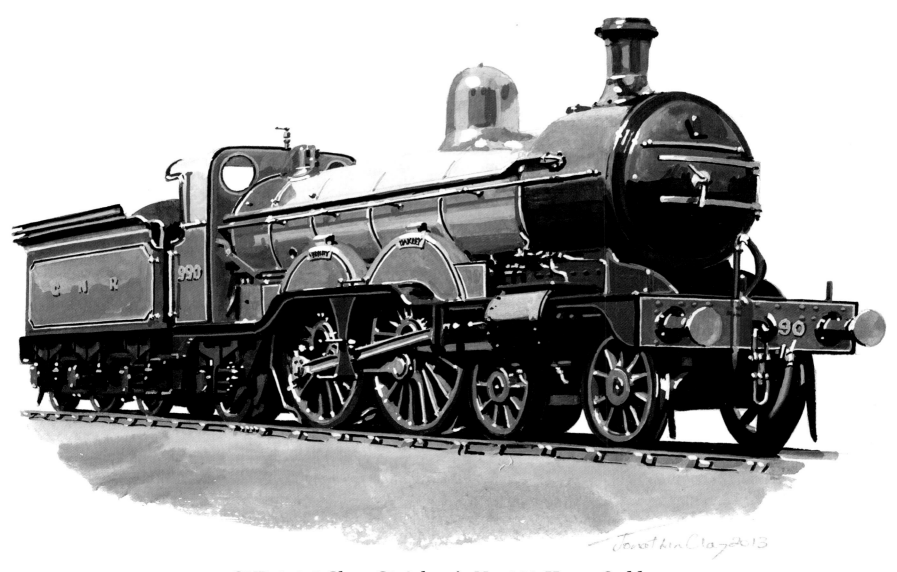

GNR 4-4-2 Class C1 Atlantic No. 990 *Henry Oakley*

Atlantic locomotives are rare in preservation, but we are fortunate to have two examples from the Great Northern Railway, and both belong to the National Railway Museum. Large Atlantic 251 is normally kept at York, but *Henry Oakley* has been a bit more nomadic over the years. Both locos were built around 1900 and have been in preservation for a considerable time, and both were restored to working order in the early 1950s to work enthusiasts' specials. In the 1970s *Henry Oakley* was again restored to working order, and was used at the Keighley and Worth Valley Railway on a number of occasions. In deference to its advanced age and historic status, it is now a static exhibit at Bressingham Steam Museum, on loan from the NRM, and is unlikely to be restored to working order again.

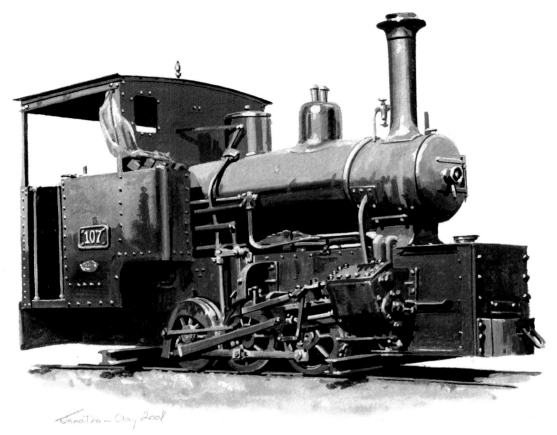

Hudswell-Clarke G Class 0-6-0WT No. 107

The Hudswell Clarke G class was originally designed to meet the War Department's need for a simple shunting locomotive for 60cm gauge railways to serve the trenches in France and Belgium. Two survive in the UK. One was built for Surrey County Council and named *Penrhyn Quarry*. The other is Bressingham Steam Museum's *Bronllwyd*, currently at the Statfold Barn Railway. It had seen service in Ghana, where it fell into a river during a storm in 1952, recovered in 1995, brought to the UK in 2008, and was restored to working order, appearing at Statfold Barn Railway in 2014. It is currently on the Apedale Valley Railway.

It is perhaps fitting that as I write this in 2014, a lot of emphasis is being made of the 100th anniversary of the start of the First World War, as railways played a very important part in that conflict. It wasn't the first war to use railways, however, as Christian Wolmar's book *Engines of War* explains.

Another Hudswell Clarke 0-6-0 well tank was built in 1930 for Surrey County Council for use on the construction of the Guildford Bypass, and was purchased by the Penrhyn Quarries in 1934, where it worked until 1949. In 1951 its boiler and cab were used in the rebuild of the Quarry Hunslet *Pamela* and the chassis put in the scrap line. In 1966 the chassis of *Bronllwyd* and the boiler of the Kerr Stuart loco *Stanhope* were acquired by Alan Bloom and put together for use at Bressingham in Norfolk, where the loco operated for many years. The boiler was later renewed. The original cab was not restored, and the bright red livery was quite different from the sombre Penrhyn black.

In 2010 it was announced that the loco had been acquired for the Statfold Barn collection. By 2012 it had been overhauled and appeared in Surrey CC livery, with the cab replaced.

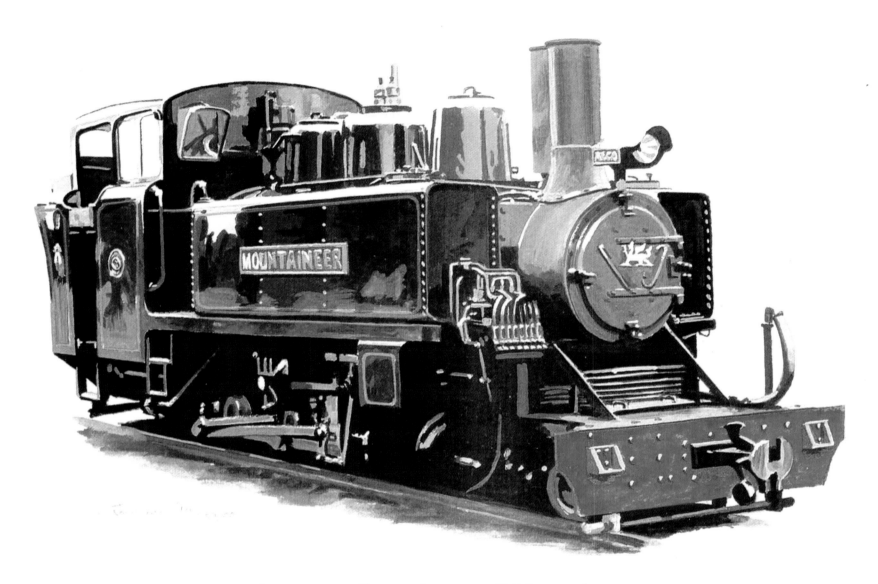

Ffestiniog Railway Alco 2-6-2T *Mountaineer*

Another survivor from the trenches of the First World War, this time from the American side of the Allied forces, who tended to prefer 2-6-2 types due to their better stability. Built in 1916, this loco remained in France after the war and was used firstly for reconstruction work and then (possibly) in a factory. It eventually found its way to the Tramway de Pithiviers à Toury, along with two other War Department Alcos which are both still in France.

In 1967 it was sold to John Ransom, who shipped it to the UK and donated it to the Festiniog Railway Company. It was then given the name *Mountaineer*, although it is generally known as 'the Alco'. The cab had to be modified to fit the FR's loading gauge, and it received a new boiler with an extended smoke-box. Sadly, it was taken out of service in 2006 and now awaits the funds to undergo a major overhaul.

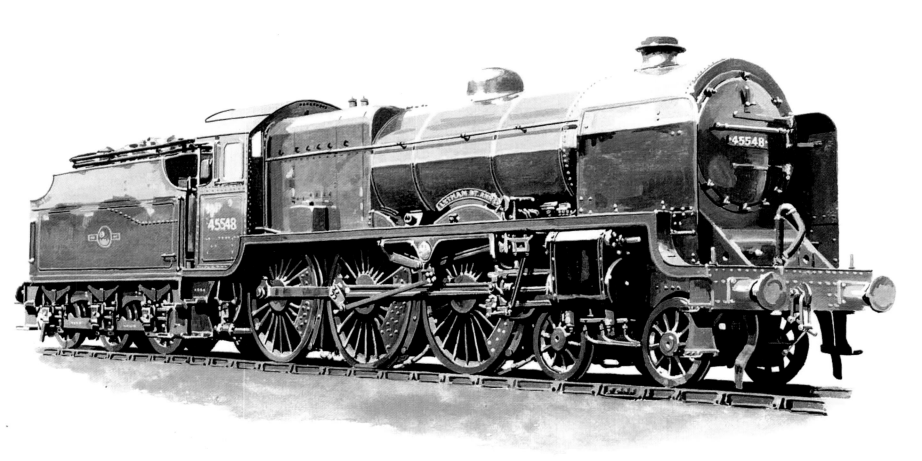

LMS Patriot Class 4-6-0 No. 45548 *Lytham St. Annes*

When the last few 1930s Patriots were taken out of service in the early 1960s, a number were stored in the loco shed at Preston. They were effectively a smaller and lighter version of the Royal Scot 4-6-0s, and even acquired the epithet 'Baby Scots'. Even though some were rebuilt with taper boilers, none managed to survive into preservation.

The LMS–Patriot Company set out in 2008 to remedy that omission. Building a locomotive from scratch is no mean feat, but that is exactly what this group is doing, and by November 2013 the frames, complete with wheels, smoke-box, smoke deflectors and cab, were displayed at Warley Model Railway Club's annual exhibition at the NEC in Birmingham. In September 2014 it was displayed at the Great Dorset Steam Fair. New loco, numbered 45551 and called *The Unknown Warrior,* will be the Royal British Legion Endorsed National Memorial Engine, and is on track to be completed a year ahead of the 100th anniversary of the Armistice in 1918.

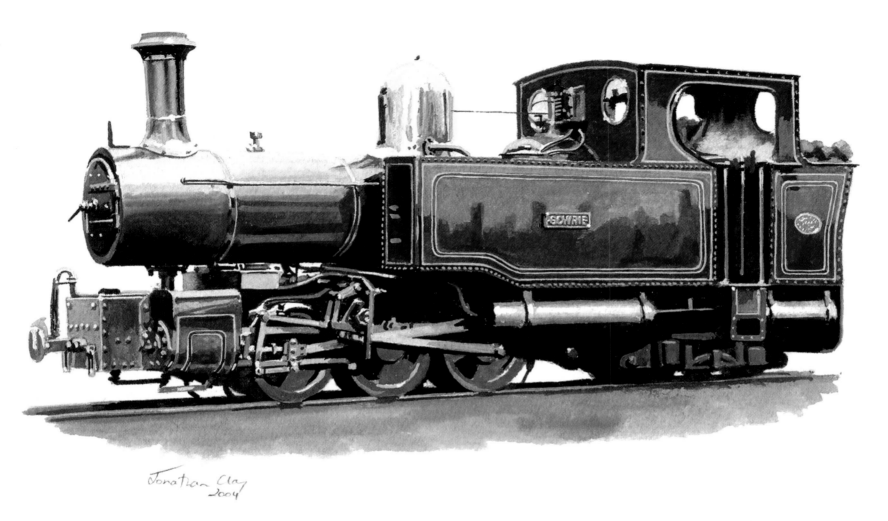

North Wales Narrow Gauge Railway Hunslet Single Fairlie 0-6-4T *Gowrie*

Mystery surrounds the fate of this locomotive. The third and last Hunslet single Fairlie it was built in 1908 for the North Wales Narrow Gauge Railway. Unlike the Ffestiniog, the NWNGR preferred single boiler Fairlies, of which they had three, including the late, lamented *Moel Tryfan*. *Gowrie* was named after Gowrie C. Aitchison of the Portmadoc, Beddgelert and South Snowdon Railway, predecessor of the NWNGR. Although more powerful than the line's two Vulcan Foundry locos, it was not a success, and was sold for government use in 1918. In the early 1920s it was in industrial use, and was advertised for sale in 1928. After that we lose all trace of *Gowrie*. Perhaps it went abroad, although it is more likely to have been unceremoniously scrapped.

Acknowledgements

It has been my great privilege to meet and, in a lot of cases, to make friends with some lovely people who have helped make it possible to turn my hobby into a career. Sadly, I find it impossible to list all of those who have had the tremendous good taste to ask me for a painting, but to those who have provided advice, guidance, patience, patronage, encouragement and friendship to all those who have asked me to paint something for them, I offer my thanks. I would also like to express my gratitude to the following:

Mark Allatt, Graham Langer, Gillian Lord, Alexa Stott, and all at the A1 and P2 Trusts, builders of bespoke steam locomotives; Giles and Sue Margarson, Andrew Barnes and all at the Bure Valley Railway in Norfolk; Kay and Nigel Bowman from Launceston Steam Railway (for their all-round eccentricity); Nigel Bird, the famous book dealer of Cardigan Bay; Terry Turner, Kevin Heywood, Keith Bide, Eileen Niblock, Simon Bowden, John and Kaye Forman and all at the Welshpool & Llanfair Railway; David and Marie-Ange Blondin, and the rest of the family at le Petit Train de Haute Somme at Froissy, in France. All at Steam Railway Magazine, including former editors Gary Boyd-Hope, Danny Hopkins and Tony Streeter; David Burleigh, he of the 009 and 7 $\frac{1}{4}$ gauge societies (and London

Transport); Simon Buxton – 'Mr Bufferbeam' – who provides me with quality merchandise for my exhibition stand; David Bradshaw, Andrew Laws, Gavin Schell, the Kinseys, and all those of the LMS Patriot Project; Eileen Clayton – a great friend from a bygone age – and her husband, Neil; Matthew Cousins, Mike Turner, Chris Ashworth, Barry Freeman, Malcom Root and all at the Guild of Railway Artists; Andrew Charman of Narrow Gauge World magazine – and Llanfair Caereinion; Quentin and Liz McGuiness of the Betton Grange group; Jeff Cogan and Ken Bull, railway photographers extraordinaire; Anthony Coulls of the NRM; Bob and Rosemary Darvill of the Industrial Railway Society; Jeremy Davey – computer wizard, lumberjack and all-round good egg, who has a beautiful wife. All at the Ffestiniog and Welsh Highland Railways – especially John Wooden, Claire Britton, Ian Fraser, David Firth, Adrian Gray, David Gwyn, Robert Shrives, Oliver Bennett and, of course, Paul Lewin. All at the West Lancashire Light Railway – Graham Fairhurst, Paul Smith, Neil McMurdy. Mike Spall, Alan Jones, and the other two Alans. Our good friends Martin and Joan Farebrother, for their French endeavours; Ian Hughes, Kim Winter et al from the War Department Locomotive Trust; the Hewitt

family and all at Heritage Painting; Peter Johnson, that well-known author and photographer – and good friend – especially for his foreword to this book; Robin Jones and all at Heritage Railway magazine; Paul and Sarah Jarman from the Living Museum of the North at Beamish; Vaughan and Eirian Jones of Criccieth, for correcting my very poor Welsh; the Kerr family of Arbroath; Simon Lomax, John Rowlands, Phil Robinson and all at Apedale; Austin Moss, good friend and miniature railway collector of note; Stuart McNair and Alisdair Stuart, engineers extraordinaire; Neil Marshall, Gordon Rushton, Terry Bye and Dennis Dunstan of the 5BEL Trust; Martyn and Liz Owen of the Welsh Highland Heritage Railway; Andrew Burnham of Peco, who has most, if not all, of my cards; Chris Proudfoot and the Massaus and all those building the Standard Class 3 tank; Danny Martin of the Romney, Hythe and Dymchurch Railway; Henry Noon, Graham Lee and all at Statfold; to John Scott-Morgan, for asking me to write this book, and Helena Wojtczak, my editor at Pen & Sword. I would also like to mention a few who are no longer with us: Robin Butterell, one of my childhood heroes; John Keylock, a true English gentleman; Ronald Nelson Redman, of Hudswell Clarke fame; and David Perrin, who gave me a lot of advice and support when I was starting out. My warmest thanks go to Barbara, without whom I wouldn't be doing what I am today.

I am painfully aware that I might have missed someone out. If your name is absent, I prostrate myself in apology. You can remonstrate with me later, preferably over a refreshing glass of lemonade.